THE WORLD
CATACLYSM
IN 2012

Other Books by Patrick Geryl:

THE ORION PROPHECY

HOW TO SURVIVE 2012

THE WORLD CATACLYSM IN 2012

Patrick Geryl

Adventures Unlimited Press
Kempton, Illinois
Amsterdam, Netherlands

The World Cataclysm in 2012

First Printing
September 2005

ISBN: 1-931882-46-0
ISBN 13: 978-1-931882-46-0

Published by:
Adventures Unlimited Press
One Adventure Place
Kempton, Illinois 60946 USA
auphq@frontiernet.net

www.adventuresunlimitedpress.com
www.adventuresunlimited.nl

10 9 8 7 6 5

THE WORLD CATACLYSM IN 2012

CONTENTS

PART IV ASTRONOMICAL AND MATHEMATICAL PROOF

PART V THE DRESDEN CODEX DECIPHERED

APPENDIX

INTERNET: www.howtosurvive2012.com

FOREWORD

2012 and Super Galaxies

In my book *The Orion Prophecy* I came to the staggering conclusion that in 2012 AD, the earth will be subjected to a huge disaster. The cause: the magnetic field of the earth will reverse all at once, resulting in an enormous shift of the earth's crust. Virtually nobody will survive this, and at the same time all our acquired knowledge will disappear. These scientific predictions originate from the Maya and the Old Egyptians. Both civilizations are descendants of the legendary Atlanteans, and they had very highly-evolved astronomical knowledge. In ancient antiquity, they were able to accurately predict the tidal wave that would herald the end of their civilization. Knowing this sent me on my quest for the background of their calculations. After years of intensive research, I finally succeeded in cracking the millennia-old codes of the Maya and Old Egyptians. All my findings make up an amazing exploratory expedition into the secrets of a very distant past. What I discovered is astonishing and concerns everybody. At the same time this discovery explains why the Egyptians built the pyramids of Gizeh according to the star system of Orion.

In 2012 AD, just as in 9792 BC, the year of the last polar reversal, Venus will make a planetary loop above the star system of Orion. In the Egyptian Book of the Dead this is described as the crucial signal for the reversal of the poles, because after this, the earth will start turning in the opposite direction. The astronomical description of this phenomenon left by the Egyptians is amazingly clever and beyond any scientific knowledge. Also, I discovered that the Dresden Codex of the Maya talks about the sunspot cycle (about which our modern astronomers know nothing yet!). At a certain moment, when the sun's magnetism reaches a crucial point, a colossal catastrophe will destroy the earth. The Egyptian astronomical zodiac describes the eras in which previous catastrophes occurred, and also contains the codes of the sunspot cycle and the movement of Orion: the next disaster will take place when Venus makes a reverse movement above this constellation. The combination of these facts proves the origin of the number 666—known from the Bible as the number of the Apocalypse. This number describes an aberration in the sunspot cycle, which lays the foundation for the forthcoming world cataclysm.

The Maya and Old Egyptians also had incredibly precise calculations for the orbit of the earth around the sun. They are so accurate they exceed our current values. Completely astonished

by my discoveries, I could do nothing else but conclude that these ancient calculations were exact. And that leads us to the crucial question: should my discoveries be taken seriously or not? Is my case scientifically strong enough? Do I have evidence to back it up? Do I have enough knowledge of astronomy? This is crucial, because the calculations of the Maya and Old Egyptians are totally based on this science.

In the end, I believe my knowledge is sufficient. My previous astronomical predictions have become reality, exactly as I announced them. And they are not trivial! That is why my discoveries about the Maya and Old Egyptians should be taken very seriously.

To give you an example: more than 20 years ago I was the only one in the world to predict the discovery of billions of quasars in the infrared spectrum, as well as the accelerating expansion of the universe. I explain this in a very simple manner in my book *A New Space-Time Dimension* (yet to be published in English). At the time, not a single astronomer thought it possible; moreover, they scorned it as being impossible! But only a few years later they had to bow their heads. Articles in the Flemish press and an interview on Belgian television in 1990 evidently proved that I was right. And what is this all about?

The Dutch satellite IRAS was launched on January 26, 1983. A few weeks later, on February 11, an article of mine was published in the Flemish newspaper *Het Laatste Nieuws*, explaining in detail that IRAS would show that the relativity theory is wrong. The paper commented: "According to Geryl, IRAS should be able to prove that his calculations are correct and that the satellite should trace billions of supergalaxies that radiate extremely high energies, and are besides very rapidly moving away from us, almost at the speed of light. This implies that these kinds of systems cannot be seen from Earth with normal light telescopes, but only with the help of an infrared telescope, like the one the Dutch space probe has aboard. Should IRAS discover such systems, this would mean that the relativity theory of Einstein is not correct, and would give us a complete new Space-Time dimension, so says Geryl."

Another article, published in the newspaper *De Gazet van Antwerpen* clarifies: "According to the relativity theory, the quickest galaxies of the cosmos, the quasar-systems, should age more slowly. Moreover, one should not detect any rapid changes in their structure and gravitational force. Besides, the quasar-worlds should radiate less energy because of their time dilatation. However, according to the man from Deurne, one doesn't actually see this time dilatation, but something completely different. Something that subverts the complete theory of Einstein.

The quasars are collapsing! They perish even faster than other galaxies. In fact, the superexplosions are taking place at a very high speed. So this means that the quasars are not at all sensitive to this time dilatation. On the contrary, they are far more unstable and they are destroying themselves with a catastrophic gravitational collapse. They even accelerate their self-destruction through the coagulating mass (because mass increases with speed) and they finally die in the most violent explosions of the universe."

On November 23, 1990, I explained everything again to the popular science magazine *Modem*, which belonged to the Flemish television at that time; I emphasized the fact that the universe must expand with acceleration.

In the early nineties billions of quasars were discovered in the infrared spectrum. In 1998 it became known that the universe is expanding with acceleration. I made several more predictions in my book, which still have to be proved by astronomers and physicists. Which brings us back to this book and my findings for the year 2012.

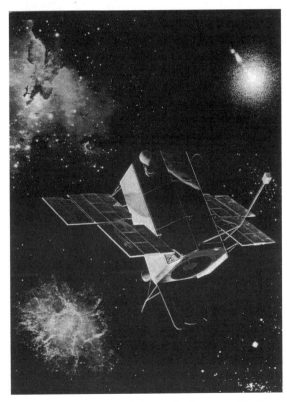

Figure 1. Satellites orbiting around the earth discovered billions of star constellations normally invisible to the human eye by using infrared light.

INTRODUCTION

A Lost World

Imagine the largest dilemma of all time: you have knowledge that could save the planet, but most people don't believe you. It is a quest for a lost civilization that nobody knows how to find except you. The scientists and artists belonging to this civilization have disappeared, but they left behind a crucial message, a message about an imminent catastrophe that will destroy the whole earth within several years. You are totally convinced of this because you were able to decipher the crucial codes. Codes containing things they could not possibly have known unless they had a highly advanced knowledge of astronomy.

And what if they did, and you were able to indisputably prove it? Even so, only a few people believe you because the story is too incredible. There you are. What are you going to do? What are your chances of convincing your fellow human beings that you are right? And you don't have much time, because the fatal disaster will occur in just a few years. This is the dilemma I am confronted with, and it makes me feel desperate, without a prospect of a possible solution. Maybe you, reader of this book, can contribute something to help me step out of this circle, either financially or

Figure 2. According to Herodotus, Moeris Lake is an artificial body of water: "Because two pyramids are positioned in the middle of it, both rising 90 meters above the water, while their bases lie equally deep under the surface. There is a figure of stone on the top of both buildings, depicting a man sitting on a throne."

in some other way. Then we can dig for the legendary Labyrinth in Egypt, which, as I proved in my previous book, holds all the information on the coming disaster. Thereafter, we can quickly take precautions to maybe partly preserve our knowledge. But, can I handle this? Am I able to motivate the world to dig and decipher the knowledge hidden inside the Labyrinth? Do I have enough strength to fulfil this task? Yes, I think so. This is the reason I have written this book. I want to inspire as many people as possible to help uncover the largest building ever. The shock wave created by this will be unparalleled.

For those who haven't read my previous book, I herewith give a brief description of the place where the biggest archeological discovery ever is waiting to come to light. After I read in Albert Slosman's book, *Le livre de l'au-delà de la vie*, that all the knowledge of the Egyptians lies hidden in the Labyrinth, I immediately became alert. Slosman also mentioned that Herodotus, the best-known history writer of ancient times, visited this building 2,500 years ago. After some research I found Herodotus' report. The following description is quoted from his book *Histories*:

Herodotus' Description of the Labyrinth

"I have been there and it is beyond any description. If you made a survey of all the city walls and public buildings in Greece, you would see that all together they did not require so much effort or money as this Labyrinth. And the temples in Ephesus and Samos are not exactly small works either! The pyramids are immense and huge, and each and every one of them equals many of our Greek buildings, but they cannot stand comparison with the Labyrinth. The Labyrinth has a dozen indoor gardens, six of which lie in a row at the northern side, and six at the southern side. They are built in such a way that the portals face each other. An outer wall without openings surrounds the entire complex. The building itself has two floors and 3,000 rooms; half of them are underground, and the other half on the ground floor. I have personally visited and watched the ground-floor rooms. But concerning the underground chambers, I have to rely on the authority of others, because the Egyptians refused to let me in. The tombs of the kings that originally built the Labyrinth and of the holy crocodiles are to be found there. So I've learned from hearsay everything I know about these rooms. But they did show me the ones on top of them. You would not believe they were built by human hands. The passages connecting the chambers and the winding paths from court to court were breathtaking in their colorful variety.
Filled with admiration I walked from the courtyards of the rooms to the colonnades, from the colonnades again to other chambers,

and from them into still more courtyards. The ceiling of all of these places is made of stone just as the walls, which are covered with figures in relief. Every courtyard is surrounded by a row of seamless pointed limestone columns. Close to the corner where the Labyrinth ends, there is a pyramid at least 75 meters high, decorated with a relief of large animal figures. The Labyrinth is located next to the Moeris Lake. The lake does not get its water from natural sources. It is connected with a canal to the river Nile, which lies very close next to the pyramid."

Our Search for the Labyrinth

As a result of this description I started to search together with my friend and archeo-astronomer, Gino Ratinckx. After several weeks Gino found the location. He had intensely studied the map of Egypt. According to old tradition the Nile forms a projection of the Milky Way on earth. This seemed visually right. So Gino questioned if a similar principle applied for the most important temples and buildings? Bauval had already shown that the three pyramids of Gizeh coincided with the belt within the constellation of Orion. According to the same principle, the temple of Dendera should be aligned with the star Deneb, and the temple of Esna with Altair. Following this argument, the Labyrinth would have to be found in the Hyades, which form a labyrinth of stars in the sky. Therefore the place had to be Hawara, where there is a pyramid that coincides with the star Aldebaran of the zodiacal sign of Taurus. So we left for Egypt, equipped with a GPS (Global Positioning System), a device that is used to determine exact geographic coordinates. With the help of the GPS we were able to calculate stellar projections on earth. Initially we did not seem to need it at all!

We found, to our big surprise, that the Egyptians had associated the temple of Dendera with the star Deneb! This fact confirmed our newfound theory. What surprised us even more was that in 1843 a famous German archeologist, Richard Lepsius, had dug for the Labyrinth in Hawara. The archeologist's excavation was based on the instructions of Herodotus and Strabo (a Greek geographer who visited the Labyrinth in 25 BC). However, Lepsius only did some shallow digs and stated that the Labyrinth had collapsed. Since that effort no more steps were taken to dig up this gigantic building. Inquiries with Egyptologists and the highest Egyptian authorities ended up with the same answer: the Labyrinth lies in Hawara, but it has collapsed! And there are no plans for future digs. To hear something like that is of course terribly frustrating, but it reminded me of a similar case. A few years ago, all Egyptologists knew that Cleopatra's palace had disappeared in

the sea during an earth crust movement. Everybody could point out the exact place, however, nobody did anything to find out more about it—until a diver discovered it, more or less by chance. It lay quite shallow, only a few meters below sea level. A similar phenomenon has occurred with the Labyrinth. Everybody agrees on the location of the Labyrinth, but no effort is made to bring it out in the open! Incredible!

Secrets from Lost Worlds

Nothing is so exciting as searching for and deciphering old riddles hidden in the mist of time—to uncover hidden secrets in an exciting series of discoveries. Although the treasures of the pre-tidal wave civilization still lie hidden in Hawara, I was able to decipher the codes of several messages. I am still surprised when a new code is revealed to me. They had been kept hidden for millennia from the outside world. Thanks to the unique coding of the Egyptians and the Maya I could discover an advanced pattern in them. They form a one-way communication channel with my thinking. Mathematical inscriptions and pictograms have a key role in an endless flood of discoveries. Magic numbers in a whirl of calculations. They are the messages from a long-lost, exotic civilization.

The Old Egyptians were convinced that they would reincarnate beyond the star system of Orion. Modern astronomers are of the opinion that it is in this same location that large quantities of new suns are being born. Maybe the Old Egyptians thought that the pharaohs' souls would wake up again in Orion in the shape of a star. Is there any other physical evidence for their star religion? In any case, Orion is a crucial player in their predicted end-time. Many of their expressions are meant to be taken literally, not metaphorically. The sunspot cycle theory, which they mathematically established, can be unveiled again, provided that we rapidly discover how they managed to perform their observations and extract from them their calculation of the fatal end-time. The basic principle of this must be easy to decipher, especially if we take into account their highly advanced civilization. Through number series we are able to communicate with their brilliant minds. Even if we cannot decipher the messages of the hieroglyphs, the numeric message speaks for itself. In the distant past, the high priests were aware of this problem. They knew the secret of the codes that was only meant for their eyes. Others did not have a clue how to translate them. However, if anything ever happened to them, later generations would be able to draw their own conclusions on the basis of the numbers. The key to their knowledge is therefore dominated by mathematical calculations. In my previous book I showed some very fine examples of this.

Now I am going even further! I succeeded in deciphering the Dresden Codex. Deciphering is like landing on a strange planet and searching for the creators of the buildings left behind. But luckily I have at my disposal some common sources of knowledge, which will make my quest easier. I discovered, for instance, that we share the denary scale, the same time chronology, and that they divided the circle into 360 degrees. All this knowledge contributes to a better understanding and deciphering of their "Mathematical Celestial Combinations." And that is what it is all about—to decipher their message as soon as possible, to verify and announce worldwide that their predictions were accurate. Our present science has not addressed this and can only acknowledge that their calculations are correct ... and that they mean the end of our world.

Figure 3. Somewhere in the Egyptian soil, the biggest archaeological discovery of all time is waiting for us. We can recover with it the date of the forthcoming pole shift in the year 2012. Will we be able to dig it up in time?

PART I

THE EARTH
SUBJECTED TO CATASTROPHES

1.
THE POLE SHIFT
CATASTROPHE OF ATLANTIS

The history of Atlantis that I relate in the following paragraphs has been translated from old manuscripts by the Egyptologist Albert Slosman, and also from his unique deciphering of hieroglyphs inscribed on temples. His work is so meticulous and astonishing I have to acknowledge the following text to be true.

You are now going back to the year 21,312 BC, the year of a shocking occurrence. In those days, Aha-Men-Ptah (Atlantis) had a moderate climate. Vast forests covered the north of the country. It snowed only occasionally, and ice was an almost unknown phenomenon. In the south, excessive vegetation predominated the whole year. Many now-extinct species of animals used to live here, like gorillas without flat noses, enormous but peaceful mammoths, rhinos four meters high with four toes, and sabre-toothed tigers. On the southern end of this immense continent, you could mainly see mountains and plains, which contained valuable treasures: fertile lands producing their goods almost without any help. The horizon was dominated by mountain chains. You could also see a few pyramid-shaped cones of extinct volcanoes. They had been inactive for such a long time that nobody could remember their last eruptions. The inhabitants could imagine nothing but green trees, some of which had lovely fruit they could eat during all seasons. In short, the legendary paradise described in the Bible was located here. This story has simply been taken from Egyptian history.

Paradise Subjected to Huge Earthquakes

The inhabitants had knowledge of the earth's movement around the sun and the shifting of the zodiac. That is why they were able to pass on to us what happened in those days. In less than one hour a catastrophe took place. It did not involve a total pole reversal like the one of 9792 BC, but a partial one. Not only the continent, but also the whole earth was subjected to huge earthquakes. Then the earth's axis began to glide. Buildings collapsed, mountain chains shook and crumbled while it seemed that the world had started to slip away. Before this event, the sun had risen in the 15th degree of Sagittarius. After the elements had spent themselves away, the axis of the earth had moved to the end of Aquarius! The movement of the planet filled the seas with an enormous quantity of kinetic energy. Uncontrollable water floods washed over large parts of land. Atlantis sank below water level,

19

and because of the shift of the earth, it came to lie partially under what was, at that time, the North Pole, and was covered with a thick layer of ice.

From that day, the true history of Atlantis began. The few survivors regrouped in the south, since the north had become uninhabitable. (Even though The Great North had vanished, Atlantis was still many times bigger than Europe.) Deeply shocked, they decided to study the sky even more intently than before. They registered in detail a specific interval of time. All movements and combinations of the sun, the moon and the planets were most thoroughly noted down and graphically reproduced on scrolls. Those days, there was no television, radio, cinema or other diversions. Therefore, people had loads of time to gaze at the stars while sitting by the ashes of a hot glowing campfire. A long time ago, their ancestors had discovered figures in the sky. Some resembled animals like a bear, a bull, a horse, a lion, etc. They would argue over these for hours, until they could agree on an appropriate name.

Now specific attention was being paid to the movement of the Zodiac. The slightest detail was intensively studied and described. They thought that a clue to what had led to the catastrophe could well be hidden within this movement. They saw that the stars and the sun always rose in the west (nowadays this is in the east), so that the stars needed one whole night to cross the sky. In addition, they noticed that different star signs were seen in different seasons. It never happened that suddenly a new star sign would show up in the west. Everything evidenced an order and predictable regularity. It comforted them in the loss of all that had died in the catastrophe. As time went on, they discovered other stellar phenomena. Some stars rose or sank just before sunrise and the times and places varied with the seasons. It was actually a rediscovery of what their ancestors had already found out. However, with their dedication and skill, they were eventually able to explore in depth lots of celestial codes.

Furthermore, they researched the constellation of Orion and the star Sirius with the utmost curiosity. When you call up the starry sky after the catastrophe on your computer screen, you will see this is quite logical. At that time, Orion ruled over the northern and the southern starry skies of the earth, and it was the clearest visible constellation. Sirius was in line with Orion and the Zodiac, and it is a big, brilliant star. This is why they paid so much attention to it.

After the catastrophe, life on this huge continent recuperated. People discovered metals like iron, copper and lead and found out how to exploit them. They made beautiful silver and gold

ornaments and they ascribed healing values to "precious" stones, originating from the essence of each of the twelve signs of the Zodiac. As they progressed in obtaining more knowledge and in the rational use of raw materials, they decided to build religious buildings. This led to a super-construction with a diameter of eight kilometres, which took them hundreds of years to complete: "The Circle of Gold." In this indescribably gigantic building the "Mathematical Celestial Combinations" were studied by the "Experts of the Number," and all astronomical and other observations were registered. They studied the sun, the planets and the stars. They discovered the laws of movement, gravity, cartography and of countless other sciences. More than 15,000 years ago, the world-famous theorem of Pythagoras was formulated and they developed mathematics almost up to our present level. Finally, this led to the unveiling of the biggest secret of science: the sunspot cycle theory. Through accurate deduction, they were able to predict the cycles. The critical issue was the magnetic fields of the sun. When these fields reach a crucial point, they result in enormous sun-outbursts or solar flares that are capable of reversing the magnetic field of the earth. With the aid of this knowledge, they calculated the exact date of a forthcoming "Great Cataclysm," which would completely destroy their country. Despite the fact that this was solely announced at the royal palace, the news spread like wildfire. Panic broke out, until the high priest announced that the date lay two thousand years in the future.

In the year 10,000 BC, a high priest gave the signal for an enormous exodus, because the catastrophe was now upon them. However, that story is told in my previous book, *The Orion Prophecy*.

The Egyptian Labyrinth

If you knew that an identical copy of "The Circle of Gold" remained at present underground in Egypt, it would be reason enough to alert the most fanatic treasure diggers in the world. However, they do not need to search anymore, because Gino and I have found the location. Now we are only waiting for sponsors to help us to dig up this unearthly monument in which super secrets are hiding.

It is also known what we will discover there: Egyptian papyruses announcing unbelievable things lying ahead of us. There are some clues in several of Slosman's books about the Labyrinth. According to his decoding of the hieroglyphs, the archives talk about a civilization with the same background and culture as the Egyptians, as well as the same laws, art and

Figure 4. Here is an extract of the Book of the Dead, that tells a heroic poem about the "Escaped" and the resurrection of Osiris (See Chapter 3). The original work should be found in the Labyrinth.

diplomacy. And their secret knowledge, hidden in their sacred texts, should not be forgotten. Priests-in-training were schooled extensively in this. In a period of four years, they had to struggle through 42 textbooks, originating from the Labyrinth. The first two contain hymns worshipping Ptah and Ra. The following two contain the chronicles of the Pharaohs, which go back more than 30,000 years! These are exact, because they coincide with the astral mathematical combinations of the Zodiac. Then they had the "Books of the Four Times" about astronomy, the first scriptures of which go back to their first native country: Aha-Men-Ptah, a name that was later phonetically changed into Atlantis. The first of these writings discuss the astronomical past, the second the period at that time and the future; the fourth is completely dedicated to Ptah. Ten scriptures describe in detail the traditional religion with its celebrations and ceremonies. Four discuss medical knowledge, the structure of the skeleton, medical instruments and healing through plants. Ten books contain laws, an unprecedented treasure full of secrets. Other books discuss their escape from the previous catastrophe and their flight to Ath-Ka-Ptah (Egypt). What else is there to find in this "Circle of Gold?" More than you could ever imagine!

In the center there is a circle depicting the zodiac of Dendera, in which the twelve star signs are represented in large scale. Ptah stands in the central point and must have had a statue that is beyond any description. Nut, the mother of Osiris, stands close by. In the second circle there are more complex things to see. They illustrated here the thirty-six elements that enabled them to calculate the previous catastrophe in advance. This was of vital importance. Without these calculations, nobody could have survived that cataclysm, which had been many times bigger than the one of 21,312 BC! Besides, their country had disappeared completely under the South Pole (after the reversal of the poles). Geb, the last ruler of Aha-Men-Ptah, who had died in the previous catastrophe, is also depicted here. He carries on his head the weight of the earth, which was to be resurrected through his wife Nut. She would escape and, together with the other survivors, set the basis of the new native country.

Without proper knowledge of this mixture of historical and spiritual events, you cannot make a reliable reconstruction of the history of Egypt. The Great Sphinx, for instance, is in the form of a lion because the previous catastrophe took place in the Age of the Lion. In the Zodiac of Dendera there are broken lines underneath the lion, which symbolize a huge tidal wave.

The Labyrinth also contains heaps of hieroglyphs about the exodus to Egypt, and illustrations that point to a new Age,

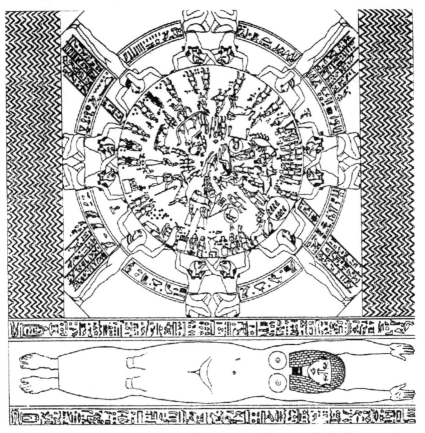

Figure 5. The Labyrinth contains a huge planisphere on which the exact date of the previous pole shift was engraved. We must try to find this construction as soon as possible.

like Taurus and Aries. Furthermore, it shows an indescribable planisphere (a map of the sky with two hemispheres), which depicts an innumerable amount of stars. And most important of all: we can find the knowledge of how to calculate a polar reversal! In short, the knowledge you can find within the Labyrinth overshadows any other archaeological discovery. Hopefully, we do not have to wait too long for this anymore.

Worldwide Consequences

Right now, the excavation of the Labyrinth is most urgently needed; otherwise, humanity will be in great danger. Twelve thousand years ago a highly developed civilization ruled on this planet. In those days, people had knowledge of space-geometry, geology, mathematics and geography. They sailed the oceans and had incredibly accurate calendars—the proof of this lies piled

up in the Labyrinth. The unveiling of this knowledge alone will forever change the history of the earth. Moreover, the evidence of where they found their knowledge and the wisdom to predict the destruction of the earth will be at our disposal. At first, immense panic will arise at the idea that our civilization will imminently be wiped out by a gigantic geological disaster. However, quickly after this, worldwide precautions will be taken to preserve the most precious and important knowledge for the survivors of the catastrophe.

During my investigation, I was frequently astonished by the highly evolved science of these ancient geniuses. On many issues their science reached a much higher level than ours. They were able to calculate beforehand exact orbits beyond four million days long, something we have not yet mastered completely. From numerous facts they distilled the final destruction of the earth. They knew that an event like this repeats itself in cycles, and therefore it became the basis of their whole religion. I hope that by now everybody acknowledges that the revelation of this astronomical center is of an extraordinary urgency. If we do not start digging now, the mission of this grand endeavor to inform later generations about the upcoming catastrophe will have failed. As has been repeatedly mentioned before in this book, this disaster could mean the end of humanity. I hope that there are enough reasonable human beings in this world who will bring this mission to excavate the Labyrinth quickly to a favorable end. Otherwise, the biggest catastrophe still to come in history will wipe out human traces forever.

Facts about the Labyrinth

Although very few people have ever heard of it, this Labyrinth is indeed the largest building ever made by humans. Superlatives are lacking to describe it, but let me give you an example: it contains "The Circle of Gold," a legendary room to which the Egyptian Book of the Dead refers. It is made of granite and covered with gold. Inside there are documents about the history of Egypt, and the astronomical knowledge of their civilization. It was gigantic in size, and therefore its construction took many years. They worked with might and main on "The Double House" of the "Mathematical Celestial Combinations" for 365 years (from 4608 until 4243 BC). Comparison: the biggest pyramid was built in about twenty years! Therefore it is not so strange that the total length is 48,000 Egyptian elbows (one Egyptian elbow = 0.524 meters), or 48,000 x 0.524 = 25.152 km!

Should you get lost in the building, you would encounter sure death, because many walls could move—one of the aspects that

made it a real labyrinth! Old scriptures tell stories about people who got lost and died of exhaustion. Nobody knows the present situation, but considering the superior building style of the Egyptians, we would surely be awestruck. Some rooms must be impressively large, with all possible star constellations engraved on the walls or the ceiling. Besides this, the practical astronomical knowledge of the Egyptians is illustrated on long walls, and can be read in the hieroglyphs. Amongst them the countdown from the previous catastrophe to the one in 2012.

2.
THE SURVIVORS OF ATLANTIS

After I had read in *Le Grand Cataclysme* (described in *The Orion Prophecy*, my previous book), what happened in Atlantis, I was of course dying to know the follow-up. I hastily started to search for Slosman's next book *Les Survivants de l'Atlantide*, however the book had been sold out for years and had not been reprinted, so it proved quite difficult to find. That is why I decided to go to the National Library in Paris. They would certainly have it. On January 3, 1998, the morning of my 43rd birthday, I took the TGV from Antwerp. Several hours later I was in Gare du Nord, a huge station where one train after the other arrived and departed again. Just outside the station, I took the subway toward the world-famous Louvre Museum, where age-old paintings and pieces of art are exhibited. The old library was located not far from there, founded by no less than Napoleon himself. Fifteen minutes later I arrived at the library and asked for a one-day entrance ticket.

Passing a well-guarded entrance, I walked into the heart of the complex. It is a gorgeous building with a large dome, beautifully decorated with colorful illustrations, set off with gold. Asking in my best possible French how to find my way, a friendly clerk showed me how to insert the card I got at the entrance into a computer. In this way I could electronically ask for any book. Several minutes later I had the corresponding number. When I asked for it, the clerk smiled. She accompanied me, pressed a button and showed me my number-allocated chair. Within half an hour the book would be delivered to me! In the meantime, I curiously looked around in admiration. The place was quite busy. Many visitors

Figure 6.

were noting down information in their laptops. Fifteen minutes later the book was there. With a big sigh, I picked it up and noticed it was almost 300 pages long! This would be impossible to read in a couple of hours, so I went for the copy department. Here I received an unpleasant surprise—it was not allowed to take the books home or make copies of them! That is why I had

seen so many laptops! However, I am not fobbed off that easily! I took the plunge and went to the management office. After a lot of talking and going from one department to the other, I made some progress. I had to fill in several forms about how and why I wanted a copy. They would inform me later about their decision. I left the library sighing and walked back to the station.

Two weeks later, I received a message that the book was not completely sold out and that it could be ordered from the publisher, which I did immediately. The publisher, however, replied saying that the book was actually sold out. Almost desperate, I sent a copy of the publisher's answer to the Library, together with a detailed letter. I explained that I needed a copy of the book in order to do some excavations in Egypt. They would surely be receptive to this appeal, because they had just opened a large Egyptian department in the Louvre.

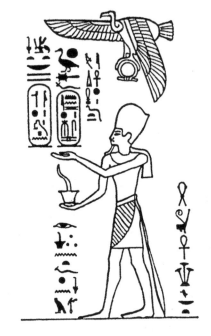

Three weeks later, I got a pro-forma invoice for 500 French francs, almost five times the price of a similar book. But what can one do? I sent them a check, and a week later I received a new invoice for the same amount! Trying to sort out this dilemma took weeks, but finally a registered parcel was waiting for me at the post office. Impatiently I picked it up and started to read.

Figure 7. Ath-Ka-Ptah, the "Second Heart of God," is the personification of the eternal flame that has risen from the ashes thanks to Osiris, the First Born, and his descendants.

The passage following is a summary of the story. Albert Slosman has translated this material from the Holy Scriptures, carved out as hieroglyphs.

Aha: The First Born

At the dawn of The Chosen, a "First Born" with special gifts was brought forth: his name was Aha. He taught the Divine Law of Creation, and for this reason thousands of years later all kings of the Egyptian dynasties were named Per-Aha (descendants of The First Born), a term which the Greeks phonetically changed

into Pharaoh. These First Born descendants knew that they were made in the image of their Creator. Therefore, it was of vital importance for them to abide by The Celestial Laws. An Alliance would consecrate Harmony.

Nevertheless, as time went by, part of the knowledge vanished. Man thought he was God, which led to the big catastrophe of 9792 BC. An immense tidal wave washed away tens of millions of the Chosen of the Creator. From then on, this withered land of A-Men-Ta was named The Empire of the Dead in the Hereafter. Deeply shocked, the survivors decided to enter into a new Alliance with their Creator. They thanked Him for their survival and asked forgiveness for their faults. In order to have Eternal Peace on Earth, this time their treaty would be indestructible. They wrote down everything carefully to create unbreakable chains forever and ever. It is for this reason that their exodus can be traced. From the coast of Morocco where they landed with their Mandjits (unsinkable boats), they followed an exact delineated route to Egypt, on a journey that lasted thousands of years, always remaining at the same degree of latitude. This was done by the followers of Horus as well as by the Rebels of Seth. Their high priests had the same ethnic origin, and after studying the starry sky, they drew similar conclusions since the Celestial Laws were not to be disturbed.

However, as years went by, cracks appeared in the Alliance and people forgot their commitments. This exhausting and tragic period was wilder than the wildest imagination: for more than five thousand years, the clans of Seth and Horus kept on fighting. These mind-boggling wars did not end until they reached the Promised Land. The ancient chronicles tell jubilantly about the arrival in Ath-Ka-Ptah (Egypt), the "Second Heart of God." In addition, the clans united at a moment when stars and planets were in a favorable position. A new era could start.

The influence of the terrible catastrophe can be seen in all the buildings constructed after this event. Two lions are depicted in the sarcophagus of Ramses II, looking in opposite directions. They indicate that after the catastrophe, and therefore after the polar reversal, the era of the Lion passed reversed. In between the lions, a sun is resting on a reversed sky with the Cross of Life connected to it. Symbolically this stands for a radical revival of life on earth. This also shows the horrible possibility of a prospective new catastrophe—if the Celestial Laws are not respected.

This deep-seated reasoning is the driving force behind the creation of the enormous monuments in honor of Ptah. They formed the heart of the new Alliance with the Creator in the "Second Heart of God." The incredibly large Labyrinth with its 3,000 rooms is not the only example of this. Impressive monoliths

were used for its construction, which took 365 years. In addition, the temple of Karnak and the pyramids of Gizeh are highlights in their worship of Ptah. On all the temples you will find hymns and texts depicted in honor of the Creator. The deep faith of this civilization originates from their resurrection within a new mother country. Even if fantasy and fact had been mixed with the passing of thousands of years, it would not have made any difference. The Old Egyptians were completely convinced that their inherited beliefs were reality, and they based all their doings on them. You might notice that the story of the Old Egyptians shares a lot of similarity with the Catholic religion, including the resurrection of Osiris.

After the Catastrophe

That night the survivors saw the last spasms of Aha-Men-Ptah. After gigantic earthquakes, the capital city had disappeared under the rising water; an unreal purple glow surrounded the sinking continent. From their boats, the survivors saw exploding volcanoes shooting lava into the sky, while the immense continent sank. It had been their mother country for an eternity, and now it had almost disappeared. But their suffering had not yet ended. Macabre gigantic light beams were dancing around the Mandjits while the crews took pains to keep up with the hurricane forces. Nobody knew whether they would survive. The night seemed to last an eternity, while the moon and the stars were making abrupt movements. Again, volcanoes burst out, shooting their deadly

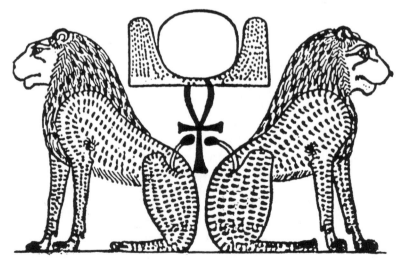

Figure 8. The two lions, looking in opposite directions, show that the earth started to turn the other way 'round after the previous catastrophe.

wreckage far past the Mandjits. A strong smell of sulphur filled the air, while at the same time an apocalyptic high, shining pillar of light rose in the sky. In fact, the night went on; this was no illusion, but a mathematical reality, because the earth's crust was moving thousands of kilometers. Not only the survivors, but also everything on earth was thrown into commotion. Burgeoning civilizations that did not have a clue about what was happening were wiped out. Dozens of animal species encountered their inescapable end, while the appearance of the earth changed drastically. Mountains rose from nothing, while other parts of the earth descended rapidly. Water was everywhere rising to catastrophic heights, while hurricanes were lashing the earth's surface. During these events, the survivors had to keep on their feet—a terrible task to fulfil in a world that was slipping away. Occasionally the sky seemed to clear up, but it only appeared to be so. Finally, at last, a miracle seemed to occur and a new day did begin. Screams of joy escaped the lungs of the afflicted people. However, a big surprise became visible in the sky.

Was it true what they were seeing or was this a fata morgana? Perhaps a celestial phenomenon even more difficult to understand than the previous one created this illusion. Or was it real? Who could tell? The omnipresent evil-smelling fog was still lingering, which made it difficult to recognize the diffuse rays. Then they got stronger. They announced the sunrise in the east! Surprised cries rose from within the fragile boats. They simply could not believe it. The sun was rising from the point where it had set! Full of surprise they pointed at the reversed movement of the sun. For many of them this was an incomprehensible riddle. However, some priests were able to understand why the night had been so dramatically long. The earth used to move from east to west, and because of the catastrophe this motion had reversed; for this reason, that fateful night had lasted several hours longer than usual. The earth's crust had shifted, adding even more hours to that night.

A huge tidal wave, caused by gigantic seaquakes, came rolling towards them. This captured the survivors' attention completely; they forgot the miracle and concentrated on surviving. Staying alive, that was the mission! Moaning, the Mandjits rose. "Shall we overcome this?" wondered the exhausted passengers. They could hardly stand much more. Under normal conditions, the boats could withstand the roughest waters of the oceans. But this was an accumulation of all possible natural disasters. Nobody had ever experienced anything like this before. Knots had been torn away, sails had disappeared, rudders had been slashed and boat sides were leaking. In short, most ships were not seaworthy anymore. At

that moment, they did not realize that a new Harmonic Celestial Law was ruling. Their Creator had given them the possibility of building up a new existence. To illustrate this, time started to run in a new solar year, but everything celestial now moved in the reverse direction from the previous solar year. Several hours later on that unforgettable day, it became clear that Harmony went cyclic again. The elements had calmed down.

In the following days, deathly pale and distraught people were washed ashore in the south of Morocco over a length of hundreds of kilometers, brought there by the tidal wave. This had only been possible because of the frail, but magnificent construction of the Mandjits that were well known to be unsinkable. A large number of corpses were washed ashore on the new coastline, increasing the risk of epidemics. Their suffering had not ended yet. For many nights to come their dreams would contain the images of torn-up bodies with contorted faces and wide-open, staring eyes

Figure 9. The time has arrived! Osiris takes the burden of the mistakes of humankind by crowning himself with the Deceased Sun, in order to make the New Sun rise in the East as a new instrument of God.

frozen in horror. Only a few of their unfortunate fellow beings could be buried. Most of them were sent back into the sea, where the breakers drew them into deeper water to become food for scavengers such as crabs and fish.

Besides the immensity of the sea, some mountaintops and volcanoes that escaped the flood were still visible. Volunteers started to search for survivors and found some original inhabitants, who were called the survivors of the "Fortunate Islands," which were so called until the sixteenth century, when they became known as the "Canary Islands."

On the place where the survivors regrouped, a city was founded and named after Nut, the "Lady of Heaven," mother of Osiris, and the last queen of Aha-Men-Ptah. Nowadays this place is still called Cape Nut. The chronicles tell about 144,000 people that survived the catastrophe. Strangely enough, this number coincides with the preaching of the Jehovah's Witnesses. They believe that after the "End of Times" only 144,000 chosen ones will be admitted into Paradise. Undoubtedly this is based on the Egyptian history (should the Jehovah's Witnesses want to survive the next tidal wave, I urgently advise them to start building a new ark).

The first days after the catastrophe, the survivors lived aimlessly. Great sadness about the immensity of the event had taken away their vital impulse. Some of them were desperate, torn apart with grief over the loss of their relatives. Others meditated over their situation, and still others were so deeply shocked that they were in a trance-like state, just staring off into nothingness. Nothing would ever be as it had been, of that they were convinced. For now, they had made it safely to a new land, but nothing more. They would never see their country again. For eight long days the sun rose in the east, when suddenly cheers of joy resounded through the crowd. Nefthys and the remains of Osiris had landed! Despite the fact that Osiris was living in the Hereafter, he remained the First Born of God. Nobody knew why, but everybody felt revitalized with growing strength and trust. The twin sister of Isis and her four children re-joined her husband, the High Priest. She had never doubted she had to fulfil a divine mission. The next morning an envoy came to bring the good news that Nut, the Queen Mother, was on her way. The crowd enthusiastically welcomed her arrival. She immediately gave orders to found a village. Everyone worked together and this was done. Then she instructed the workers to build a high wall of earth around the village. It bore no resemblance to her palace Ath-Mer, but she was not sad about it. She resigned herself to the fact that it was similar to the first primitive villages that had

Figure 10. On top, the sinking Aha-Men-Ptah is depicted. Below, Osiris is embracing one of the Mandjits where the survivors are sitting, symbolically seen. The Scarab, Master of Life, is the divine symbol of the celestial mechanism. He holds the old sun that is going to sink.

been built after the previous catastrophe. Ironically, thousands of years had passed and they were back at the beginning!

In this time of adjustment, one aspect remained almost unnoticed. After having a vision, Nefthys, together with some women, built a final resting place for Osiris. In the vision, she was ordered to not bury the body of the First Born, nor were they to take the body out of the skin of the bull in which it was wrapped. Her husband, the High Priest, had protested slightly against this, but knowing her gifts as a Seer, he did not insist that they do otherwise. Nut, her mother, found it difficult to accept the postponed funeral.

The "Annals of the Four Times" describe this as follows: "Only Isis can make a decision on this, but we have no news of her…"

"Dear mother, she is taking care of her badly injured son. They will be here shortly."

"What lovely news! I was so worried! Tell me, should we not ask some men to pick them up? Where is she?"

"Mother, they do not need any help because we will meet them. Prepare enough huts for those that are accompanying them."

While these words were being spoken, Isis, the wife of Osiris, was still suffering at sea, desperately wondering about her future. As a widow and ex-queen of a country that did not exist anymore, her future looked very somber. Only her son, Horus, gave her the courage to live on. She dozed off until suddenly she heard voices. Isis, still exhausted, opened her eyes and looked around. The coastline was very close and the Mandjit came to a halt with a grating sound. With the last of her strength, she pulled her son on the beach as far as possible and laid him in the shadows of some uprooted trees. Soon a small group of survivors surrounded her. They had gone inland and had found mountains, so they had had to return empty handed. Although Isis was in an extremely weak condition, the people immediately recognized her. Men as well as women got to their knees. They quickly built two beds for the royal family. That night everybody slept around them. In the morning they started their journey; two men carried Horus. They cheered up when they ran into a group of twenty. They told Horus that the Queen Mother was regrouping all the survivors who wished to found a "Second Heart of God." From then Horus decided to walk, limiting their speed considerably. After a journey of twelve days, they arrived at the primitive village. When they came together, a deep joy took possession of them!

Meanwhile, Seth had succeeded in regrouping part of his troops at a place that was situated two days south, at a well called E-Lou-Na or "The Escaped from Heaven." He was extremely

Figure 11. The esoteric depiction of the Mandjit of Horus.

offended when he heard that his family was working on the foundation of a new life. How could his mother and his sisters do this to him! He imagined his revenge and soon his sick brain was buzzing with new plans. Full of anger he ordered his troops to take over the city. However, his troops rebelled, because nobody felt like continuing on with the war. With bowed head the tyrant had to acknowledge his temporary defeat.

At the same time, Nefthys was teaching her twin sister: "The celestial signs will serve us as guides, enabling us to find out in what way we have sinned against the Laws of God. The Great Power, the Lion, dominated us and therefore the destruction could take place. A very long time ago, a similar disaster took place, under the same circumstances. God wants us to understand this. That is why He taught us, manifesting this through the Sun, and the Lion was his executioner. Harmonic connections are now given to us to form a new Alliance with the Lion and his double. This is to show us that the sun is now moving reversed in the Lion. Only a Descendant is able to create the existence of this tie between his people and his Father, God. As soon as your son has recovered, he will be initiated as Per-Aha. Through his initiation, the Alliance with the Twelve can be restored. This tie unites the Earth with the Heavens and it will protect our people forever. On the day this tie is broken, an even more horrid catastrophe will destroy our civilization. There will be nothing left but stones as symbols of a glorious past."

These last words kept reverberating in a sinister way through Isis's thoughts. She would never forget them. Some time afterwards, Nefthys thought the time was ripe for what God wanted. She had then the honor of executing what He had written. In the presence of her beloved High Priest, Isis and her priests started the ceremony.

"May our honorable High Priest speak the purifying words to wake Osiris from his long sleep. May the old ritual for the Protection of the Living disclose itself to us. May the Son of the First Born be given back to her beloved and all descendants!"

Then, the servants of God strode to the corpse wrapped up in bull skin. The assistants knelt, and the clear and beautiful words of the High Priest were: "Praise the Lord in this special moment, so that He can help us with his immense mercy."

And he continued with the honorable words, which would be kept forever as the Hymn to Osiris in the future Book of the Dead:

"Honor to You, Father of us all, for all that is good that You have given us after our arrival on this land. Come to us, Oh All-knowing Father, so we can give back to You at the end of this

ceremony, Osiris, Your son and father of Horus. He came from You and went back to You, Father of the happy ones in the Hereafter. But we beg You to give him back to us in his human form..."

The Resurrection of Osiris

After praying for some time, the High Priest and his assistants took a scalpel and carefully started to cut the bull skin, when suddenly a miracle happened. Osiris appeared in perfect shape

Figure 12. The Mandjit that transported Osiris' body without signs of decay to Ta-Mana during the Great Cataclysm.

and it seemed that he had just slept for a couple of hours. Only his beard had grown, but the rest of his body looked perfect and well preserved, without traces of decay. Screams of joy and amazement were heard. At this moment nothing seemed impossible for Isis. Only God could have done it. Knowing this, a spiritual force—stronger than the cause of the Great Cataclysm—came into her.

She threw herself upon her beloved, whose body felt alive, although until then it had not shown a sign of life! Isis started a litany of laments, hoping to invoke the resurrection of her husband. Although almost twelve thousand years have passed, this invocation is still alive, engraved on dozens of tombs in Thebes and Saqqara: "Oh Master of the Spirits, this calling is also Yours! Oh Lord without enemies, we are your children begging You! Please answer the prayers of Your daughter whom You cannot reject, because You let it be born in my heart. My soul is on its way to You, to Whom I offer my eyes. I beg You for the return of Osiris. Come, look at the one who loves Your son and all of his soul. Oh Lord, please grant the wish of Your daughter!"

Then, suddenly all those present felt an extremely unusual and intense spiritual force. They trembled with emotion, and Nut and Isis let their tears run freely. In that specific moment, Osiris woke up as if he had never been dead. The miracle everybody had prayed for so fervently appeared before their eyes! Insanely happy, Isis was the first to embrace her husband. Thereafter, everybody reacquainted with Osiris and wanted a piece of the bull skin that had preserved him in such a miraculous way. Much later, it would be described as "The Celestial Force" which through its "Breath of Life" gives back life. Thousands of years later, this event would form the bases of a cult, the alliance between "The Followers of Horus" and the "Celestial Taurus."

Meanwhile, there was no limit to the enthusiasm the people felt for the resurrection of their king. At that moment, Isis still did not know that her husband had returned with a special task: to teach their son Horus, and thus enable him to rule over the chosen people of God. Only in this way God's Laws and Commandments would be well understood and respected. The following day Osiris started the lessons.

"You will soon recover, my son. Your eyes will symbolize the awakening of the new History. As of tomorrow you will be the protector of the people because of the complete sight of your eyes. The symbol of the day will be your left eye, which the sun will protect while navigating the Big Celestial Stream. Your other closed eye will be the Justifier of the night, there where time passes hesitantly. Until the end of time you will be the Guide of your people."

"But Father, you are still among us! It is your duty to lead our people."

"My son, my days are numbered. I am here to teach you the holy symbols and their significance. Look at the sea, Horus. She has calmed down, but she is not the same as she used to be, because the sun rises on the other side. A new cycle has started…"

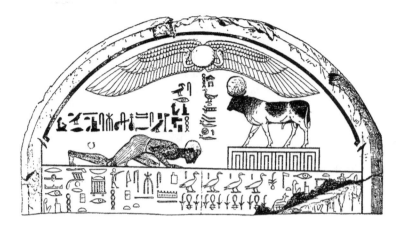

Figure 13. The worshipping of the "Celestial Taurus." Its head is covered with the new sun that represents Osiris resurrected in the sky.

"I remember the prophecies of your Father Geb all too well," Horus replied, "and they have all come true… Why did it have to happen to us?"

"In order to make people understand. It concerns our commitment to God, which is very frail and that brought about this drama."

"What do you mean, oh my dear Father?"

"To become completely connected again with our Creator, we have to respect his commandments again. Our sources of spiritual knowledge need to become one. Therefore we need to base ourselves on the new "Mathematical Celestial Combinations" which will bring us back to living in Harmony with the movement of the sky."

"But Father, is not God the first responsible for that?"

"Surely not, Horus! Our ancestors, the Chosen, made a one-time treaty with God, which was not respected by their descendants. Without doubt this must have called the Celestial anger upon us. A long time before Geb, the destructive forces had started their evil work. Egotism, hatred, envy and dozens of other negative vices were all undermining the alliance. If everybody had remained faithful and had kept on praying, God would have been merciful to us, because he is the Father of All. However, the temples were deserted and almost collapsing. It is for this godlessness that the indescribable horror of the Great Cataclysm was called upon us."

"You are right, oh my Father. As long as the priests do not forget their most important tasks, they will be our guarantee for our Resurrection."

"That is right my son. Therefore, it is necessary to repeat all-

important facts constantly for the forthcoming generations. Only intensive oral training can realize the transfer of our knowledge, so there will be no separation between God and Ka, Creator of his physical images. When this is accomplished, we will acquire the right to have a Second Fatherland. The Second Heart of God will then be named Ath-Ka-Ptah, in honor of our mother country, and to thank the Celestial Harmony which has allowed us to escape to a new country."

There was a long silence before Osiris continued: "The sea is still red, drenched with blood, but shortly she will be blue again and everything will be forgotten. It is up to you to imprint this in the memory of your people forever, because if they forget, the chains will be broken again. And this time, I assure you Horus, it will mean the definite end."

"I will take care that the Alliance with our Creator will never be broken. The strict Orders of the high priests will also be of help to them."

"As long as our people remain united, this might well be possible. But there are already two hostile groups. Your task will not be an easy one!"

"What do you suggest then?"

"Your only aim is to prevent this from starting all over again. Everybody must actually feel that they have the lifelong

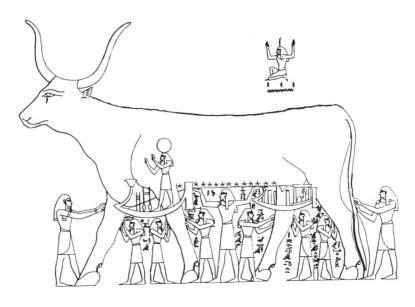

Figure 14. The Age of Taurus guarded by Osiris. At the front His Highness the Sun is standing, guarding the Two Earths and the descendants of Osiris.

protection of God. Moreover, it is necessary to teach everybody with the utmost priority until the night of times, no matter which governments follow. Therefore, you have to engrave God's laws in these indestructible rocks, as well as the history of the past Great Cataclysm, with its precise date and consequences. The two lions, each looking at a different horizon, with the sun between them, will be the symbol which will be understood by the younger generations."

"But of course, oh my Father. I still have to learn a lot. First of all we will need to study the "Mathematical Celestial Combinations" again, after which we can restore our lost harmony with Heaven."

"That will not be too difficult, my son. If am right, our Creator has left the movements of the Universe as they were. Only the Earth turns in the opposite direction without any influence on our spatial travel around the sun."

Figure 15. Here the Sun is navigating in a new direction in a reversed sky after the Great Cataclysm, guided by the Holy Eye.

"So the sun is still at the same place?"

"Yes, but the Earth has changed its course; because of that, we are now seeing everything in the opposite way. Soon this Mathematical Knowledge will become clear to you. And the other elements I am going to teach you will help you to finish your studies through meditation. Within a couple of months you will have unmatched knowledge at your disposal. Hereby I will give you the Word that is based on twenty-two phonetic verses.

An almighty knowledge will then be part of you. Thanks to your name you will be yourself and no one else."

"I will fulfil my task, oh my Father."

"Don't take it too lightly my son. The calculations of the Masters of the "Measurements and Numbers" are the only ones that count. You should never let anybody make a joke of it. By the way, you will have to make the complete Mathematical Combinations much more difficult to understand; otherwise, they can become the subject of mockery."

"I know this only too well my Father. The high priests were humiliated for their prophecies, which were based on their calculations. I can still hear sarcastic words of countless skeptics. Poor Geb, he had to endure so much in order to save the children of the Light that were born on his Land."

"Therefore Master Geb will be described in the Annals as the Father of the Earth, because it is due to his perseverance that the Mandjits have allowed us to escape from this immense horror. You are his grandson, Horus, and also a First Born, and the connecting link to the next generations. Through you the Divine Laws will be restored."

"I understand Father."

In the meantime, the High Priest had carefully studied the new combinations again. He knew the old ones by heart. They were in the Holy Scriptures, which every priest taught his First Born, as he had learned the Celestial Mathematical Combinations during his own childhood. He therefore knew the mechanism that enabled them to create a New Alliance with God and his Second Heart. Spiritually, he was already getting prepared for this journey to their new fatherland. However, it would not be easy at all. Vast numbers of reflections of suns were exerting their positive and negative effects. So the right reflection had to be chosen carefully. Only he could decide the exact route to be given to his successor and to no one else. It would become a long and exhausting journey to Ath-Ka-Ptah (Egypt), of that he was sure. He knew precisely the point of departure, as well as the final destination; in between lay the road to follow. This way should not be too long or too short, and still more important, it had to be inspired by Divinity. The path that the fixed stars were following was identical to the opposite route that the sun followed in the larger configurations, such as that of the Lion. An accurate observation of Orion and Sirius showed him the road to follow to the Second Heart. Much later, scriptures would confirm this: the west and the east are joined together with the watchful eye of the Heart of the Lion showing the way to their destination.

A heavy assignment was waiting. All boys and girls were

to be instructed, as Horus had ordered. However, due to lack of knowledge, just a few of them could fulfil this task. Besides, the Tradition and Sources of Knowledge could not be put in just anyone's hands. On top of that, this knowledge had to be thoroughly repeated to these young ones, without a single mistake. They, in turn, would have to pass this knowledge to their children, generation after generation, until the Word would be transformed into a Scripture, which would bring back civilization. This could only happen on the day predetermined by God and not earlier, because otherwise the Laws of God would be violated. In this way the descendants, in a very far future, many centuries or even thousands of years ahead, once arrived at their destination, could start again learning and teaching all the sciences. It was a huge gamble, but it was the only possible way to regain harmony with the Celestial Laws. The High Priest intently reviewed his calculations. Time would progress slowly in this opposite march in relation to the Great Celestial Stream, which ran next to the twelve constellations.

Besides, the cycle of the sun would stay in the Lion much longer, adding even more time to the progression. Yet, even by the time it passed out of Leo, the moment would not be favorable enough, and they would have to wait until the age of Taurus. In that far future, and not sooner, they would be allowed to start up their Second Heart.

While the High Priest was contemplating the numerous possibilities, his wife Nefthys met with Horus, the son of her sister. Being all knowing, she immediately asked the right question: "What is bothering you, oh son of my beloved sister?"

Figure 16. The Lion looks to the right, while all faces of the hieroglyphs are looking to the left. The Holy Eye is depicted in its two positions: the old one to the left and the new one (Creation) to the right.

"My Father has suggested an Alliance with God through an unconditional Faith in our Creator."

"Do you not agree with this?"

"With the Alliance I have no problem at all, but the Faith will not be eternal and therefore the persistence of the Alliance will be impossible."

"Horus, I understand your doubts, but the Faith is the only possible ground. This has to be passed on to the coming generations, otherwise everything will be lost. This catastrophe was also caused by complete atheism; if it returns it will be the end of mankind."

"Do you mean that a cataclysm will destroy our new fatherland?"

Nefthys kept silent and looked inquiringly at Horus. Then she continued: "Please do not make the Celestial Law more difficult than it actually is. The Faith should be sufficient to explain the "Mathematical Celestial Combinations." In all the years to come the priests and the "Masters," of which you are the first, have to cooperate with each other to profess the dogma of God, as well as his power over all things and beings under all circumstances."

"Is this task not too heavy for me?"

"Most certainly not, Horus, you are the image of the Creator. This knowledge will protect our people. You are able to ensure that all children and their descendants are convinced of this fact. What is more, you need to teach the Celestial Law in all its glory, without ever changing anything. The Faith has to become an integral part of life. You are the descendant of the First Born, and you will be the guide whom none will doubt. Thus, the agreement will pass from generation to generation in a natural way. God will then reward us with a long period without the threat of Heaven, the duration of which He will define himself."

Meanwhile Osiris was visiting the High Priest: "Are the new calculations difficult?"

"God has been good to us, Osiris. Everything remained the same, only in a reversed way. Tomorrow they will be the subject of my first lesson, which give the basis to determine the route to our Second Fatherland. There are some indications that under a favorable star in a distant future we will be able to start up a new calendar, to which we will have to adjust ourselves."

"You are thinking of Sirius indicating the Divine Year?"

"Yes, she is the center of our new Alliance with God."

"When does this new calendar start?"

"The observations we made in the last ten days are quite interesting. Our calculations show that the sun will remain in the Lion almost its whole cycle."

"That is good news. Our knowledge will allow our descendants to secure the Alliance until the end of time."

This conversation, which took place not long after the Great Cataclysm, would be decisive for the future of Egypt. Nevertheless, the prophecy of Osiris would be dissolved in the following thousands of years in the mist of time, especially under the influence of the different invasions of Persians, Romans, Greek and Arabs. The knowledge of the cyclic rise and downfall of civilizations, together with the pole shifts, were completely lost with the prophecy.

Life continued and Seth again controlled his troops. He declared that the sun had created them, and as of that moment they had to worship Ra. He also gave them a new name, the "Ra-Seth-Ou," that is, the "Soldiers of the Sun." To get the sun completely on his side, he spoke the following words to Ra: "Overflow me with your well-doing beams, Oh Holy Creator. May my sceptre with Your acquiescence give the order to destroy all my enemies!"

In addition, an army, followed by women and children, started to move up. Not long thereafter, they met the troops of Horus. Seth looked in disbelief at his cousin still alive, who immediately ordered: "Stop marching! It is I, Horus, who orders you. God allowed you to escape. If we join, God will send your souls undisturbed to the hereafter!"

However, Seth would not hear of this. "It will be my pleasure to kill you. I terribly regret that I did not succeed the last time we met! Being a Master of the new land, this is my duty. Besides, you have no right to the throne."

"Are you sure you are the new Master?"

Not knowing exactly the meaning of these words, Seth looked around in wonder. A resounding voice broke the silence:

"You should all be ashamed of yourselves! Shame on you! Have you forgotten you are the children of God?"

Seth recognized the voice immediately. Shock numbed his mind and the following words made it even worse: "Yes, it is I, Osiris! I have returned to tell you that Horus is the only and true successor. Horus is the son of the Sun, the bull of the Celestial Taurus that has returned to earth. Only he has God's authority to lead you to the 'Second Heart of God,' where prosperity and happiness await you."

Filled with anger Seth answered: "You are nothing but a replica, without a body or soul. Get lost dark ghost!"

"It is me alright! Therefore, I herewith give Horus my Celestial authority. I am telling everybody very clearly: I, Osiris, herewith put Horus on the throne of this Second Land. He will

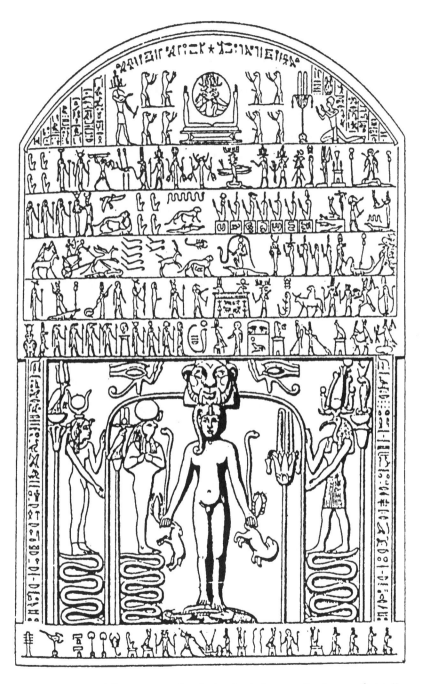

Figure 17. One of the many copies dating back thousands of years that tells about the life of Horus.

be the indisputable Master and the first Per-Aha with Celestial descendants. Those who do not agree with this must speak up now! They will have to leave immediately, so that no harm will be done to them. But beware, those that stay here with an impure heart!"

These words had a mesmerizing influence on the women and children that were following Seth. They withdrew in restlessness. Seth had to go ahead with his troops. Thousands of years later this ancient conversation would be engraved on several temples memorialized as the Fight of the Giants, the "Followers of Horus" against the "Rebels of Seth." And again life continued.

The "Followers of Horus" came to realize that they missed some essential materials to accomplish the rebirth of their people. One of them was iron. Osiris decided to lead an expedition himself. Horus gathered forty of his most loyal and best soldiers. Nefthys caused a thoroughly unusual conflict, insisting that her First Born son, Anubis, should go with them for assistance. Without asking any explanation, her husband, the High Priest, agreed to this. She would certainly have a good reason, considering the age of her young son. Anubis, together with his enormous dog, loyally followed the group. After a couple of days, the expedition slowed down. Osiris knew where to find an iron mine. Some former seamen had given him the description of the route to the mine before the Great Cataclysm. However, this event had changed the surroundings quite a lot, and in such a way that the actual place did not fit with his memories. In the days before the catastrophe, there used to be a wild river in a luxuriantly vegetated area. Now he bumped into an extremely high mountain situated in a disrupted landscape. He couldn't find his way north in this.

A gigantic and completely famished snake suddenly curled around Anubis. His enormous dog came to help, and through this action, instantly became the mascot of the group. The days passed by slowly, until a mountain chain appeared on the horizon, covered with eternal snow. Osiris knew this was the right direction and with renewed courage they resumed their travel. As they moved on, the temperature dropped rapidly, but before the first snowflakes fell, they found a passage between two mountains, and then the road started to descend. The physical aspect of the terrain changed completely. Seen from above, what had at first seemed to be a sea changed into an immense plain of sand. When they got closer, it looked like an extinct sea. Steep rocky walls were rising up from what surely had once been a big stream. They carefully stumbled on, onto the powdery sand mass that was surrounded by dunes of different heights. A warm wind tortured the sand hills, once battered by the waves of a vanished

sea. Huge quantities of shells that were not fossilized confirmed that this hallucination-like sight was the aftermath of the disaster that had caused turmoil in the world.

That night Anubis could not sleep. Filled with admiration he watched the sky, and his eyes passed mainly along the clear, milky-like fog that looked like a stream: Hapy. Too young to understand much of it, he kept on staring, fascinated. Osiris came to stand beside him, and spoke: "Our Masters of the Measurements and Numbers have gotten to the bottom of many things—sometimes in the slightest detail—which now seem inexplicable to you. You will transcend this stage, oh Anubis, and you will be the executor of the Celestial Decrees, the mediator between death and the

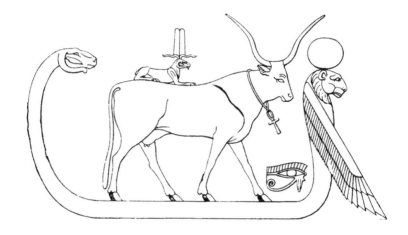

Figure 18. In his new celestial navigation, the Lion is dragging along Osiris on the back of Taurus, guiding him to his eternal resting place.

hereafter. In addition, you will bring our people in the direction of the new land. But no quicker than the slow movement of the sun." Filled with pride, Anubis kept staring at the sky, and saw a falling star, acknowledging the fact that this message would have a favorable ending. The next evening they seemed to have arrived in another world. Everything seemed to have been swept by a whirl, showing an apocalyptic vision of the disaster; one could even see it on the mountains with immense recent-looking cracks. There were many burnt, carbonized trees and grass that had just started to grow on the remains of withered plants. Here they found the first pieces of iron. Then Osiris left his men to search for other resources, while Anubis and his dog started to explore some caves. During his meditation in one of the caves, a celestial

voice spoke to him. The words were transformed in his head into images showing him a terrifying event.

Incidentally, Seth had landed on this spot, together with twenty of his Rebels of the Sun. When he saw his brother, he burst out in anger: "Take a good look at him! This time his fake God will not save him. The brilliant disc that crosses the sky will be my witness. Being the creator, he will justify the death of Osiris."

The First Born looked calmly at this brother and answered with a powerful voice:

"Yes, you will kill me, but only because God has decided so. It is He who will lead your arm to do so, in order to show our descendants that you are the disloyal son of the one and only true God, Ptah."

Red with fury Seth took a spear from one of the rebels and shouted: "I am the son of the Sun! You are not my brother and you will die!"

"You are completely mistaken. Your punishment for this murder will be that you will not rule for a single day over one of my territories."

Leaning on one foot, Seth launched the spear. It went right through the chest of Osiris with moaning force. He fell down and the pointed end disappeared in the earth. Screaming with joy the victor danced in delight.

"Osiris is dead! And this time for eternity. Nothing can bring him back to life! Oh Ra, I offer this conquest to you!" After these words, Seth thought it wise to disappear. That much luck in one day was too good to be true, and the army coming his way would surely follow them. Therefore it seemed better not to rest, but to flee at once.

The dog was the first to arrive at the body. He licked the face with devotion. A bit later, Anubis arrived and heard the last crying words of Osiris: "Bury me close to the place where the iron is... My spirit will protect all our descendants during many centuries... Oh God, I am returning to you...!"

Nowadays it is possible to reconstruct the route they followed. It started in Ta Mana, which lies approximately 100 kilometers from Agadir. In Ta Ouz, close to the border between Morocco and Algeria, there are tombs which have lain there since the earliest times. Buried next to Osiris lays Nut, Nefthys and Isis, and several high priests and advisers of Horus. Visitors feel they are entering a different world while touring these remnants from the mists of history.

Centuries went by under the star sign of the Lion. Hor-Ou-Tir, the ruling pharaoh at that time, late descendant of Osiris, gathered his council. It would be an important day for the

inhabitants of Ta Mana. The pharaoh started to speak with a forceful voice: "Esteemed members of the council, I have called for this extraordinary meeting, because the day of the Great Departure is close by. We need to start the march together on the predicted day of the "Mathematical Celestial Combinations," in order to enjoy its beneficial influences. But first we need to solve some problems." With a majestic gesture, he swung his mantle over his shoulders and sat down on his throne.

Figure 19. Osiris is actually buried in Ta Ouz (his sanctuary). The eternal flame that leads the 'Escaped' to their 'Second Heart', Ath-Ka-Ptah or Egypt, is collected from his body.

Then the High Priest spoke: "May Ptah give our Pharaoh a long life and the Great Force to destroy anybody who resists the Laws of God! We are all descendants of the lineage of Osiris. Our victory is not far anymore. For this reason we need to solve a dilemma: the destruction of others like us, the Ra-Seth-Ou, descendants of the apostate Seth. Only then shall we be able to go to our Second Fatherland in peace and quiet. This council therefore needs to find the most suitable men to end this mission favorably. May the presence of God help us in these memorable times."

The High Priest bowed with dignity in front of the pharaoh, and then the president of the council stood up and started to speak with a resonant voice: "We have talked too much already.

An army should be formed immediately. A long time ago, the sun changed itself into the era of the Lion. The sun will now leave this era, and as we urgently need to vanquish our enemies, we should leave immediately. All our acts will be recorded in the Annals. Do not forget that a long march is awaiting us; we will not only have to defend ourselves, but also launch counterattacks in order to protect our families."

Following this, the pharaoh called upon the chief of the troops, Mash-Akher, who declared his point of view: "To conquer the Rebels, Oh descendant of Osiris, I herewith offer you my men. I am at your disposal, Oh Master who represents Eternity on this earth. We only lack the arms, but if the council agrees to my plans, we can have them at our disposal rapidly."

Thunderous-looking, the pharaoh rose from his throne: "We will discuss your proposal in a minute, but in the meantime I appoint you captain of my exclusive escort."

Mash-Akher bowed deeply and waited for further instructions. The First Born spoke again: "I order you to follow his plans. On the day when the sun awakes for the fourth time, everything should be in order, because it will be the day of our Great Departure. I will lead the army myself. It will be the day of the "Followers of Horus." By Celestial Decree, I order that it be written so in our Annals."

On the morning of the fourth day, the High Priest saw an immense troop of soldiers. Thousands of spears, made with the iron that Osiris had discovered, were gleaming in the sunlight. Fourteen centuries after the fight between their legendary leaders, a new confrontation was awaiting them. Quite sure of their coming victory, the "Followers of Horus" threw themselves into the battle. The fight was short, bloody and intense. Only a few were captured. With a thundering voice, the pharaoh ordered: "Tell your leader it is not necessary to threaten us further. I, Hor-Ou-Tir, Pharaoh with pure blood and descendant of Osiris, am the Son of God. It is

Figure 20.

He who granted me this victory. We will leave this land, which is not meant to be yours and therefore will never be yours. Should we meet any of your brothers on our road, we will show no mercy and we will kill them. Leave and tell this to your leader!"

The sun was on the point of leaving the era of the Lion. With this auspicious sign they left for Ath-Ka-Ptah, the Second Heart of God. On that same morning, Sirius had risen just before sunrise. On this twenty-second of July in the year 8352 BC, a new era started with the long march to the Light.

3.
POLE SHIFT CATASTROPHES
AND ICE AGES

The story of the preceding events now allows us to explain a lot of geological mysteries. More than 12,000 years ago, huge parts of Europe and North America were covered with glaciers, countless mountains of ice. At that time Denmark did not exist, but there was a gruesome landscape reaching more than one kilometer high. The major part of the British Isles lay hidden under the ice, and there were vast glaciers in many more places. The present Hudson Bay used to be a frozen landscape of an unearthly whiteness. There was ice everywhere. The layers were so deep that even the top of the nearly 2,000 meter high Mount Washington in present day New Hampshire lay buried underneath. In the west another blanket of ice lay stretched out, from the northern Rocky Mountains to the Aleuts. In the Southern Hemisphere, glaciers hurtled down from the Andes and from the mountains of New Zealand. Why are we nowadays so certain of that? It can be explained easily: ice layers and glaciers leave impressive traces behind. When the melting point has been reached, the ice slides down hundreds of meters deep under its own weight. It grates the earth's surface and takes the debris in its frosty grip; rocks as big as trucks are thus broken off and dragged along countless kilometers. The waste flows to the river valleys, eroding away their V-shaped beds into U-shapes, and where these valleys covered with ice lie close to the sea, it cuts out deep fjords.

No geologist is able to explain logically why there was so much ice in Europe and America. All sorts of guesses have been circulated. Astronomers presume that the orbit of the earth could have been responsible for this mass of ice. The possible explanation would be that it might have been located a bit further from the sun, in a somewhat slanting position. But others were able to prove that the difference in sun radiation would not have been big enough. Innumerable theories were sent into the world but came back empty-handed due to the lack of evidence. The only thing they are sure of is that there is a relation between the Precession (of the Zodiac) and the existence of the ice ages. Aside from that, the rest is guesswork. But now you can put an end to all these doubts. You know what happened in Aha-Men-Ptah, the perished paradise. In 21,312 BC the axis of the earth slid; in 9792 BC, the earth started to rotate in the opposite direction, and the earth crust shifted thousands of kilometers.

Each catastrophe changed the position of the poles. With that, in one go, all conditions are met to explain the alternation of ice ages and moderate climates. First of all, there must have been increased precipitation otherwise ice masses cannot develop. So where did the water come from? The explanation is simple. The shifted ice masses from the poles start to melt and evaporate into the atmosphere. This increased evaporation increases the amount of rainfall over the whole earth. Where the new poles are now located, water drops in the form of snow and ice, which rapidly bank up to huge heights. Billions of tons of ice now lay on top of the dead cities and the astronomical center of Atlantis. Within a few years, snow and ice will dominate over an enormous part of the European and North American landscape. This is inevitable.

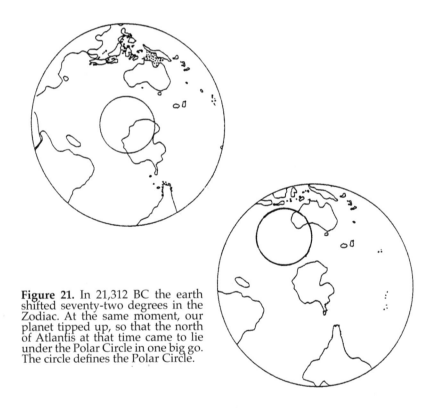

Figure 21. In 21,312 BC the earth shifted seventy-two degrees in the Zodiac. At the same moment, our planet tipped up, so that the north of Atlantis at that time came to lie under the Polar Circle in one big go. The circle defines the Polar Circle.

To survive this catastrophe, urgent priorities need to be fixed. Just a small part of the world population will be able to survive a pole shift and the resulting tidal waves, earthquakes and volcanic eruptions. And, afterwards, when people are thrust into temperatures of 50 degrees below zero, one doomed scenario changes for another. And yet, this is awaiting us. This paralyzing

and fearful knowledge tells you what has happened many times before. It also answers many geological riddles. Why did glaciers cover most of Europe in antiquity, while northeastern Siberia, which is now located above the Polar Circle, remained free of ice? The answer of the traditional scientists is: "Uh, we don't know … No idea…" A satisfying answer is yet to be forwarded by these groups. But that does not mean that you cannot have the real answer right now because it's all explained right here. Through the shift of the earth's crust, Siberia changed its latitudinal location all at once and it was destined to become the coldest place in the world—changing from a moderate to an ice-cold climate, all in one day. There is massive proof at hand.

Before the shift of the earth's crust, a lot of the world's now extinct animals were living in this area, such as mammoths, which fed on plants. At a time simultaneous with the end of the last ice age, these mastodons became extinct. In northeastern Siberia great numbers of mammoth skeletons were found. Not that shocking, you might say, but then they found well preserved frozen corpses of mammoths. This finding stunned the world! To date more than fifty perfectly preserved corpses have been exhumed, some of which still had remnants of plants in their mouths, and of which had undigested pieces of food in their stomachs. The bodies were so well preserved that dogs could eat the meat without negative consequences. According to eyewitnesses, the flesh looks like frozen cow meat. Their end must have arrived all of a sudden; there is no doubt about that. Analyses showed that they choked to death, probably from drowning. If they had not frozen immediately, they would have rotted, the flesh disintegrating. Only a catastrophe such as a pole shift can provide sufficient explanation for this riddle. In such an extreme cold, mammoths could not possibly have survived. They were killed in one go, without warning; with food still in their mouths and stomachs, they were carried away thousands of kilometers and afterwards covered with ice.

An Identical Scenario for Us

This phenomenon awaits the greatest part of the present world population. Regions that have a moderate climate at present were ice-cold thousands of years ago. Because a new pole shift is now going to happen, the earth will begin turning around the other way. The most populated and lowest parts of land will suffer a real slaughter. Almost nobody will survive this catastrophe. In any case, without boats you will have no chance at all. Through the vast upheaval of the reversal, millions of perfect, well-preserved bodies will lie hidden below the ice masses for thousands of

years—until they are brutally dislodged by the following pole shift. A horrifying thought. This knowledge disturbed me for days, in fact, for months. I got up with it in the morning and went to sleep with it at night. My dreams became nightmares in which billions of people died, while the earth was shaking. Again and again ghostly images of a huge world fire showed up. I used to wake up shivering and sweating. When I tried to calm down I did not succeed, I really could not. I dreamed about the previous victims, not only human, but also about peculiar beings like the horrifying sabre-toothed tiger and the large kangaroo that stood 3.5 meters high, all of which died in this destructive violence of nature. Again and again these ghost images of a huge world fire showed up.

Giant beavers almost three meters long, sloths which used to feed on trees while resting on their colossal thick tails and weighing in at more than three tons while standing more than six meters high when prancing on their rear legs; they all died during these inexorable events. The words of R. Dale Guthrie of the Institute of Arctic Biology ("Big Disasters," *Reader's Digest*) kept ringing in my nightmares. He discovered that 12,000 years ago the fauna and flora of Alaska were completely different from today: "The way these animals died must have been disastrous. The animals lived in a totally different environment. Only in this way can you define the exotic hotchpotch of hyenas, mammoths, sabre-toothed tigers, camels, rhinoceroses, deer with huge antlers, and saiga antelopes. Then it became ice-cold and they suffered massive extinction." The worldwide fate of these bizarre creatures gives us a serious warning: it has happened before and will happen countless times again. We have just a few years left until the next catastrophe takes place. What is awaiting us is so apocalyptic that it is beyond imagination. Everything points to a complete extinction of humanity during the coming events, just as most of the large mammals of the past were brought to death. More than a hundred years ago the well-known zoologist Alfred Wallace (*Big Disasters*) wrote: "From a zoological point of view, we are living in an impoverished world in which the utmost colossal, wild and peculiar sorts of animals have recently disappeared."

In exactly the same way a massive slaughter will soon take place. This time the greatest victim will be humankind, since it is ruling over the whole earth. There is no possible escape. My findings are devastating to this extent. We are heading for this event, and we are powerless to stop it. This knowledge is ruining my constitution and me because there is nothing to be done—except possibly warn people. Maybe after reading this book, enough people will be motivated to take the necessary steps for

survival and will be able to start a new culture afterwards. You never know—my fearful dreams would surely lose some of their drama.

The following quote painfully reminds us of the last catastrophe (*Atlantis*, Berlitz, 1984): "The face of the heavens had darkened. Nobody knew what was going to happen. Suddenly a fire from Earth flew into the air, a rain of fire and ashes fell down and boulders and trees were thrown down. People got torn apart and buried in the sand and the sea. In one big, sudden and forceful flood the Big Celestial Snake was kidnapped from the Sky. The Sky fell and the Earth sunk, when the four gods, the Bacabs, rose and took care of the destruction of the world." In the sixteenth century Diego De Landa wrote the following about this happening: "Amongst the large quantities of gods that the Maya used to worship, there were four that were called Bacabs. They said that they were four brothers that God, after creating the world, placed on its four corners to brace heaven in order not to fall. They also said that these Bacabs escaped when a flood destroyed the world."

Similar reports can be found everywhere in the world. The Avestic writings tell about the disaster that hit their paradise, Airyana Vaejo. From a mild climate it was torpedoed to an ice-cold place (*The Arctic Home in the Vedas*, Tilak, page 340): "Then Angra Mainyu, who is filled with death, created an enemy… Snow is falling everywhere in thick layers; this is the most horrifying of all plagues…" Furthermore, we read in their scriptures that this terrible cold was predicted and that people were advised to protect themselves from it: "Therefore make a var … Bring to it a representative of each species. Put there all sorts of plants and the juiciest fruit, the most beautiful and sweet smelling. All these things and creatures will not die, as long as they stay in the var."

The Toba Natives scriptures tell about a huge cold accompanied by darkness. According to them the disaster was sent because the earth has to change as it gets filled with people. In order to save the world the population has to be depleted. All these myths prove that a phenomenal disaster has taken place. Again and again we find identical motifs in them: stars falling from the sky, titanic earthquakes, a huge flood and a terrible cold. Prophets predicted the disaster under the orders of God; Noah-characters built the necessary arks. Their descendants populated the world again. Such stories were written down to warn us. A long time ago these worldwide myths were conceived to convey these apocalyptic visions. They will shortly become a terrifying reality. The memories from the past will then haunt our minds.

Professor Hapgood (*The Path of the Pole*, 1970) wrote the

following about the events of almost 12,000 years ago: "Everywhere in Alaska there is proof of an unprecedented severe atmospheric turmoil… Although some of the animals were weighing a couple of tons, they were simply torn apart and spread like straws on the land. The piles of bones are mixed with trees, which were also jumbled and torn apart… The whole is covered with a fine layer of frozen dust."

When you read this, you immediately know that fierce powers have created this massive grave during these events. Tens of millions of animals and people suffered an instantaneous death, caused by floods, earthquakes, huge storms and an instantaneous setting-in of a glacial period. The whole earth was staggering. In the New World more than seventy big mammal species were lost. To put this in the right perspective: during the preceding 300,000 years, not more than 20 types had become extinct. The same pattern was repeated throughout the world. Alaska and Siberia were hardest hit. Hundreds of thousands of animals froze to death on site and were preserved, so that after more than 10,000 years they could still feed the huskies. These quantities only headline the list of apocalyptic numbers that suffered annihilation during the previous catastrophe.

Thousands of volcanoes must have exploded, because volcanic ash is frequently discovered around the frozen animals. Skeletons of mastodons found standing up were discovered in the San Pedro Valley, supported by huge piles of volcanic ash (Velikovsky; *Worlds in Collision*). Most of Europe and the land that became known as the New World, was covered with an ice cap several kilometers thick. When the earth's crust slid, it landed on a moderate zone. Then the big melting started. Ten million cubic kilometers of ice were reduced to water. It streamed into the seas and oceans and made the water level rise more than 160 meters. Low coastlines were flooded again. Millions of liters of water evaporated and fell as snow at the poles. As a result the water level sank back. In northern Florida one finds marine sediments up to a height of at least seventy-five meters. Areas that are now barren, like the Sahara, were at that time full of life and green with vegetation due to the abundant rainfall.

This gruesome period left deep traces all over the world. In many places people feared that earthquakes could be the foreboding of a new catastrophe. On the west of the river Volga in Russia, the Mari believed that the earth was resting on one horn of a big bull. They believed that every movement of the bull could cause an earthquake. At the moment the head of the beast would tilt, the sky would seem to come down and the earth would fall into the ocean. In a distant place, in Machu Picchu, the Incas

Figure 22. At the end of 2012 the creations of the Maya will be destroyed forever; among them there is this beautiful bas-relief.

had a settlement of young women. They were to populate the world again after a new disaster. In Iceland a myth starts with the terrifying prophecy of a visionary: "The sun gets black, the land sinks into the sea. The hot stars will tumble over the sea ..."

There is no doubt that the sun was playing the main role in these events. During the previous catastrophe it moved restlessly on the horizon. Everywhere in the world you will find this theme. During their observance of the winter solstice, the priests of Machu Picchu fastened a mystical cord to a big pillar. In this way they believed that they could prevent the sun from leaving its path and spreading death and destruction. They thought that a controlled sun could not cause a new tidal wave. In Stonehenge, as in all prehistoric Europe, huge stone buildings were raised in honor of the sun. They are standing there as a magical measure against a new tidal wave. Through mesmerizing formulas the movement of the sun could be kept under control. For thousands of years these stones have ensured the safety of the world. But these rituals haven't been performed in a very long time. The violent sun god cannot possibly be happy with this. In an all-destroying outburst the wandering sun will launch a chain reaction, which will shake our world to its foundations. The sky will fall, the earth will be broken and torn apart by earthquakes. And huge waves will crash down destroying everything. So it is written in the myths of countless cultures, because it has already happened many times before.

We read in the scriptures about the super traumatizing events of almost 12,000 years ago: fire, lightning, hurricanes, tidal waves, volcanic explosions, a black sky, famine, cold, and so on. The poor unfortunate people who experienced these events had to have been so shocked, it dominated their whole life. They passed warnings on to their children and great-grandchildren, who in turn passed them on down to the next generations. In the center of all this are the stories about the survivors. And these stories contain codes so that their descendants can prepare themselves for this horror of all horrors. The conveyance of this knowledge lies for us mainly in the writings of the Old Egyptians and the Maya. In their well-preserved secrets we can find the foreboding numbers that will lead us to the unveiling of the previous period of catastrophe, and to their predictions of the next.

4.
THE COMPUTER PROGRAM
OF THE PREVIOUS CRASH

In my previous book *The Orion Prophecy* I partly cracked the "computer program" designed by the Old Egyptians and the Maya, that predicts the coming of the end of the world. It contained a mathematical logic, which led me to suspect more: an extensive plan leading to the Apocalypse in 2012 AD. I could just see it hidden, after which my fear grew many times—pure, naked fear for my life. I walked around for days, trembling like a leaf. After a couple of months a zombie would have looked better than me. Finally, when I was completely worn out, I took courage, because my task had not yet ended. A lot of codes would surely be hiding in the previous crash which had destroyed Atlantis. Maybe I could find more clues about the forthcoming disaster from that event. And with this evidence I would probably be able to convince enough people to take life-saving measures. Who knows, something could possibly be done to help humankind to survive. In any case I thought it worthwhile to try, although my dreams were haunted with horrible images. I woke up a couple of times in the middle of the night seeing earthquakes destroying nuclear plants and causing nuclear holocausts. And I truly did not have a clue on how anyone could prevent this. However, I kept pursuing my task and very soon I was rewarded with clues that told about the downfall of Atlantis.

Breaking the Codes for the First Time
From the calculation leading to the next crash in 2012, I found the number series of 2.66666. I decided to test the series 0.66666, because I had seen these numbers in several other calculations, and it seemed to me that it was a series of numbers that could lead to evidence of the Atlantean outcome. Why? Pure coincidence actually, but it appeared to be the right gamble. It seemed I was predestined to be allowed to break the codes. I found out later that the series 0.66666 was assimilated in their calculations of the orbit of the earth around the sun. Given this number, you can prove that the Atlanteans measured the solar year up to nine figures after the decimal! It also contains the number of the Biblical Apocalypse, 666, which would later lead me to other astonishing discoveries. I still did not know this at that time, but it was my intuition that led me to the first codes. Much later I was able to associate other decipherings, because the numbers of the

Maya and the Old Egyptians had different meanings. But at that moment I had not reached that far, and I decided to investigate my original conclusions further. From my previous book you will know that they had three different calendars of 360, 365 and 365.25 days. Don't let these numbers scare you off, because the calculations are very understandable. Everybody knows how to add, subtract, divide and multiply. It is that simple. You don't even have to make the calculations because my pocket calculator has already done this for you. Here are the first codes:

$365.25 \times 0.66666 = 243.499999$

$365 \times 0.66666 = 243.33333$

$360 \times 0.66666 = 240$

At first I could not make heads or tails of this. My brain was burning out; I fretted about it while pacing around. I could place the number 240; it contained the twenty-four hours of one day. But the number 243 did not give me a clue. I got stuck there. Where was I to look? I decided not to calculate any further until I had found a solution. This kept me busy for two whole days and I began to regret my promise. I searched in several chapters of books for a possible hunch. All clues seemed to lead to a dead end. Damn it, why was I wasting my time here? But then I suddenly had a flash of inspiration and opened my encyclopedia of astronomy. Something pushed me to the chapter on Venus. And there it was! The number 243 meant the orbit of Venus around the sun! To be exact: it takes Venus 243.01 days to revolve around the sun (later I found out I had made a mistake; it wasn't the orbit of Venus, but actually the time it took to rotate on its axis, but that didn't make any difference in the deciphering). The Atlanteans rounded off a lot of numbers, so in this case it was more than logical that this number (243) concerned Venus.

I was able to find through this discovery many other Atlantean codes. I have revealed them in Chapter 17, "Venus, the Key to all Mysteries." And as you will see, there is an undeniable connection between the number 243 and the number of the precession. I could derive from it pages of decipherings, some of which are quite important. They concern the well-known numbers of the Maya as well as the Egyptian Sothic cycle. There is also a connection with the Mayan sunspot cycle. And to top it all I could prove the direct connection between the number 666 and Venus. As you can see, thanks to my obstinate persistence, this small list is not so bad. Together with later discoveries I could end this search with overwhelming evidence. But at that moment I still had a foggy notion of my actual goal. I decided intuitively to make more calculations with the series of 0.66666. To my astonishment

I stumbled across three numbers that I had seen before in other calculations (see further and in the Appendix). Of course this could not be a coincidence! You may do it yourself if you want:

243.49999 x 0.66666 = 162.33333
243.33333 x 0.66666 = 162.22222
240 x 0.66666 = 160

I also knew immediately where they had found these series of numbers. Some time before I had been racking my brain about them, and during previous "breakthroughs" I had accidentally stumbled onto them. Indeed... Accidentally? Didn't it seem more than logical to conclude that there was a connection between Mexico and Egypt? The figures and combinations were such that I came to discover it automatically. This proves once more that the program was conceived in such a way that there was no option but to discover it! Stumbling across this identical series, I proved again the beauty and complexity of their "software." But even more shocking is the fact that you also find these numbers in the decoding of the Dresden Codex! Mathematicians and others who are interested will find this at the end of the chapter. And this was just the beginning! Multiplying the above-mentioned series again by 0.66666, I was presented with another set of holy numbers! When I repeated this, it was bingo again. Even more beautiful, there were several interconnections between them, which all fit together nicely (for mathematicians: see Appendix). With this I proved undeniably that these numbers were being used!

0.66666 and the Solar Year of the Maya

By the way, hadn't I seen somewhere in *Fingerprints of the Gods* by Graham Hancock something about the number 66.6? I quickly opened the book. Yes indeed. In short it comes to this: Mexico, the Pyramid of the Sun. On the equinoxes of the 20th of March and the 22nd of September a phenomenon takes place: for 66.6 seconds a shadow passes over the west face of the Pyramid of the Sun. This has taken place year-in and year-out since the beginning of the construction of the pyramid. "This is it!" howled through my head! One of the many functions of the pyramid was to communicate the encoded messages of the wisdom cult that had ruled over the earth for thousands of years! There was here an undeniable connection between the solar year, as shown by the equinoxes, and the number 0.666, by which it had to be multiplied to unveil a whole series of encoded numbers! I was completely amazed by their peculiar interwoven knowledge of science, construction engineering, and their culture. The result of a complex intellectual challenge, a commitment to prove that

they were indeed capable of calculating the date of the end of the world!

This discovery left me speechless and gave me a good feeling. By indicating that a shadow appeared for 66.6 seconds, a phenomenon that takes place only twice in a year, they were telling us that this number relates to a solar year. Depending on the calendar they used this took 360, 365 or 365.25 days. And so my intuitive search was confirmed! I lost my head at the sight of so much magical

Figure 23. This reconstruction of the Pyramid of the Sun shows how the religious center must have looked at its height. Since that time a shadow slides over the west face during each of the equinoxes. This phenomenon lasts exactly 66.6 seconds.

knowledge. "What else could I find out?" I desperately asked myself. What secrets were still hiding in these masterful creations of days long gone? Filled with admiration I looked at photos of Mayan buildings hoping that they would give me inspiration. I read, awestruck, how many stones they used in some of them. Mind-boggling numbers were whirling before my eyes. Big, bigger, biggest, in that way you could describe the pyramids and temples. And all that to express their "Holy Numbers." It was too much to

comprehend, too amazing. A sort of trance seized me. My thoughts kept going with unflagging zeal.

I realized that the construction of this phenomenon requiring precisely 66.6 seconds of shadow falling on the Pyramid of the Sun was based on the "Holy Numbers" I had found in my calculations. Not only could they construct superior buildings, but also their underlying knowledge to build them was magnificent. A purely geometrical creation, connected to the passage of time, dominated by the Number and the memory of heroic times. Combinations of surprisingly strange angles were joined together to create eye-boggling masterpieces. The magic of esoteric figures, interwoven with thousands of tons of artistically cut pieces of rock, as if it had not been any effort at all for the ancient builders to do this. There is nothing more insane and imaginative than this. And this applies to the Maya as well as to the Old Egyptians.

It is obvious that these numbers are part of the legacy from the lost Atlantean civilization. Without any doubt the Maya are the most facile and inspired followers of this old science. You can find everywhere their continuous obsession with the subject of time. It controlled all their enterprise and doesn't have any equal in the history of humankind. By breaking their codes, which accurately describe time, many Mayan mysteries and bottlenecks of their religion can be solved. Awesome riddles and awkward manifestations of their bonds to time will have a logical explanation with the help of modern scientific thinking.

The Precession Code from the Maya and the Old Egyptians

Of course the above-mentioned numbers were put there in order to be used by future generations. Is it not logical that they had something to do with the inheritance of a lost civilization? That these are magic numbers originating from a wisdom cult, which had been destroyed by a terrible disaster? They probably are. I was ready to look in that direction. But first I had to carry out another calculation. For this purpose, you have to think of the two previous pole catastrophes. The first one happened in 21,312 BC and pushed part of Aha-Men-Ptah in one big go under the North Pole at that time. Thousands of years later, on July 27th in 9792 BC, Atlantis was completely destroyed and came to lie under the present South Pole. The period in between lasted 11,520 years. Keeping in mind the codes of the program that were already broken, I multiplied the number of years between the two catastrophes by each type of year:

$$11,520 \times 365.25 = 4,207,680$$
$$11,520 \times 365 = 4,204,800$$
$$11,520 \times 360 = 4,147,200$$

As you can see, the period between both catastrophes takes more than four million days, which is a terribly long time. And yet the downfall of Atlantis took place more than four million days ago. Time flies. The proof is here. One crash has hardly been consummated (only recently have we become able to do what the Atlanteans were capable of doing) when the next catastrophe is already knocking on our door. But this could be the last one for humankind. Again, my mind runs ahead of me, because time is definitively proceeding with great strides toward our downfall, and nobody seems to worry at all. I am still trying to motivate people with my books, and if I don't succeed in time, well, you can forget all this collected knowledge. By then only insects and some mutated animal species will rule the earth. They will have the whole kingdom for themselves.

Again it was too much for me. I could not finish the calculations; each day my hopes for a prosperous life grew weaker. Trying to push away my somber thoughts, I divided in desperation the above found numbers. Due to these numbers I had found in the past a number that was quite similar to the precession number. From this last one I was able to find two code numbers of the Maya, which resulted in further deciphering. So maybe I could now find something similar. Or not? I was astonished. It happened! I was shocked to see the numbers that turned up:

$$4{,}207{,}680 \div 163.33333 = 25{,}920$$
$$4{,}204{,}800 \div 163.22222 = 25{,}920$$
$$4{,}147{,}200 \div 160 = 25{,}920$$

The identical result of these calculations is the precession number, which made me break out in cold sweat. The end of the Atlantean world must be true! Still, this was not all. On the basis of these and other decipherings, you can prove that indeed 11,520 years passed between the previous crashes. When you look closely at these decipherings, you will find an identical way of calculation, leading to 2012 AD, this time with another precession number! This means undeniably that the 11,804 years between the previous and forthcoming catastrophe were calculated in the same way. And also that 2012 is actually the final year of the big countdown to the forthcoming catastrophe!

25,920: The Holy Number of the Atlanteans for the Zodiac

As you may have read in my previous book, the number 25,920 not only stands for the duration of a complete zodiacal cycle, but also for the number of years that Atlantis existed. Three catastrophes in total took place in the history of this legendary empire. By the third, whose codes I was now breaking, the

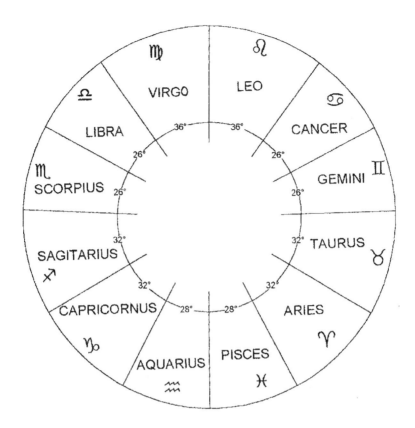

Figure 24. The Zodiac was an essential part of astronomical science for the Old Egyptians and the Maya.

country was completely swept away from the map. Exactly 25,920 years had passed since the foundation of Atlantis. Before the catastrophe, the high priests had exactly calculated that the empire would be destroyed completely. Aha-Men-Ptah, the true and original name of the empire, would become just a land of shadows. This calculation probably had something to do with this. After all, this number shows that the cycle has been completed. For this reason, it appears so many times in the myths of Egypt. Examples can be found in my previous book *The Orion Prophecy*. The archeo-astronomer Jane B. Sellers subscribes completely to this. In her book *The Death of Gods in Ancient Egypt*, she states that this is a well-chosen number. I took her statement seriously and succeeded in breaking a great number of codes. Now I was staring right in the face of the original number.

After meticulous calculations, the Atlantean high priests had picked the number out of an incredible array of possible

combinations. They built their whole history around this number. It is not impossible that they should have recalculated former periods of time that had passed in their Zodiac, in order to conform to the predictions of this magical number. Besides, I had read in Slosman's book *L'Astronomie selon les Egyptiens*, that the names of the signs of the Zodiac were changed many times. And it could be the same with the periods of time. Otherwise, it would be too much of a coincidence.

When you study in depth the years that had passed in a certain zodiacal sign, you are drawn to the same conclusion. It is impossible to work with such specially coded numbers from the beginning of a civilization. They were deliberately put there once the Atlantean priests had made their calculations about the approaching end of their world. After all, everything had to meet the expectations of the Holy Celestial Laws. Only in that way one can logically explain all this. In their eyes this was not a falsification of history, but simply an adjustment of the laws of reality. The "Divine Reality," as they experienced it. Of course this deciphering is not a coincidence; it is the result of a well-pondered and finely tuned decision. Should there ever come a civilization after them, it would have had to be able to trace back along their important discoveries. The precession of the equinoxes, or furthermore, the shifting of the Zodiac, is at the center of these discoveries. The corresponding number, 25,920, shows up worldwide again and again. In Egypt, the Great Pyramid is an example of a building where important numbers of the shifting of the Zodiac are hidden. This in itself cannot be coincidental, because the Egyptians originated from a highly developed civilization that found its resting place under the South Pole.

When we find this number while decipherings the codes, and we also find it in the antique masterworks of remote times, one proof is reinforced by the other. For instance: the number automatically shows up in elementary calculations that later form a logical unit in the pyramids. Thanks to the work of Robert Bauval, we know that the three Egyptian pyramids are placed according to the constellation Orion. Not only that, but also that they were arranged in such a way that they are reflecting the precession of this constellation, specifically showing the situation of almost 12,000 years ago. And that is terribly important. The shifting of the Zodiac can be reproduced with mathematical calculations. The survivors of the catastrophe designed a plan with scientific details to show the precise date of the catastrophe. But there is more. When Gino Ratinckx and I studied the precessions more accurately, the one of 9792 BC appeared to be the same as the one of 2012 AD! For this reason the Egyptians wanted us to observe

this constellation as accurately as possible. As soon as we reach the same precession a disaster will take place on earth, identical to the catastrophe that caused the downfall of Atlantis! I described the implications extensively in my previous book.

In fact, the pyramids, a sort of "star clock," were built by people who were able to calculate the declination of star signs, forwards as well as backwards in time. They were highly civilized scientists. At the same time they were very competent land surveyors who knew everything about geometry and the four directions of the wind. That is why the pyramids need to be examined further. The following words of Bauval about the Great Pyramid tell enough (*Fingerprints of the Gods*, Hancock, 1995): "Watch its power. It forces you to a specific thinking process… It forces you to learn. The moment you ask a question about it, you ask a question about construction, about geometry, about astronomy. You will begin to realize slowly how advanced it is. And you will want to find out. That's its power."

72: The Holy Number

From this point of view, a lot more of these codes could probably have been assimilated in this building. Which does happen to be the case. Just a tiny bit of research immediately yields evidence that the precession number is hidden in the Great Pyramid. One discovers in it an angle of 72 degrees that leads to the number 25,920: 72 x 360 = 25,920 = the precession number. The number 72 is mentioned here to give a code value.

In her book *The Death of Gods in Ancient Egypt*, the archeo-astronomer Jane B. Sellers states that the myth of Osiris is intentionally coded with a couple of key numbers, with which one can derive surprisingly exact values. It takes 72 years to complete a shift of one degree over the ecliptic. According to Sellers, this number, the basic ingredient of the precession code, shows up persistently in antique myths and in architecture. Furthermore, this esoteric numerological number can be used in other combinations. The number 36 is often added. The resulting number, 108, is usually divided in half, with the outcome of 54, a number that we will later find again in the Dresden Codex.

But the code is not restricted to the scriptures of mythology alone. The temple complex of Angkor in the jungle of Cambodia appears to be a well-chosen metaphor for this esoteric number and its combinations. Each of the five roads leading to the complex is flanked by 108 stone figures, 54 on each side. Every row of figures carries a portion of an enormous Naga snake. It is just as if the end of our world was displayed here, because as Santillana and Von Dechend point out in *Hamlet's Mill*, the figures are pulling the

snake. This signifies that the 54 figures are "churning the ocean of milk" (the Milky Way), which means that the snake plays an important role in the catastrophic developments the earth is bound to encounter. As we know, Venus passes the star sign Serpens during that fatal period in December 2012. Mythically seen, the Serpent therefore lies at the source of the violent turbulence that will sweep the oceans.

Figure 25. One more example of the prevalence of this number, the "Zayi Palace" in Yucatan contains 72 consecutive apartments.

In Mexico we find extensive evidence of the use of the number 72. The relevant resulting numbers turn up abundantly in the Mayan calendars: 1 katun = 7,200 days; 1 tun = 720 days; 5 baktuns = 720,000 days. I came across the number 72 everywhere, no matter what civilization I was researching. Was it merely a coincidental cultural development? I could hardly believe that. This unquestionably had a common source!

Then something amazing struck me—in the disaster of 21,312 BC, Aha-Men-Ptah had shifted 72 degrees in the Zodiac! If your image of the world changes this drastically, this number has to play a decisive role in your life and that of your descendants as well! That is why all civilizations have put it in their myths. And not only in their stories, but it is also in their architecture, science, mathematics, and so on. And the Maya had processed it in a solar year. The final decisive factor was my discovery that, when you

multiply a solar year of 365 days by 0.666, the final outcome is 72! It was impossible to multiply further, because it resulted in an incoherent mathematical pattern. Could there be a connection with the above lying numbers, I wondered?

The Origin of the Numbers of Venus

Feeling that I was on the track of something incredible, thousands of questions kept whirling in my head. Did the Maya inherit their calendar and mathematics from the Atlanteans? If so, how were they able to adjust them to their way of thinking? I was completely convinced of this, and because of this certainty I stumbled across exceptional evidence. Here is the result of dividing the numbers of years between the cataclysms by 72:

$$4{,}207{,}680 \div 72 = 58{,}440$$
$$4{,}204{,}800 \div 72 = 58{,}400$$
$$4{,}147{,}200 \div 72 = 57{,}600$$

The last two numbers are extremely important. In earlier days I had calculated the number 576 from the Zodiac. Through that number I had traced the synodic period of Venus, which contains 584 days. Right now I was looking at both numbers standing neatly one on top of the other. And of course there had to be more. The number 576 had some significance in all this; I was convinced of that. But what? A difficult question if you do not know the answer. Later I found the answer in the Dresden Codex of the Maya. It appeared to be the essential value for Venus! Do not underestimate the power of these numbers. The Atlantean way of thinking was mostly based upon them. The Egyptians and the Maya adopted this and made other combinations with the same numbers. Once you know the source, then you also know that you are allowed to use these numbers. This leads in turn to other possibilities, through which you can decode the whole, step by step, like a good detective who solves a murder case. As you can see, I stumbled upon the numbers of Venus with just a few simple calculations.

Venus was sacred for the Maya. Generations of researchers have been busy probing the question why the Maya were so obsessed with this planet. Once you know how to unveil their motives, then you stumble upon amazing answers: the numbers of Venus are involved in the catastrophes that tortured earth regularly, and in the ones which will do it again. It was the same with the Egyptians, although the numbers of Venus were hidden in their codes. The Egyptians gave more emphasis to the Sothic cycle; the reason for this will be made crystal clear in later decipherings. In any case, among the Maya everything was focused on Venus.

They kept a sharp eye on our sister planet, noted everything down, and built around it a complex time calculation system that was used for thousands of years. Research on the Dresden Codex, the most important of all Maya documents, showed that other planetary movements could be calculated on the basis of the movement of Venus. Furthermore, it contains moon tables used to calculate possible solar eclipses, which have been found to be accurate to within just a minimal deviation in relation to the actual values. The tables in the Dresden Codex also coincided with the extremely important Tzolkin, the cycle of 260 days, which was greatly respected by the Maya. It was also discovered that they had correction numbers at their disposal, with which they could adjust the first table and reduce the margin of error to one day in 4,500 years. Based on this finding, I continued searching in depth and found that the Maya knew even more accurate numbers than researchers think!

In the Dresden Codex, five pages were devoted to the calculations on Venus. The average cycle for longer periods was of major interest to the Maya. One Venus year could comprise 581 or 587 days, but the average lasted 584. This number and its multiples were of great interest to the priests. The above-found numbers of Venus are part of an immeasurable inheritance. They are the legacy of a lost civilization, destroyed by a catastrophic disaster—an inheritance of an old, star-gazing people, kept alive, cultivated and enriched by their descendants.

And this legacy of knowledge of a higher order points at an as yet unidentified civilization. This pattern of thought means fresh air in the search for the Atlantean civilization. As long as there is no proof on the table, contemporary science remains unconcerned and doesn´t change its point of view on this "lost" culture. They view it as a play in a cosmic drama, impossible to prove and forever engulfed by the waters. But, is this actually the case? Don't these decipherings show something different, something much more alarming? Without any doubt the numbers revealed are leading us to the disaster that meant the end of their civilization. It predicted Armageddon, the end of times for their homeland. Such a downfall asks for the largest scientific and mathematical connections. And I have found those too. During my restless search I have run into so many paradoxes that even the biggest skeptic will have to acknowledge that this cannot possibly be a coincidence, because the affinity is too large.

The Sothic Cycle of Egypt

It all comes down to thinking in the Atlantean way. Nothing else. I am getting more and more familiar with this way of thinking in my progressive disclosure of their long-lost secrets. The fact that

I was able to find essential numbers on such simple calculations meant that there should be more to discover. My thoughts went to the disaster of 21,312 BC. At that time the earth was turning 72 degrees in the Zodiac. Was there another number relevant to this, I wondered? My thoughts started to follow a logical path. A circle has 360 degrees. When you subtract 72 you get: 360 - 72 = 288 degrees. Later, the number 2,880 appeared to have an essential value in the sunspot cycle. This proves once more that the same number was used several times.

From the many calculations I made, it became only too clear that they were almost always using the same numbers in their calculations. Nearly all the numbers that the Maya used were derivatives from the sunspot cycle. A similarity in the Egyptian way of calculation shouldn't surprise us at all. The uniformity was of no importance for them, only the number had to be exact. Following is the calculation using the interval of the cataclysms with the number 288:

$4,207,680 \div 288 = 14,610$

$4,204,800 \div 288 = 14,600$

$4,147,200 \div 288 = 14,400$

Just before the publication of this book I was able to prove that the number 288 was no coincidence. It contains the difference between the first two calendars: 4,207,680 - 4,204,800 = 2,880! With this, I came across some "Holy Numbers" of the Egyptians. Every 1,461 years they celebrated the Sothic cycle. This requires further explanation, because several ancient Egyptian mysteries can now be correlated. Once more this will show how the Egyptians interwove their knowledge and science with their buildings. It has to do with the star Sirius, the above-mentioned "Holy Numbers" and the pyramids. In Dendera the star Sirius rises every year with a deceleration of six hours. Every four years this results in one day of deceleration. After 365.25 x 4 = 1,461 years, Sirius has travelled a whole cycle. This interval is called God's Year. In those days Sirius had risen 1,460 times. The hieroglyphic notation for Sirius has the shape of a triangle with its vertex upwards. It is identical to the one for "the creative bundle of beams" that we find in all the scriptures and archives.

So what does this mean, this light? According to the sacred scriptures, it originates in the twelve star signs. Except for a couple of days, it is constantly visible in the regions of the tropic of Cancer. Every morning at sunrise it appears in the east and every night, shortly after sunset, in the west. It starts at a high point in the sky, from where it comes down and unfolds itself into a huge pyramid that has the basic geometrical shape of a beautiful triangle. From

the temple of Dendera you can watch this extraterrestrial clear vision for more than half an hour. In December and January one can see this phenomenon at its best. Especially during the twilight, one can be overwhelmed by it. It is as if this clear light in its neat geometrical pyramid shape was sent by a divine power from an exact point in the Milky Way. It vanishes, just as quickly as it appears. Should you see this phenomenon, this almost magically pyramid-shaped light will surprise you. To the Old Egyptians it must have been a supernatural phenomenon, a divine sign of the Creator, who was sending it to his earthly creatures. The Masters of Measures and Numbers and the high priests studied it thoroughly, focusing on the physical characteristics of this light and its influence on the mind. They made plans to copy it on an earthly scale. The star Sirius was associated with this radiant light. Its hieroglyph literally stood for: "The radiant light that glows on earth with its divine particles, thanks to Sirius."

Nowadays the astronomers know the zodiacal light only too well. They suspect that it results from the ionization of the air, like the northern lights. But they still do not really know what causes it. There are plenty of different theories going around, but up to now none of them have been satisfactory. In any case, it is an impressive phenomenon. Seen from the roof of the temple of Dendera it must have been a magical show. Thousands of years ago, they used to stay there watching and investigating the sky for nights on end. Besides the pyramidal bundle of radiant beams which came forth from a steady, high point in the Milky Way, nothing emanating from that unknown, steady, high point in our galaxy could escape the attention of the masters and their still-inexperienced pupils.

The course of all the planets was strictly calculated and recorded. Moreover, as soon as the pyramid of light disappeared, some specific grooves made it possible to precisely delineate the movement of Sirius. The "Papyrus of Kahoen" proves that they were able to do it. These astronomers from long-lost times compiled from this document some charts that showed the height of Sirius above the sun, on the geographical degree of the latitude of Dendera. This had to be done very precisely, in order to check the end of the calendar. Again the "Papyrus of Kahoen" proves that they were able to do this. A high priest tells us the following: "The glorious rise of our loyal Sirius will take place in the fourth month of Perit of this year, on the fifteenth day, to be exact. Mention this date to people in your vicinity and announce it at the entrance of your temple, so that the believers will celebrate that day joyfully and bring the required sacrifices." The date noted at the end of this message is the third month of Perit, the eighth day: this has been

Figure 26. In a corner of the Temple of Dendera, a Master of Measures and Numbers is meditating on possible new combinations.

proved and acknowledged by all Egyptologists. So, this scripture was written 37 days before the actual occurrence. But besides this, thousands of years beforehand, the same calculations were made. This proves the high standard of Egyptian astronomy.

The above-mentioned decipherings of the Sothic cycle are only the tip of the iceberg. They show up many times in other calculations and in analyses of the Mayan numbers. The Egyptians knew where their inherited knowledge came from. Establishing elementary codes was of key significance, in order that these numbers could easily be found by means of other numbers, providing a way to correct the reservoir of affected traditions, to gain back the full meaning of distorted memories. So here we cannot simply talk about coincidence, but only about a purposeful way of thinking, conducted by brilliant minds. They combined their astronomical observations into calculations that were easy to understand. Through all this arithmetic, you must draw the following alarming conclusions:

• The Egyptian "Holy Numbers" originate from the calculations that led to the previous crash. Their mother country Aha-Men-Ptah (Atlantis) completely disappeared with it under the South Pole. The accompanying shock was so devastating that these numbers were imprinted in their memory forever and ever. The pyramids contain numbers that were used to calculate the date of the downfall of Atlantis. They honored in this way all those who had died during these events. But this proves in addition the reliability of their way of calculation. Through this we stumbled on the fact that the precession code of the previous catastrophe is similar to the one of 2012 AD. In fact, the pyramids inform us of what is going to happen.

• In the present cycle, you can find the same code numbers that were used at that time. Besides, the circular movement of Venus above Orion, with an identical code as the one in 9792 BC, returns in 2012 AD. This is the most frightening thing of all. This cannot be denied. I am personally astonished by it. Many times, when I understood the outcome of the calculations, cold sweat ran down my back. But this doesn't help to stop the crash. When you divide 360 degrees by 72 and 288, you will find the "Holy Numbers" of the Egyptians and the Maya, after dividing it by the period between the previous crashes. The endless series of 36 would later lead to an incredible series of decoded numbers that are related to the sunspot cycle, and besides this, to the origin of 360 degrees.

• If I was able to get to these essential numbers through such simple calculations, there had to be more to discover. The Egyptians were known for their double work on everything. I

had to find the same numbers through a different path. Therefore I decided to have another good look at it all. There had to be common codes somewhere, which would lead to the unveiling of the secrets of the Atlanteans, the Old Egyptians and the Maya. You will read in the next pages about that particular quest.

For mathematicians: see Appendix

5.
THE HIDDEN CODE IN THE
INTERVAL BETWEEN THE CRASHES

In the previous pages you have read about the history of Aha-Men-Ptah, which over time became known phonetically as Atlantis. You have also read about the catastrophe that took place in 21,312 BC when Atlantis became partially covered by snow and ice at the North Pole. In 9792 BC the poles reversed and a massive shift in the earth's crust occurred. In one night Aha-Men-Ptah disappeared under the present South Pole. The period between the two cataclysms (one rapid shifting and one reversal) was 11,520 years. The most recent of those catastrophes definitely took place, because the year 9792 BC correlates with the star code mentioned in the Egyptian Book of the Dead. During several months of that year, Venus made a retrograde movement behind the sign of Gemini, to the left and above the constellation Orion. To verify this, read the corresponding chapter in my previous book and study carefully the drawing in the next chapter. This code proves the accuracy of that date.

This code was not mentioned in any record we found relating to the catastrophe that took place in 21,312 BC; we were able to confirm that using a computer program with which we were able to dig farther back in time. Therefore we had to look for other evidence. The task wasn't as insurmountable as I thought it would be at first, but it turned out to have a different answer than I had assumed. For months I investigated all kinds of possibilities. I was able to find several clues in the Atlanteans' pre-computer program designed to explain the previous crash, but it still fell short of offering up the irrefutable evidence required to convince experienced scientists. Although they thought the game with the numbers was very clever, it was not convincing. Suddenly, I was struck with a brilliant flash of intuition and with that, I was able to retrieve the detailed instructions of the Maya. You see, I had already ascertained that certain numbers were hidden in their way of calculation. It was just a matter of pulling them out. Venus was everything to the Maya and I wondered if I could solve the riddle with it. According to the Egyptian Book of the Dead, the Venus code returns in 2012, the same year in which the Maya predict another super-catastrophe: a reversal of the earth's magnetic poles which will result in huge earthquakes and massive oceanic tidal waves. Given the original way of calculation, common codes

had to be retrieved. With this I had a serious clue how to bring my investigation to fruition. But where could I find these codes? Were they easy to find or had the Maya hidden them deeper because of their obsession with the "End of Times"?

My answer is that everything has a solution when you are obsessed enough to examine all possibilities in the utmost detail. For instance, try to search for their holy numbers. To the survivors, the downfall of their country represented such a super-catastrophe, that their thoughts were completely possessed by it.

They honored the tens of millions of dead through their buildings and code numbers. No detail could escape, least of all the number of years between the catastrophes. According to the numbers of the Maya, I could finally prove that the period between the two crashes is undeniably correct. This can be proven through mathematics, my dear readers, pure numbers. When there is a specific line of thinking behind identical manners of encoding, you come across incontestable proof. Every smart reader can recalculate this "tour de force." You don't need a brilliant mind. In the Maya Codices the number 365 is crucial. Further on and in other chapters I will prove that the Maya knew the exact period of the earth's orbit around the sun: 365.2422 days. However, since only the high priests were allowed to know this, it was kept as secret as possible. For this reason the figures after the decimal point were left out. Knowledge is power. This adage prevailed in ancient times as much as it does in the present.

Undeniable Evidence

Multiply the period between the crashes by 365. This amounts to: 11,520 x 365 = 4,204,800. For now, don't worry about the math because I have already done it extensively. Just read on. First of all you have to know that Venus is related to the Egyptian Zodiac. The Egyptians used a value of 576 days for the orbit of Venus. Those who have read my previous book already know this. To the Maya, Venus was exceptionally important. Armed with this lead, could I come closer to the solution, I wondered? The Maya actually give 584 days as the orbit of Venus before it returns to the same place in the sky. How can this be? The fact is that both numbers are right, but I will explain that in another chapter. I would like to note here, however, that Venus disappears for eight days behind the sun (576 + 8 = 584). How can I prove that the period between the crashes is exact? Because the number 4,204,800 equals the two most important numbers of the orbits of Venus, when multiplied with two important Mayan code numbers:

584 x 7,200 = 4,204,800
576 x 7,300 = 4,204,800

With this we see the first piece of irrefutable evidence. Without thinking hard, we are able to see the correlation. You don't even need to be able to count. I have recalculated these results many times. The correlation is indisputable. Even the staunchest critics cannot deny this. When you combine these Mayan facts with those of the Egyptians, you can unfold all their secrets. Who else could have designed such a complex system? Were these the distorted memories of their predecessors and their astronomical knowledge? Only by having all the facts at your disposal, can you figure out the underlying connections. Of course this is not all. The numbers 7,200 and 7,300 are extremely important Mayan code numbers when multiplied by a holy Mayan year of 260 days! But there is more. The deciphering of the Mayan calendars will show that the number 260 can be found on the basis of the precise synodic orbit of Venus. Later, you will find its accurate calculation. The same holds for an elementary unit of the sunspot cycle. Every 260 days the polar field completes 7.027027 revolutions, a code number that leads to the unveiling of the greatest Mayan secrets.

The preceding evidence shows the resourcefulness of the Maya. Their calendar of 260 days is based on a superior combination of advanced astronomy and mathematics. In other words, their calendar was not only a religious instrument, but at the same time a mathematical and technological miracle. Without any doubt, the deciphering of the codes shows 260 as the main code number of the present cycle. In this way the Maya interwove important messages into a simple and understandable system to make clear to us that Venus, in its previous cycle, was responsible for the main code. But right now we are in a different cycle that belongs to a different main code. Due to the fact that it is the magnetic field of the sun that decides when the earth's magnetic field will swing over, they have interwoven the new value in the calendar that ends in 2012:

$$1,898,000 = 7,300 \times 260$$
$$1,872,000 = 7,200 \times 260$$

The last Mayan number is incredibly important and is used as a countdown to the date of the forthcoming catastrophe! Their calendar started on August 11, 3114 BC. It ends on December 21, 2012; exactly 1,872,000 days later. According to the Maya and the Old Egyptians this is a fatal period in which the magnetic field of the sun will swing over again. At the same time, a wave of charged particles called solar wind, will force itself upon the earth. When it reaches our planet, it will cause the earth's magnetic field to crash and the earth's crust to slide. Exceptionally violent earthquakes, volcanic eruptions and all-demolishing tidal waves will result.

The number 1,872,000 wasn't just picked out at random. After having studied the theoretical sunspot cycle of the Maya for months, I achieved striking decipherments with this number, which made their code message only too clear: the End is near. The date of the disaster is unquestionably true, because too much mathematical and astronomical proof keeps piling up. First I just had scanty hints, but now it all built up into an overwhelming wave of facts. Of course this is due to the beauty of their software program.

Figure 27. On August 11, 3114 BC, the countdown of the Maya to 2012 began. The Street of the Dead pointed to the setting of the Pleiades.

If they had not used a similar logic with identical numbers to the Egyptians', I could never have broken their codes. I encountered incredibly often the numbers that lead to the period between the previous catastrophes and the forthcoming one. These numbers were at the core of their way of thinking. For this

reason I am confident enough to guarantee that their calculations were extremely accurate.

The deciphering of the first codes and clues in the genesis of Aha-Men-Ptah's history was soon followed by more. From then on it was quite easy to switch over to the Maya. A meticulous consolidation of the facts finally brought me the badly needed keys to settle this job. For instance, the Maya made a correlation between five Venusian years and eight terrestrial years. In their mind-frame this produces the following: 5 = 8. Using the right orbit of Venus I could retrieve the first Mayan codes. Then, in a tearing rush, I cracked the other Mayan codes. These calculations are described in detail at the end of this book. Reasoning through, I could finally decipher the Dresden Codex with the help of Venus. As you already know, Venus made a planetary retrograde loop above Orion during the year of the previous crash and will do so again in 2012. That is why they interwove Venus in their calculations in every possible way. Through this discovery I was able to correlate the Sothic cycle and the Mayan numbers.

These "Mathematical Celestial Combinations" are representative of a frame of mind that is different from ours. Albert Slosman's translations tell us that such combinations represent geometrical figures and movements in the sky: "Of moving lights in relation to fixed points." These combinations,

Figure 28. In the Mayan astronomy, the Pleiades play a leading part.

which depend solely on one law that creates the universe, bring about the cosmic harmony. Of course I can only agree with that, but it doesn't make the decoding work any easier. With mathematics you can prove almost anything. But you are on to something only if you stick strictly to using the same rules. After I had broken the first codes, in my previous book, I stuck to the same way of thinking. Only because of this could I further work out the points of coincidence between the Maya and the Egyptians and present the undeniable proof that they had an identical origin. All these rules were worked out in "The Double House of Life" a temple in Egypt and in a corresponding Mayan temple. These ancient schools with their "Holy Secrets" were the basic source of all the knowledge of both civilizations. They relied

therefore upon the calculations made by their ancestors in the "Circle of Gold" in Aha-Men-Ptah. These calculations resulted in the "Celestial Laws." These Laws remained with the survivors of the catastrophe. It was their decision, and again that of their progeny after them, as to whether they would continue to use such a gift and to what end it should be used, for good or bad.

The Priests of Aha-Men-Ptah in antiquity had fathomed many truths that they kept secret. They knew about the existence of cycles in the universe, as well as those that occurred on earth. After a cycle ended, another cycle began, which again gave life, but in another projection of space. This means that the earth is never the same, on the contrary, it is totally different from all previous periods. This also applies to all beings on earth, because our planet evolves with everything living on it, according to the rhythm of the sun and the movement of the twelve constellations of the Zodiac. These new combinations are formed day after day, second after second, and are influencing the future.

The Main Code of Venus

You have read before that $7,200 \times 584 = 4,204,800$. This reflects the number of days between the crashes. Although 584 days is only a rough estimate, it's a fairly accurate value for the orbit of Venus. Did the Maya know a more exact value? Of course they did. Their calculation of the average time that Venus needed to return to the same place was based upon their observations over a longer period, and resulted in 583.92 days. Could this number hold the solution to this millennia-old riddle, I wondered? It had to, because after multiplying this value by the "Holy Maya Number," I came to a most intriguing outcome: $7,200 \times 583.92 = 4,204,224$.

The complete decoding of the Dresden Codex lies behind these simple calculations.

If you take your pocket calculator and subtract this number from the larger one you will find the code number of Venus: $4,204,800 - 4,204,224 = 576$. This calculation undeniably proves the origin of the number 576. It was the main code number from the calculation that indicated the previous crash. Try to memorize this number, as the Egyptians and the Maya tend to base many of their calculations on it. Their complete method of coding is based on the following principle: honor the "Holy Numbers" by using them as much as possible. Once you are aware of this little secret, there is much to discover about these peoples and the reasons behind their methodology. "Atlantean thinking," that is what it all boils down to. By projecting your thoughts into their world, you can easily solve the riddles they pose. This is exactly how

I succeeded. By applying these principles I finally succeeded in deciphering the most important part of the Dresden Codex. It is through using the exact same puzzle solving methods that you find the number 260, the main code of the present cycle, referenced in the Codex. I will show you this evidence in Chapter 21, "The Maya Calendars Revealed."

What is important here is that this old culture used exact astronomical numbers in their mystical calculations. Many of their ideas reflected their knowledge of the fact that events occurring in the kingdom of heaven held great influence over them. The temples, magic objects, relics and religious scriptures later created in Egypt and Mexico generated an echo of their far-distant past. For the Egyptians, as well as for the Maya, heaven was the Kingdom of the Gods and the Hereafter. The temples and pyramids on earth were formed in a mirror image of the skies, representing the metaphysical structure of the supernatural.

Figure 29. Pictured here is the staircase-pyramid of Kukulcan with its 91 steps. On the side of the left staircase you see a wave-like shadow whose movement would have given the illusion that is was an enormous snake. On the ground, at the beginning of the staircase, there is a snake's head.

In Chichen Itza, for instance, there is a structure, built as a rectangular platform with two floors and having a cylinder-shaped tower erected on top of them. The tower has three windows, from which you can observe the southernmost and the northernmost setting points of Venus. Furthermore, one of the diagonals of the platform points in the direction of the sunset in

the dead of winter. Another diagonal points in the direction of the sunrise at the height of summer. More than 700 meters northeast of this structure stands the staircase-pyramid of Kukulcan, whose four flights of stairs point to the four directions of the wind, and each of the four flights has 91 steps. Four times 91 amounts to 364; add the common last step and you get 365, the solar year of the Maya. On the evening of the equinox, Kukulcan guarantees an impressive show. Esoteric triangular patterns of light and shadow appear in a dramatic manner, creating the illusion of an enormous snake slithering over the land then up the pyramid. Because the high priests were able to explain this as a cosmic event, they were highly respected and were afforded great political and social power. Of course they wanted to maintain their status and they could do so only by translating their scientific findings into code. When you begin to think like these ancient peoples, you will notice that their secrets hold the same curious sway over you as they did over them. Behind these secrets lies the compelling strength that defines the very structure of the temples and pyramids that they built.

The Definite Evidence Furnished

Of course there is much more behind all this. Take the number that the Maya used to indicate the earth's orbit around the sun: 365.242 days. Here you come to a crucial fact—modern science agrees that the value of the earth's orbit around the sun is 365.2422 days. You multiply both numbers by the period between the two crashes. Then add some very simple calculations according to the previously cracked pattern, and you again come across the Sothic cycle of the Egyptians! (The mathematical explanation can be found in the Appendix).

This discovery is excellent proof of the advanced science these ancient civilizations possessed. The best Egyptologists will be at a loss for words. Even they will have to admit, however reluctantly, that the Old Egyptians and the Maya were much more developed civilizations than they thought possible. Why? Because they knew the orbit of the earth around the sun as we know it today! But they disguised this by working with code numbers. The code meaning earth's orbit in years, is a useful tool you can use to break or discover other codes. For instance, you can use it in order to learn the super important numbers of Venus. Moreover, it will later become clear that the two numbers of Venus, 576 and 584, are essential in deciphering the Dresden Codex. The Maya inherited these numbers from their ancestors and used them in their own calculations. With much pleasure, I looked at this deciphering many times. One can compare the beauty of these

numbers with the beauty of a Strauss waltz. Once I was sure of the mathematical consistency, I tried to control my enthusiasm. Venus, as the calculations showed, was the key to almost all their mysteries.

Figure 30. Many illustrations of snakes in relation to the sun are to be found among the Old Egyptians.

I was indisputably right, but I still couldn't believe it. By taking literally the statements of the Maya, the Egyptians and the Atlanteans I had stumbled upon a manner of calculation within an orderly system. This discovery baffled me, but also set me on a wonderful series of further disclosures. I revealed with it a similar

system behind the pattern of thinking of these ancient giants of mathematics and science. When focusing on it, a magic world of numbers opens, full of unexpected but undeniable and strange similarities. This is unique. No mathematician whomsoever can deny this. They will have to admit that this coded mathematics is more beautiful than the dull number crunching we engage in.

With feelings of awe, many will contemplate the revelation of the Mayan codes as something almost supernatural. And it actually is. To make such calculations, you need genius scientists at your disposal. The ancient ones observed the cosmos with curiosity, and distilled laws, which were poured into specific numbers that formed a summary of a whole series of discoveries. If you don't know this, you will be dazzled at the sight of the Dresden Codex. The quantity of numbers and possibilities of combinations is huge. However, when you know where to look you can search according to the decrypted rules and—be assured—you'll succeed.

That brings us back to the myth of Atlantis. As we have already proved, it contains some key numbers that were designed in such a way that they allowed entry into the "science" of the polar catastrophes that tormented the earth regularly. It concerns an interwoven pattern of religion and advanced thinking. Only through tenacious effort was I able to crack the codes, so as to correlate the downfall of Atlantis, the shifting of the Zodiac and the sunspot cycle, as you will read in the following pages. You are dealing here with an anomaly. Such complicated encryptions do not belong here. They are too advanced for an ancient civilization, unless, of course, the science of this ancient civilization was extremely advanced. And I am talking here about highly civilized people who lived in a very distant past—the myths and numbers date back at least tens of thousands of years. This means you have to reach unavoidable conclusions, the most important of which is that the catastrophe of 21,312 BC really happened, as was described in the Annals. This will be shocking for many people, and yet this way of calculation is so exact that you can no longer disregard their coded messages.

So we can further conclude:

1) Our starting point is the existence of a connection between Venus and the period between the previous crashes. With this fact we stumble upon the similarities between the Sothic cycle of Egypt and the Mayan numbers. We have undeniably proved this by deduction.

2) The correlation between Mayan super-numbers and Sothic numbers will later be proven extensively. Several Mayan numbers are multiples of Sothic numbers multiplied by code numbers.

Using these code numbers I was able to decode the Mayan calendars and the Dresden Codex!

3) The Maya and the Egyptian way of calculation are both supported, undeniably, by the same series of numbers. For this reason the Maya and the Egyptians have the same origin, in this case Atlantis.

4) You discover the numbers they used for the countdown to the previous crash in the computer program set up to explain events leading to the crash in 2012. It confirms their mathematical way of working.

5) The Maya as well as the Egyptians knew exact astronomical numbers. This finding is the most shocking of it all. Through this knowledge they were able to perform extremely accurate predictions about planetary orbits thousands of years in advance of their actual occurrence. Because of this, they could also perform with incredible accuracy the calculation giving them the "End Date." We should therefore take their warnings more than seriously.

6) Anyone who still dares to say that this evidence is not incontestable doesn't understand their way of thinking. Numbers were the most important starting point in their world of thought, because they are universally accepted. In fact, today we apply an identical mode of calculation as the Maya—every four years we adjust our calendar with an extra day. This adjustment is a bit too gross. After 128 years we do not count an extra day and therefore there is no leap year!

If you think about it carefully, you will easily understand their way of calculation. They used it in all of their operations. In the case of a leap year it concerns one day. When you accumulate this over thousands of years, you get a large number of extra days. After a certain period they got, for instance, so many thousands or millions of days. To match this with other calendars they either subtracted "X" number of days, or they counted up "Y" number of days, until a similarity was reached. In the previous time period a great many numbers correlated with Venus. That is why the Maya and the Old Egyptians kept honoring Venus, and why I was eventually able to reveal so many of their codes.

For mathematicians: see Appendix.

6.
THE RISING OF THE SUN

The numbers we have discussed in the previous chapters disguise unprecedented human dramas and spectacular natural phenomena. Let me try to explain this to you. You are used to seeing the sun rise in the east. On March 21, the first day of spring, the sun is always in the same spot, in height as well as in latitude. The sun also rises at the same place on the horizon. It reaches its highest point at the same place. Starting with this fact, the ancient scientists calculated the precession of the Zodiac. So far everything is normal. But, had it always been like that? Had the sun always risen in the same spot? In old scriptures there are testimonies of catastrophes that made the earth "turn over." Nothing was the same after that. The next shocking sentence comes from the Egyptian Book of the Dead: "I have placed the sun on a new horizon."

While researching my previous book, this was one of the first codes I encountered. It can be explained as follows: after the slide of the earth's crust, the sun rose in a different place on the horizon. Keeping this in mind, everybody will understand this remarkable sentence. If you happen to live in Sweden, you know that in summer the sun hardly ever sets, and that the daylight shines brightly all day long—the famous midsummer-night sun. At the equator the story is quite different; there the sun "goes to sleep early" and sinks completely in a few minutes. Holidaymakers who visit exotic islands know this only too well. One moment there is bright daylight and the next there is sudden darkness, as if the End Times have struck as quickly as lightning. Imagine now that you are living in England when suddenly, the earth's crust slides and, in one big blow, your town is moved to tropical regions thousands of kilometers away. For anyone remaining alive, it will be clear to him or her that the sun will rise and set on a totally different plane. You don't have to be an astronomer to prove this. Just like in the tropics, the sun will rise from a different spot, will stand much higher in the sky, will shine brighter and will set much quicker.

Well, this is just part of the story. The fact is that Herodotus wrote an extremely intriguing side-note in his report on Egypt. It literally says that the Egyptians had assured him "that the sun rose twice where it is setting now." To date, scientists have ignored this highly remarkable statement. They simply detach themselves from it laconically. Many writers have searched in vain for

possible explanations. This famous excerpt in the second book of Herodotus continues to put the wisdom of commentators severely to the test. Of course you can always question the credibility of the priests and their statements. You have every right to do so. You can also doubt the accuracy of Herodotus' transcription. Still, this will not clear things up, because a Latin writer, Pomponius Mela, wrote in the first century: "In the authentic annals of the Egyptians one can read that the course of the stars has changed its direction four times, and that the sun set twice on the place where it is now rising." (*De situ orbis*; 9.8). Here Mela underlines what Herodotus wrote. Not only the sun but also the stars changed the direction of their course! When you think about this, it produces a new code. Instead of rising in the east, it rose in the west and vice versa.

The code of the Egyptians has, therefore, a twofold meaning. Not only was the height of the rising sun different, but so was the direction it was travelling in! In the Papyrus of Ipuwer it is stated: "The land is turning around like a potter's wheel." And the Papyrus of Harris points out: "If the South becomes the North, fire and water will ravage the earth while it is turning over." A catastrophe cannot be pictured more clearly. A remark of this kind proves that the magnetic field of the earth has reversed. Of course this begs further explanation.

East Becomes West

Everybody knows that the earth revolves around the sun. The sun doesn't move at all—the rotation of the earth causes its apparent movement. How is it possible that the sun should suddenly appear on the other side? Well, that is easy to explain, but first let's have another good look at the movement of the earth. The earth moves in the direction opposite to the rising sun. Practically speaking, this means that the movement goes counter-clockwise, from the west to the east. To illustrate this for yourself, you can make a large circular movement with your hand. You start at the point where the sun sets, and you will encounter the sun with your hand, from the right to the left. Stop reading and try it, because only then you will realize that by this simple mechanism the sun rises in the east and sets in the west. Now try to imagine the situation during the catastrophe. The poles reverse. And of course here lies the explanation of the mysterious quote of Herodotus. Because when the North Pole becomes the South Pole, it means that the interior of the earth is turning in the opposite direction! The external crust of course has to follow, and not without protest. Through the reversal, the land areas will collapse and titanic earthquakes and tidal waves

will torment the whole earth. Some continents will sink, while others will rise. You cannot imagine a worse nightmare. After the elements calm down, it will be evident in 2012 that the earth's rotation will have reversed to a clockwise rotation, from left to right. Now reverse the movement of your arm. Start where the sun rises at this moment and follow its movement, from left to right. Try to realize that after the catastrophe you are heading for the sunrise—because the earth is turning clockwise! This means that the sun will inevitably rise in the west and not in the east!

Figure 31. The world directions together with their corresponding colors, according to the Maya scientists.

It has already happened many times before, as proved by the pyramid texts translated by K. Piehl in his book *Inscriptions hiéroglyphiques* (page 65: L'ouest qui est à l'Occident): "The light source stopped living in the West. A new one now appears in the East." A bit further the text clarifies: "The West, that is to say, there where the sun sets." In bygone days this was the other way round. In Breasted's *Ancient Records of Egypt, Part III*, the inscriptions unmistakably explain the following: "Harakhte,

she rises in the West." Harakhte is the Egyptian name for the sun in the west. The astronomical facts in the tomb of Senmut, the architect of Queen Hatshepsut, prove that this is the correct translation. Not far from the Valley of the Kings, Hatshepsut built the world-famous temple, where her architect was depicted in the niches of the central corridor. His grave is situated at the north of the road that leads to the temple. The architectural composition of this temple is extremely impressive; it comprises a succession of terraces and elongated doorways, which are silhouetted beautifully against the vertical mountainside. A staircase leads to a terrace, which is closed off by a double portico. The northwest corner of the building is devoted to Anubis, the dog-headed god, who supervised mummification. He is depicted on the walls of the vestibule with twelve pillars. In the middle of the rear wall, a small, vaulted corridor led to the sanctuaries. There is a courtyard in a terrace on a higher level of the building, which has a square sun-altar facing north, which proves that the Egyptians were "sun worshippers."

Considering the main role of the sun during the catastrophic events which led to the reversal of the poles, this is quite logical; which brings us back to the grave of the architect of this building. The temple holds a well-kept secret from ancient times. Its ceiling contains a panel which shows the hemisphere of the southern sky. Nothing special, you might think, until you study this a bit more closely. The signs of the Zodiac and other star signs are not depicted, as you presently know them; you will see them instead in a reversed orientation. The group of Orion-Sirius takes up the center of the southern panel of the Senmut ceiling. Orion, however, is situated on the west side, instead of the east side of Sirius, like a mirror image.

This is sheer madness for astronomers. In *The Astronomical Ceiling Decoration in the Tomb of Senmut*, A. Pogo writes: "The orientation of the southern panel is such, that one who is lying in the tomb and wants to look at it, has to lift up his head and face the North, not the South." Other astronomers are baffled as well and wonder why the Egyptians did it. It seems completely illogical to them, because through the mirror-image orientation, Orion seems to move to the east, that is, in the wrong direction. However, Herodotus gave a plausible explanation, and, still, there is yet another. Orion was the most important star system for the Egyptians. Misplacing it would have meant blasphemy. Therefore we have to see the explanation in the light of their religion. All the events that occurred during the previous catastrophe have a special place. After the immense cataclysm, the poles reversed: south became north. This also means that east and west changed places. And here we have what inspired the architect.

By placing Orion in a reversed position, he showed that a pole reversal had occurred and that the directions of the wind had changed. He could not have been clearer. In the meantime, we have also learned that the pyramids of Gizeh were placed according to the constellation Orion. To everybody's astonishment they also form a mirror image from the sky! From my previous book, you know that Orion was the astronomical code position during the year of the previous reversal of the earth: Venus made a planetary retrograde loop above Orion. After that, heavy earthquakes and volcanic eruptions tormented Aha-Men-Ptah. This retrograde loop of Venus above Orion illustrates the reversal of the magnetic field of the earth. This annihilating punishment was an act of anger by Ptah, their almighty god, because they had disobeyed Him. In Politicus, Plato wrote: "In those times, an enormous extinction of animals will widely take place and only a small part of humankind will survive." Let this be a warning to everyone who does not believe in the powers of prediction of The Orion Prophecy.

In the Egyptian Book of the Dead it is mentioned that the code position of Venus above Orion during the previous cataclysm conveys a warning. When Venus comes to a similar position, the end will be close. In 2012 Venus will make the same movement, except that it will be a mirror image of the movements the planet made in the year Atlantis met its end. All those who do not believe this will be destroyed in the catastrophe. What Euripides wrote in Electra will happen to them: "The sun went backwards with the whip of its wrath, full of anger, rewarding the mortals with disasters." In Timaeus, Plato describes this even more poetically: "The earth will be captured by stormy winds. The waters of an immeasurable flood will overflow everything, while the earth makes all kinds of movements, wandering in all directions."

A reversal is not a good-natured phenomenon; let's make it clear. All civilizations in the world have myths and legends describing how horrible it was. The Chinese and the Hindus, as well as the Maya, have numerous other stories about devastating events on our planet. According to the Nordic Lapp's cosmogonist story, almost all human beings died when hurricanes and a huge tidal wave overpowered the world: "The very inner core of the earth was shaking. The upper layers of the earth had disappeared. Many people were buried and died. And Jubmel, the Lord of the Sky, sent his terrible anger in the shape of red, blue and green fire snakes. People covered their faces and children were screaming with fear." The wrathful god spoke: "I will turn the world upside down. I will see to it that the sea becomes a mountainous wall, which I will fling upon you, wicked children of the earth."

Such a description tells exactly what happened during the previous polar reversal: earthquakes, mountains that rose and sank, lightning, a wall of water, the sun that disappeared, and so on. These appalling events left a profound impression on the few survivors. They had been the desperate spectators, watching helplessly as immeasurable tides piled up and changed the earth into a huge battlefield. At the same time the sky showed an immense spectacle, stars and planets suddenly changing their courses. The moon and the sun moved with jerks.

Through the polar lights, radiating from the sunstorms, it looked as if the atmosphere was on fire. The reversal of the poles is so devastating and frightening, that, in short, the most indescribable fear is not horrible enough to compare with this nightmare. That is why there are so many written traditions throughout the whole world in which a world cataclysm is described.

Reversed Zodiacal Time Periods

We understand only too well that this kind of catastrophe is colossal. But what will be the actual consequences? How is it possible to describe scientifically the movement of the sun after every pole reversal? Not only did the sun rise in another direction, but also the earth reached another age! The latter can be said because the earth's crust, its topmost layer, will shift over the surface of the planet while its inner core will begin turning in the opposite direction. However complicated, it is still a logical conclusion. But how do you communicate this to your descendants? By what means can you explain this properly without causing confusion? And here we come across a masterpiece of this ancient cult of wisdom: the course of the Zodiac. It contains the only possible astronomical codes that describe or indicate accurately the several different changes that will be experienced. Here they are:

•In the first place, the Zodiac describes an exact period of time. The calendar of the Zodiac counts the years that the North Pole needs in order to complete a whole circle—25,920 in total. During this time, true North will move step by step through the different ages. This is universally valid and can be shared, in spite of a long time span. You can, for instance, state that in the year of that age the earth was hit by a catastrophe. You can lend it a prophetic implication. This will be the case for our purpose. Not because of its esoteric background, but indeed because of the scientific background for which it was designed.

•In the second place, the Zodiac is the indication of a change in the movement of the sun. Because the sun rose on the other side of the globe after the first disaster, it meant that the earth would now pass through the ages in reverse sequence.

This is completely understandable. Also, it sheds new light on the use of the Zodiac. Before the first cataclysm, the Zodiac went from the star sign Libra to Leo (Libra→Virgo→Leo). In Leo, the earth's surface changed drastically: landmasses sank below the sea, new islands arose, volcanoes erupted, and so on. After everything had quieted down, it seemed that a large turnabout in the precession had taken place: it now went the other way around! In other words, a certain mechanism in the interior of the earth had turned upside down. That made the movement go as follows: Leo→Virgo→Libra.

Before the cataclysm of 9792 BC the Zodiac travelled from Aquarius to Leo. It then stopped abruptly. The magnetic field of the earth again changed, the inner core began to rotate in the opposite direction and the Zodiac again appeared to have shifted direction. That's the movement we're still following now until 2012. The indications are overwhelming and at the same time imply a warning for us: it has happened many times before and it will take place again innumerable times.

•In the third place, the Zodiac contains an exact indication of the change of the precession. As you know from my previous book, the movement of the Zodiac was thoroughly disturbed after each previous disaster. Furthermore, I broke the codes included in this book with the help of the catastrophe of 21,312 BC. At that time the earth landed in another age through a sudden shift of 72 degrees. The calendar started again from that point!

The catastrophe of 9792 BC was the most profound in recorded history; thereafter the course of the Zodiac reversed—proof of a polar reversal. And yet, curiously enough, after much wandering, the earth came to a stop, in the same age, but a bit further on.

Before the cataclysm of 21,312 BC, Atlantis had been in Sagittarius for 720 years. In one blow, the earth was then catapulted forward to the age of Aquarius. The movement of the earth didn't reverse this time. Since there was only a sudden shift of ages, we know that the earth's core kept turning in the same direction. If it had reversed, the ages would have gone in the opposite direction, as after the first cataclysm. In Chart 1, you see in chronological order the different catastrophes that tormented the earth in the last 40,000 years, together with their respective influence on the movement of the Zodiac.

Into which age we shall be catapulted this time is just guesswork, but it is a mathematical certainty that it will entail a huge catastrophe. The longer the period between the crashes, the stronger will be the bottled-up forces and their discharge. For this reason the Zodiac was "sacred" to the Egyptians. It reminded them how the recurring catastrophes could affect the

CHART 1

Duration	Age	Cum. Duration of Cycles

The year: 35,712 BC. Founding of Aha-Men-Ptah (Atlantis).

864	Libra	864
2,592	Virgo	3,456
2,448	Leo	5,904

Cataclysm. The year: 29,808 BC. First polar reversal. The earth's axis started to turn in the opposite direction! East became west and vice versa!

1,440	Leo	1,440
2,592	Virgo	4,032
1,872	Libra	5,904
1,872	Scorpio	7,776
720	Sagittarius	8,496

Cataclysm. The year: 21,312 BC. The earth turned 72 degrees in the Zodiac in about half an hour! This is incredibly fast.
Remark: No polar reversal, just a rapid turning in the same direction.

576	Aquarius	576
2,016	Pisces	2,592
2,304	Aries	4,896
2,304	Taurus	7,200
1,872	Gemini	9,072
1,872	Cancer	10,944
576	Leo	11,520

Cataclysm. The year: 9792 BC. Second polar reversal.
Total years since the foundation of Atlantis: 5,904 + 8,496 + 11,520 = 25,920 = time of one precession cycle = end of Atlantis!

1,440	Leo	1,440
1,872	Cancer	3,312
1,872	Gemini	5,184
2,304	Taurus	7,488
2,304	Aries	9,792
2,012	Pisces	11,804

2012 = NEXT CATACLYSM

earth and specifically their civilization. They were happy when they reached a new age without destruction, and then honored their god Ptah with spectacular buildings. The many sphinxes of the ages of Taurus and Aries are overwhelming examples of this. The largest spiritual monument they left us—the Sphinx—also points to the previous catastrophe that completely destroyed their land of origin. Indeed, in 9792 BC, during the Age of the Lion, their fatherland, Aha-Men-Ptah, sank in one day and one night in the tempestuous waters, to be finally covered by ice. Nowadays, this long-lost civilization lies beneath tons of ice at the South Pole. That is why we never found their buildings, and why scientists doubt the stories going around on this subject. For the same reason they are laughing off the forthcoming catastrophe. However, should they study the scientific background of the Zodiac more closely, their skepticism would soon change into fear. Astronomy, and especially the sunspot cycle theory of the Maya and the Old Egyptians, would surely stupefy them. The knowledge of these ancient scientists is so great that it shames our present knowledge! In the following chapters I will get back to this issue more extensively, because it is a crucial element in my argument. It will then become possible to decipher a millennia-old message, from which they could exactly calculate the forthcoming catastrophe. Our ancestors warned us about it through coded messages. They knew which mechanisms were hiding behind the biggest atmospheric and earth changes. With unmatched accuracy they had followed and depicted the Zodiac, and calculated the date of the previous catastrophe, in order to secure their knowledge regarding this. Their descendants—the survivors of the super-catastrophe—are warning us through their myths and exact mathematical and astronomical formulas, informing us that it is now our turn. The earth will swing around the other way, and a huge tidal wave will destroy almost all life.

These pole reversals can be proved with the help of pyrogenic rock. Geological data show that reversals have taken place countless times in the past. Scientists still do not have the slightest idea about the mechanism that causes them. It is a riddle for them why the previous poles can be found in several places— for instance, a long time ago the central point of the North Pole lay in China and, at one point, in Madagascar. Solidified lava manifesting a reversed magnetism, hundreds to thousands of times stronger than the magnetic field of the earth, proves this. It also reveals the character of the powers that were active at that time, as extensive lava streams are to be found wherever reversed polarities can be detected.

The riddles that puzzle astronomers, geologists, physicians

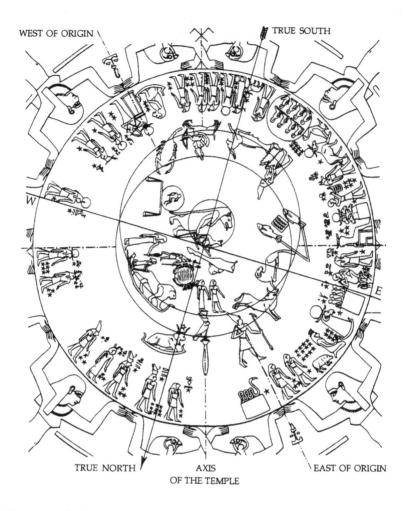

Figure 32. The Zodiac of Dendera proves more than clearly the astronomical knowledge of the Old Egyptians.

and others can be solved in one go by the catastrophe theories of the Old Egyptians and the Maya. They knew that when a beam of lightning hits a magnet, its poles reverse. Beams of lightning from the sun, or in more scientific terms, sunstorms, can also cause this phenomenon on the earth. After all, the earth is one big magnet. The moment the ionized particles from a sunstorm force their way into the poles, a gigantic short-circuit will occur. Just as with a normal magnet, the magnetic North Pole will change places with the magnetic South Pole. The earth will start turning round the other way with catastrophic consequences for mankind. Cooled-down magma with a reversed polarization already found

by geologists proves this abundantly. It is for this reason the Maya and the Old Egyptians were so afraid of this phenomenon. They knew that if the earth would short-circuit again, the core of the earth would reverse all at once. At the same time super earthquakes would shake the earth.

Everything—humans, animals, trees, buildings—would be smashed to bits. Parts of the earth would descend, and others would rise causing gushes and faults. Lava would stream from the cracked earth and exert its destructive affect on life. After that, the outer crust of the earth would break and move thousands of kilometers in just a couple of hours.

The stars would seemingly run away and the sky would collapse. Cyclones and hurricanes would rage on earth, bringing on massive destruction. Then through inertial forces, the seas would crash upon mainland after mainland, dragging along rocks, sand and sea animals. And then, while inhabitants try to escape, vast parts of land would glide away under the wild waters, carrying with it all the petrified people. The catastrophe would become bigger and bigger and the last survivors would try desperately to find a safe place. Yet, only a few would be granted survival, because the earth with its tilting lakes, subsiding lands, suffocating fires, raging volcanoes, slashing winds and super tidal waves, would destroy almost all remaining animals and human beings. At the same time the grand achievements of the present civilization would disappear completely. Houses, temples and libraries would be destroyed in a sea of water. Communications equipment would completely shut down, and food and energy supplies would be destroyed; in short, nothing would be left but massive wreckage. In just one day, some landmasses would end up with a polar climate, while areas currently having a polar climate would be catapulted toward much warmer climes.

Conclusion

This world cataclysm scenario, and only this one, is able to explain in one go tens of riddles concerning physics, biology, geology and so forth. It proves that the center of the poles can be situated in other places on earth, and explains why petrified remnants of tropical woods have been found at the South Pole; why twelve thousand years ago so many species like mammoths and sabre-toothed tigers became extinct; why large parts of Europe and the United States were under millions of tons of ice thousands of years ago; why frozen mammoths, with food still in their mouths, were found in Siberia; why skeletons of whales can be found in the Himalayas; why there are so many myths all around the world of a huge catastrophe that almost completely

destroyed humankind. In short: one theory answers many questions.

All these events and the messages from these ancient scientists give us testimonies and eyewitness reports of the repeated polar annihilations. But because the present scientists are so self-satisfied and arrogant, these ultra important historical facts are being ignored. Blind and deaf, our civilization will find its end. Anyone who's able to think logically will see where the "Holy Numbers" of the Egyptians come from.

In the coming chapters more shocking revelations await you. Deciphering the complete series of Mayan codes and the Egyptian Zodiac is possible, but only if you decipher these scientific masterpieces together. It's about time we respect these highly developed scientists for their knowledge. Then we can ring the alarm worldwide and try to help at least part of humankind to survive. That is my main endeavor. We will either encounter our Armageddon, or sow the seeds of the next civilization coming after us.

PART II

ATLANTEAN, EGYPTIAN
AND MAYAN CODES

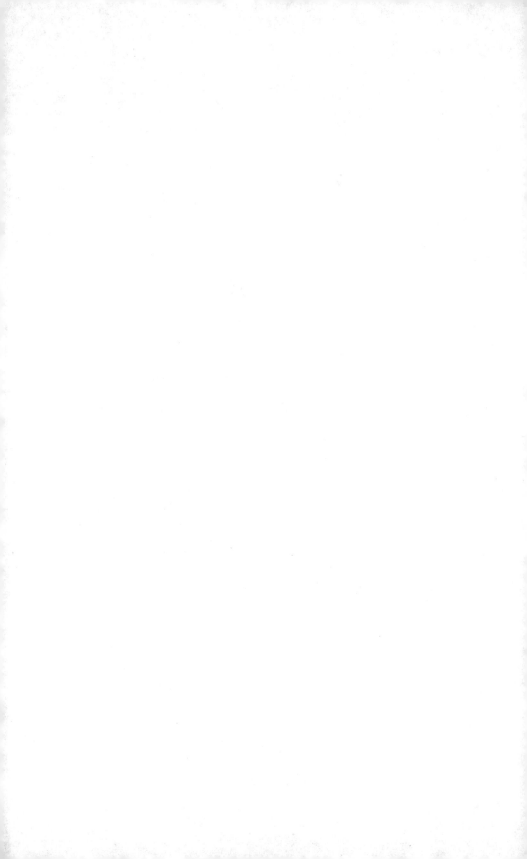

7.
THE SUNSPOT CYCLE THEORY

This chapter also appeared in *The Orion Prophecy*, however, I am repeating a part of it here, because it is necessary to understand the decoding of important numbers.

The Maya, as well as the Old Egyptians, were sun worshippers. Their entire culture was based on the sun. They had every reason for doing this, as the sun not only gives life but it also brings death.

Sunspots are remarkable. They are relatively cool areas on the sun's surface that appear dark only because the rest of the sun's surface is even hotter and therefore, burning brighter. Inside a spot, the temperature is slightly below 4,000 degrees; very hot indeed, though cool enough to make the spot look darker due to the contrasting environments. The lower temperature is caused by its strong magnetic field, which appears to be 10,000 times stronger than the magnetic field at the poles of the earth. This magnetism stops the upward-moving motions that, on other parts of the sun, transport energy to the surface. The result is that the area where the spot is located receives less energy and is therefore cooler than the surrounding area.

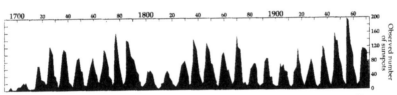

The (approximate) 11½-year sunspot cycle, from observation since 1680.

Figure 33. A graph of the number of sunspots since 1680.

A sunspot is a temporary phenomenon. The smallest spots only last a few hours to a few days. Bigger ones can last weeks to months. Some of them are even big enough to be seen with the naked eye. Sunspots appear and disappear according to a certain rhythm. At the start of the cycle, spots appear in the vicinity of the "poles" of the sun. During the cycle they appear closer to the "equator," and later, usually right before the end of the cycle, more of them appear around the poles. But the cycles do not happen regularly; there are ups and downs.

Spots occur in pairs. The components have opposite magnetic fields, as if there were a gigantic "horseshoe-magnet" on the sun's

surface. Obviously this is not the case. There are strong electric currents in the sun's interior causing the magnetic fields.

We know a lot less about the sunspot cycles than the Atlanteans. They studied them for thousands of years, applying a theory that no modern-day sun expert knows! On the basis of that theory they could accurately predict the behavior of the sun. As you can see in this book, the Maya and the Old Egyptians had extremely accurate knowledge regarding the time it takes the earth to make a revolution around the sun. With such incredible accuracy, you will have no trouble calculating the time it takes for a revolution of the sun's magnetic fields. Once you know that, you can unravel the cycle of the sunspots after a long search. That is how they did it, and that is how we will have to do it again. The problem is that we only have a limited amount of data. There is a possibility that this will not be enough to acquire the necessary theoretical knowledge to recalculate the predicted end date. In any case, I will start by showing how the Atlanteans accumulated their knowledge.

Earthshaking Theory

Astronomers and physicists still have no explanation for the sunspot cycle, but the priests that studied the "Mathematical Celestial Combinations" discovered a few phenomena. After very long periods of observation, they noticed that the sunspots moved across the equator in an average time of 26 days. Up toward the poles the average time becomes longer. They also discovered that the time required by the sunspots to move from one point to another varies with the sunspot cycle. When a sunspot minimum occurs, the spots are moving slower over the sun's surface. In contrast, during a maximum, the spots are moving faster. From their observations they propounded a theory. The main code was rediscovered in 1989 by the investigator Maurice Cotterell. He made use of round numbers for the magnetic fields of the sun: 26 days for the equatorial and 37 days for the polar field. Starting from these numbers, he found a magnetic sunspot cycle of 68,302 days in relation to the earth. This is thoroughly described in his book *The Mayan Prophecies*. He used differentials and a computer program, which he called "rotational differentiation." To simplify this matter, he used a comparison, which was based on a random indication of the magnetic fields of the sun and the earth with an intermediate period of 87.4545 days. This was chosen because the polar and equatorial fields of the sun complete a common cycle every 87.4545 days, and return to the starting point. He equated one of these common cycles with one bit.

Figure 34. The varying speeds of the magnetic fields of the sun: 26 days at the equator and 37 days at the poles.

The result was sensational: there was a clear rhythmical cycle in the long computer printout. It is necessary to emphasize here that no astronomer knows this theory! That is why nobody on earth is aware of the catastrophic effects of a complete swing-over of the magnetic field of the sun. I insist: no 'official' scientist knows this theory. That is why the warnings of the Maya and the Old Egyptians have to be taken very seriously. The fact that they were aware of this theory is earthshaking!

"Why?" you might ask. Well, there is no simple mathematical formula to calculate this cycle. I am aware now, thanks to papyruses more than 5,000 years old, that the Old Egyptians were capable of calculating extremely difficult mathematical problems. The Maya should have had the same capabilities. Just to give an example of a difficult problem the Old Egyptians could solve: calculate the volume and the surface area of a half sphere. This problem appears in the Papyrus of Rhind, which can be found in Moscow. Its age is estimated at 5,000 years, and it was copied from even older documents. When I looked at the problem, I lost my breath. It was not that simple! I needed my book of spatial mathematics to solve the problem. I even needed two hours to refresh my memory to understand the calculation once I read it!

This is further proof that the Old Egyptians knew a lot more than the Egyptologists are ready to admit. Furthermore, thanks to the breaking of the Dresden Codex and the Egyptian astronomical Zodiac, I found evidence that both the Egyptians and Maya knew the magnetic sunspot cycle theory. This is clear evidence that they could do the job, unconditional proof that they were both of similar origin, and that they had brilliant mathematicians and astronomers that were far superior to contemporary scientists. An example of this is the fact that the polar field of the sun is invisible from the earth. Only satellites in orbit around the sun are able to register it. The great mystery is: how did the Maya discover the speed of this field? And I have many other similar questions!

For both civilizations the magnetic sunspot cycle was central to their lives. This is not hard to believe when you realize that a giant solar storm, stemming from a culmination of the sunspot cycle, will switch the polar fields of the earth. The resulting catastrophe will kill billions of people, probably all of mankind, because of the destruction of nuclear power plants by enormous earthquakes. The earth will become one giant radioactive ball. These thoughts alone should make us aware of the urgency of digging up the Labyrinth, where all knowledge is buried.

Lost Knowledge and Rediscovered Codes

Many problems will find a solution in the secret rooms of the

labyrinth. Calculating the magnetic sunspot cycle is not easy and requires specific knowledge about the movement of the earth around the sun, integral mathematics and exact time measurement. The strange fact is that they possessed all these skills, but they had to be kept secret. Only the priests initiated in the sacred texts had the knowledge. For others, everything was shrouded in mystery. This does not facilitate our work. A certain code is hidden behind each number or character. Its interpretation requires extreme patience and tenacity. Without these qualities there would be no deciphering of the important encoded messages because of their complexity. It is interesting to know, however, that they always worked with the same "Holy Numbers." "Keep on trying" seems to be the message.

It is the only way to find the answers, as long as we do not possess the data from the labyrinth. If you calculate back and perform other mathematical calculations on the sunspot cycle, you will find many interesting encoded messages. Divide the Cotterell theoretical sunspot cycle by the turning periods of the magnetic fields of the sun. In that manner you will find the number of cycles that the magnetic fields go through in one cycle of 68,302 days or 187 years:

$$68,302 \div 26 = 2,627$$
$$68,302 \div 37 = 1,846$$

When subtracting these numbers, the number of times the equatorial field catches up with the polar field is found: 2,627 - 1,846 = 781. This leads to different connections. To calculate the moment one field catches up with the other, make the following easy calculation:

$$2,627 \div 781 = 3.36363636$$
$$1,846 \div 781 = 2.36363636$$

Explanation: when the polar field has travelled 2.3636 of a circle, the equatorial field catches up. The equatorial field has travelled one full circle, or 360 degrees, more. This happens after exactly 87.4545 days, and it is in accordance with the cycle calculated by Cotterell. It is amazing that in both fields the infinite number 0.36363636 occurs. Here lies the origin of 360 degrees:

1) When I learned mathematics I did not understand why a circle consists of 360 degrees and not 100. When staring at these numbers the property became clear: it originates in the calculation of the sunspot cycle!

2) Another decoding explained that the Old Egyptians and the Maya calculated the difference between the degrees that the fields travelled (360) and used it in the precession cycle, which

lasted 25,920 years (25,920 = 72 x 360). This proves without doubt the origin of 360 degrees!

3) After a cycle of 87.4545 days, a difference of 360 degrees occurs. Eight of these cycles form a 'mini cycle' in Cotterell's calculations. This results in the next number of degrees: 360 x 8 = 2,880. This number appears in different calculations. It is an essential part. Here you will find the origin of this number. Using the value of the respective times between previous cataclysms, it is possible to calculate the Sothic cycle, with the assistance of the number 2,880!

4) Later on, the infinite series 0.36363636 appears several times in the Dresden Codex and it will become a crucial code of Venus. It also turns out that this number is tied to calculations that are even more complex. Code numbers, multiplied by 36, give new combinations that lead to more revelations of the Dresden Codex and the Egyptian Zodiac.

8.
CATASTROPHES, SUNSTORMS
AND THE PRECESSION
OF THE ZODIAC

This chapter is extremely important. It shows an indisputable mathematical link between the sunspot cycle and the precession (shifting) of the zodiac. Where this leads us, you will read in a moment. But first you have to look at some brief mathematical calculations, nothing too difficult. You will face several remarkable numbers, which cannot be ignored. Before we start, you need to remember that each magnetic field of the sun has a different orbital speed. The rotation at the poles is slower than at the equator. The equatorial field rotates around its axis in 26 days and the polar field in 37 days. After 87.4545 days the faster equatorial field catches up with the polar field. In that period the equatorial field has traveled 3.363636 parts of a circle, and the polar field 2.363636. The difference is exactly one circle or 360 degrees.

"Not so hard," I guess you think. Fine, then I can go on. If you have read the chapter concerning the breaking of the code of the zodiac in *The Orion Prophecy*, then you should know that the earth shifts 3.33333 seconds in the zodiac each year. Now I will ask you to multiply that number by itself: $3.33333 \times 3.33333 = 11.11111$. This is the average duration of a sunspot cycle. Every 11 years the sunspot cycle goes up and down, from a high point to a low. Again, this is no coincidence. In later calculations I succeeded in breaking several codes with this number, which proved that my research was going well. When I multiplied this significant number by the number of rotation cycles of the magnetic fields of the sun, I found the following astonishing results, and I mean *really* astonishing:

$3.363636 \times 11.11111 = 37.37373737$
$2.363636 \times 11.11111 = 26.26262626$

In fact, the periods of the rotations appear once again, but in reverse compared to the number of circles traveled. Two infinite series of 37 and 26 are found.

Mathematically inclined readers will notice the following: this means that if you know the period of the magnetic field of the equator, you can calculate the speed of the polar field by means of the square of the precession number! And of course you can do the same the other way round.

It is an extraordinary mathematical connection, where coincidence is absolutely out of the question. It is part of a "Master Plan," a very sophisticated computer program, which defeats the most modern software in its beauty and complexity. You cannot ignore it. Just try to make something like this. This is your starting point: incorporate the two magnetic fields of the sun, which are the building blocks of the sunspot cycle, with their average period. If you asked this of an astronomer, he would look at you blankly and would not answer the question. It is even worse; he would not be able to give a mathematical model, because he does not know the formulas that the Maya and the Old Egyptians knew! These series of complex astronomical data are shocking. They prove unconditionally the intelligence of those who created these theories. Just as the discovery of the Rosetta stone induced the start of Egyptology, this way of decoding will cause a revolution in the knowledge of antiquity. It is a crucial link to the existence of our civilization. In a certain way these numbers belong to an esoteric numerology. As you can see for yourselves, these are essential numbers, which can be processed to find basic components. When those are processed in turn, they lead to the same numbers!

The relevant numbers are a metaphor for the pre-calculated catastrophic disaster that is going to ravage the earth. They are the intriguing climax of a search into the reasons for pole shifts, the falling down of skies, the destruction of land, animals and people. Brought together in an essential symbolism, an immense complexity of mythology, religion, science and mathematics, is hidden in their simplicity. It does not stop here. Apparently, the discovery that the equatorial field of the sun rotates in 26 days was easy to make. The rotation of the polar field was much harder to calculate due to its invisibility from the earth. That is why they hid in the precession number the secret code of the polar field. The proof is as follows:

$$11.11111 \times 3.3333 = 37.037037037037$$

An infinite series of 37 is found here. This is no coincidence. Once again, there are more connections that can be made between the shifting of the zodiac and the solar magnetism. If we succeed, we will have proof of the predicted and actual events that destroyed Atlantis. At the same time, we will gain more evidence of what is going to happen to us in 2012. The Atlanteans knew that a gigantic short-circuit in the sun causes enormous eruptions. The electromagnetic shock wave is so powerful that the earth's magnetic field will be blown away. After that takes place, the earth will begin to rotate in the opposite direction, reversing the

order of how we see the constellations in the zodiac! To describe this, the Atlanteans searched for a mathematical relation between these two phenomena. We shall reveal this together using the rotation cycles of the magnetic fields of the sun: 26 and 37 days. Then we will calculate the number of degrees each field travels in one day. Dividing the number of degrees of a circle by these numbers results in the following:

$360 \div 26 = 13.84615385$
$360 \div 37 = 9.729729730$

Now divide the precession cycle by these numbers:
$25,920 \div 13.84615385 = 1,872$
$25,920 \div 9.729729730 = 2,664$

Take a closer look at these numbers. The first one is already significant. For the Maya, 18,720 is a very important number. But 1,872 is also the shortest period in the Zodiac of the Egyptians! Besides, I encountered these numbers several times in calculations. The accuracy of such a simple calculation clears all remaining doubts. But, this is still not everything. Later on, the number 2,664 will be indicated as an essential code number in the Dresden Codex of the Maya. In other words, you can retrieve two Mayan code numbers by making a simple calculation using numbers from the Egyptian Zodiac! *This indicates that both civilizations must have had the same origin.* By digging deeper into these findings I was able to decode more important data. The omnipresence of the symbolic numbers used by the Maya and the Egyptians is no coincidence. It underlines a strange but understandable similarity. The numbers are the synthesis of a super-civilization that was confronted with the end of its time—mathematical gods who cleverly incorporated their mythology and knowledge into one big idea which became a source of disturbingly exact scientific knowledge. I caught my breath. What further discoveries were ahead of me? Finding the precession requires the knowledge of two points in a year where day and night are equal. Those would be 20 March and 22 September. Research indicates that the Maya and the Egyptians had this knowledge, because several temples were built at the point where the sun rose above horizon at the beginning of the spring.

And there lies the solution to the riddle I am trying to reveal. The precession cycle is a majestic machine of extraordinary complexity. Their knowledge of the cosmos had to be enormous, their math phenomenal. They knew that it takes 72 years before the sun shifts one degree over the ecliptic. This is a remarkably precise calculation according to the astronomers of today. Only

science of a mathematically and astronomically high standard can produce such accuracy. I wondered: could secret codes possibly be hidden behind these numbers? Did they initiate this encoding in the numbers found above? Was their heritage so brilliantly encoded that somebody with a scientific perspective could reduce their complex mathematical information to a more understandable model? Filled with awe, I started my calculations and soon it seemed that my hunch was correct:

1,872 = 72 circles of 26 days
2,664 = 72 circles of 37 days

I am quite sure that you were astonished to see the number 72. When it is multiplied by the periods of the solar polar and equatorial magnetic fields, the resulting numbers are the same as those that we discovered previously. These numbers appear so frequently that they cannot be ignored. We have therefore stumbled upon the essence. Without a single doubt, it is clear that the Egyptians deliberately incorporated these numbers into their calculations. Why? A thorough study of the text of Albert Slosman about the previous catastrophe gave me the answer on this burning question: Aha-Men-Ptah was shifted 72 degrees in the zodiac after the catastrophe!

This connection of important basic numbers in the sunspot cycle and the zodiac was created with a purpose. They are the mathematical answer to apocalyptic visions of volcanic eruptions, enormous earthquakes, ice ages, and a gigantic tidal wave—and therefore frighteningly realistic. What a brilliant solution, what unearthly logic, I whispered to myself. I could not really get enough of it. Was this a telepathic message through the mists of time? Something told me that this was indeed the case. There was a lot more to be found behind these numbers of the remote past. Would I be able to recall those memories? Could I break the codes encrypting forgotten messages from the past even more extensively? I looked at the numbers with renewed interest, and I was successful after a short intensive study (readers interested in mathematics can find the evidence in Part V). Subtract the number of the sunspot cycle (see previous chapter) from the calculated values:

1,872 - 1,846 = 26
2,664 - 2,627 = 37

What have we found? Here, we see a direct connection between solar magnetism and the shifting of the zodiac. Such science is extremely progressive. It exceeds the science we know today. Behind all this there is a helping hand that intends to warn us. Incredibly smart scientists were responsible for this. The reason

is that this connection is not random. There is a direct connection between dramatic time periods on earth. The precession cycle is closely connected with the beginning and the end of the ice ages. This has been known since the 1970s. The previously mentioned discoveries are the evidence that the Atlanteans had a higher level of knowledge, more than 12,000 years ago! They also discovered, just as the scientists of today, that there were several causes for the ice ages. They were confronted with this on 2 February 21,312 BC. The earth turned 72 degrees and the subtropical Aha-Men-Ptah (First Heart of God) was, in a few hours, shifted to partially cover what was—at that time—the North Pole. This tragedy was followed by a tidal wave. The survivors regrouped in what remained habitable of the continent and decided to create an astronomical center: the Circle of Gold. For thousands of years their best scientists studied the heavens. In 10,000 BC the Atlanteans were so certain of a correlation between the magnetic field of the sun and the resulting catastrophic occurrences on earth that they decided to start planning for an exodus, preparations for which took place over 208 years.

The Maya and the Egyptians, as descendants of the legendary Atlanteans, predict a similar but even more violent catastrophe on 21-22 December 2012. What did they calculate? After almost 12,000 years, there will be a gigantic reversal of the magnetic field of the sun! When that happens, unbelievable superflares will escape from the sun. Trillions of particles will reach the earth's poles and set them "in flames." Because of the continuous stream of electromagnetism, the magnetic field of the earth will become overcharged. Unknown electric forces will be generated. As the poles are filled with auroras from the falling particles, the inevitable will happen: the earth's inner electromagnetic field will get overcharged and will crash. Then, wham! The earth's magnetic field will reverse and our planet will start spinning the other way! Just like a dynamo that starts turning the other way, the North Pole will become the South Pole and vice versa! And our entire civilization will be destroyed!

I conclude that the Atlanteans discovered several relations between solar magnetism and the shifting of the zodiac. They are all extremely disturbing. Modern scientists know that the same phenomena will put the earth in terrible danger. To ignore these messages means suicide. Almost everyone will die during these events if precautions are not taken with utmost urgency! And to top it all off, the survivors will be without much of present day technology. There won't be any computers or machines to rely on to pick up the pieces and put life, as we've known it, back together.

9.
ORDER IN THE CHAOTIC MAGNETIC FIELDS OF THE SUN

Magnetism: the weirdest and least understood power of the universe. Its radiation is noticeable everywhere, even in the most secluded parts of immeasurable space. Everybody knows that a compass needle works as if a mysterious power pulled it to a certain spot. To many, this is an incomprehensible and perhaps scary fact. When we play with two magnets we also see things happening which we can only partly explain. Like poles push each other away and unlike ones attract each other. When you dredge some iron filings around the magnet, all kinds of lines will appear to illustrate the force fields. Furthermore, everybody knows that a dynamo creates electricity by the turning of magnets inside it. So far, I am sure that you have been able to follow this without any problem. I am also sure that most of you must have played with magnets and seen their enigmatic powers.

Now things get a bit more complicated. Just a few of you will know that oversize magnets are to be found in the universe: huge collapsing star systems that find their violent end in fierce convulsions—the so-called quasars. You can read the reason for this in my book *A New Space-Time Dimension*. But you don't need to reach that far to find apocalyptic visions that are correlated to magnetism. Cosmically close, but yet billions of kilometers away, a gigantic magnetic field is rotating. What could it be? Is it a pulsar or a collapsed star? No, of course not. But then, what is it? The answer is, our sun! A lot of you will be surprised and will ask the following questions: does our sun have a super magnetic field? How on earth is that possible? I thought it was weak! What exactly do you mean?

Well, dear readers, everything depends on how something is defined. According to scientists, the magnetic field of the earth is not so strong either. But when you think about this more intently, you will conclude that this point of departure is incorrect. Indeed, when you measure the force of the earth's magnetic field, it is not very impressive. However, when you look at its total size you will see figures that will flabbergast you, and you will realize it is a colossal structure.

The sun has two equally horrifying magnetic fields. Still, astronomers do not give credence to this fact and thus pay too little attention it, pretending that "cosmically seen, the magnetic fields of the sun are very weak." Of course this is a load of bunk.

If you zoom in closer to the sun, a super-impressive rotating field appears that is driven by the magnetic fields of the sun. Should you watch the field of the equator from a spaceship, you would be overwhelmed by the image on your retina. The equatorial field of the sun rotates around its own axis at the incredible speed of 7,000 kilometers per hour! And with it, cluttered masses of matter are dragged along. It is a gigantic, burning top, with solar flames tormenting its surface. If you projected the earth onto a small solar flame, you would only detect it as a tiny pinhead in all that violence. The magnetic powers of the sun are, to this extent, out of this world!

Magnetism and the Sunspot Cycle

Thousands of years ago, the predecessors of the Egyptians and the Maya discovered the powers of solar magnetism. They knew that grim events hide behind this phenomenon. Further research helped the ancient scientists discover that the rotating field of the sun winds itself like a coil, like a fight between competing powers. On one hand gravity tries to merge all matter, while on the other hand magnetic powers fight against this. For 11 years these competitive powers succeed in keeping in balance with each other, and live peacefully side-by-side. However, when instabilities start taking place, these forces are unleashed in a powerful manner. Impressive flames torment the surface of the sun at the highest peak of the sunspot cycle. This was the first element of the research. Furthermore, they saw that the speed of the equatorial field of the sun amounted to about 27 or 28 days, seen from the earth. On the sun itself it amounted to 26 days, but, because the earth turns around the sun, it is apparently 27 to 28 days. How were ancient peoples able to determine this? They figured it out using mathematics and the speed of the sunspots. When there is a solar peak at hand, darker areas appear upon the sun. At these places the magnetic field is disturbed, and as a result these areas are somewhat cooler than their surroundings. This lower temperature makes them look darker than the rest of the sun; in that way the ancient scientists could easily follow the speed of these "black areas." They scored with this a second victory on their path to more knowledge, for it was their assignment to find a mathematical connection between these cosmic events and the catastrophes that regularly afflicted the earth. But, more than that, they sought to calculate the next calamity in advance. But how? What was the physical background for the traumatizing eruptions that threatened the earth every so many thousand years?

When they looked at the sun, they saw a chaotic whole of spots, eruptions, flares, magnetic fields, entwining areas, etc. Where to

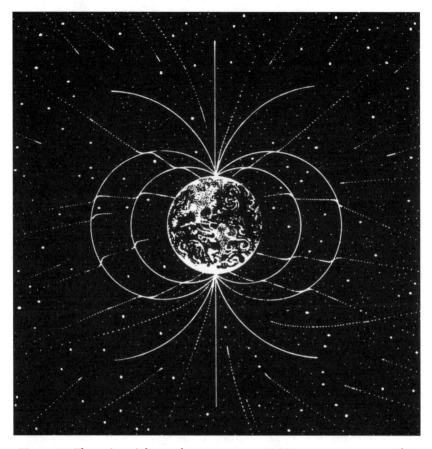

Figure 35. The poles of the earth reverse every 11,500 years on average. This means that the North Pole becomes the South Pole. At present, no scientist on this earth knows why this happens. At the same time researchers have no clue about the enormously destructive powers of this reversal. The fact of the matter is that, quite a long time ago a highly developed civilization ruled the earth and revealed the secrets behind the pole shifts. It is now up to us to rediscover this knowledge.

begin? Their knowledge of physics was extremely limited. They only knew a few basic concepts and they had no notion of the sun being an enormous nuclear heater, driven by fusion power. On the other hand, they were very good at mathematics and with that they had to find a solution. In the meantime they had solved a lot of other enigmas: the phases of the moon, the solar eclipses and the seasons. They could explain, for instance, the solar eclipses, by the fact that the geometrical positions of the earth, the sun and the moon were at that moment aligned. This is due to the regular manner in which these celestial bodies move around each other in defined trajectories. These things happened because of scientific patterns. But what about the sudden events on the

sun? What chain of causes lay behind these? By thinking logically, they knew that earthquakes were the result of the accumulation of tensions in the earth crust. Of course their knowledge on the subject had a lot of gaps, but they thought that this also applied to the sun. Somewhere, there had to be a natural cause, which, if only researched sufficiently, could be accurately described with the help of their mathematical knowledge.

Their faith became their driving force: every super-eruption on the sun was caused by a portending event. But, as they already knew, they had to describe a most complex network of influences that were closely correlated with each other, an utterly impossible task. What's more, a continuous interaction was taking place among the many different parts—a multitude of forces and fields. How could they find something useful in them? They saw immeasurable magnetic powers fighting and getting all jumbled together in a ball of solar lightning, storms and thunder, like an apocalyptic vision of the countdown to "doomsday." Where could they find the logic, the proposition that described this? The pressure of the authorities, however, was immense. Even when you can only understand a part of the total image, in principle there has to be a superior mechanism behind it all, something that rules all the other things. With the help of that mechanism, it had to be possible to predict the violent future of the sun and its repercussions on the earth.

As a result, these ancient Einsteins started to imagine a changing magnetic field around the sun—a geometrical order that, once it reached a crucial phase, would cause an obscure "short-circuit." The field would run wild then die a violent death in a super sunstorm. Shortly after this, it would reverse the earth's magnetic field resulting in a super catastrophe for all living beings on the planet. The high priests realized that the future hung by a thread, and was as fragile as the earth in the bursting violence of the sun. Therefore they had to find the answer to this imperative question: When will the rotating field of the sun decidedly change the cycle of life and death on earth?

Searching for the First Chaos Theory

After thousands of years of studying the sunspot cycle, they drew some important conclusions. They deduced the following:

•The speed of the sunspots increases a bit when the highest point of the cycle has been reached. So there must be a connection between the speed of the magnetic field and the sunspot cycle itself.

•The average speed of the equatorial field of the sun amounts to 26 days (seen from the earth: 27 to 28 days).

• At higher latitudes, the speed diminishes gradually. At 35 degrees from the equator, the average speed diminishes to 26.5 days. At 45 degrees it has further decreased to 26.9 days. Above this, it is quite difficult to ascertain the speed, because hardly any sunspots occur there! So it was impossible to measure further decreasing speed.

• After about 3,840 and 7,680 years, large (though not destructive) solar outbursts took place.

The theorists had to work this out, but what did they have to look for? What bizarre phenomenon was the basis for this? It was of the utmost importance to know when and under what circumstances the sun would violently strike out again.

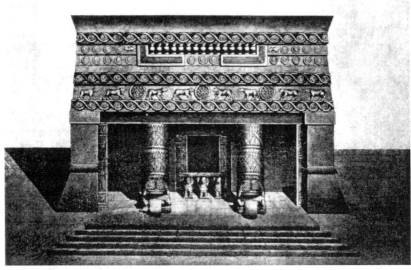

Figure 36. In the temples of Atlantis they diligently searched for the secrets of the pole shifts.

The answer led to a big revolution in the dawn of physics. They suspected that the sun supports its mass by using the immense gas pressure and the electromagnetic powers in its fuming entrails. Otherwise it would collapse. That was clear enough. Furthermore, on a small scale rapid disorganization could be seen, like turbulence and outbursts. Still, the sunspots remained stable, turning around steadily, undisturbed by the surrounding chaos. In other words, they were in a state of stable chaos. In the meantime the high priests were able to solve linear equations. But how could you describe stability in a chaotic whole? And how could chaos be generated by a regular behavior? It was an immense problem.

In the scientifically unmatched labyrinth of this highly evolved civilization, brilliant theorists were working. They started to find their way in this chaos. Mathematicians and physicists searched for the correlation between all different sorts of anomalies found on their earth. They observed the disorder of the atmosphere, the turbulence in the seas and other irregular elements of nature. From out of this disorder, they were able to create mathematical formulas that described complicated patterns while on the way to victory in their search. They saw rhythms in river waves that were competing with each other; waves absorbing each other, dividing surfaces and border layers. They saw turbulence and series of vortices, and understood that these were irregularities in a continuous stream. Because despite the chaotic patterns within, the rivers kept on flowing.

The Higher, the Slower

When they looked at the sun they saw the same chaotic patterns they had seen in the rivers: a linear stream becoming turbulent. And that was the solution to a riddle they had tried to solve for such a long time! For this reason, they started to think even harder about the change in the speed of the sun. Without any doubt this was the proof that the sun was not solid like the earth, where all points on the surface rotated at the same speed. For this reason, there had to be a rotating sphere in the center of the sun, which dragged along the surrounding layers of clouds. This power reaches a maximum in the center of the sun, where the rotating speed is consequently the fastest. The higher up from the center, the lesser this effect.

In such a pattern of turbulence and vortices, this conclusion is indeed quite easy to understand. Therefore, on the whole, this discovery had to be of decisive importance, a definite breakthrough in their thinking and search for order in the chaos. They had learned that simple systems like a river could show complex behavior, and that simple laws ruled complex systems. They gradually realized that chaos, long forgotten in a closet because it seemed too capricious, offered a new way to work on old facts. Now the time had come for them to make their presumptions in the search for things they could not see. Their best theorists knew that when they looked higher, the speed of the sun decreased. They had also observed that midway between the equator and the highest part of the sun, the sunspots abruptly disappeared and they couldn't be seen anymore! In what way was the speed evolving, they wondered? It was the biggest crisis they had ever met with, and it teased and tormented the outside edges of their knowledge of nature and what they perceived as supernatural.

Thoughts kept whirling through their heads. What power made the sun slow down at its poles? And to what point did it slow down? Was there a correlation with previous earthly events? With renewed courage they started to count. The average speed of the equatorial field of the sun amounted to 26 days. This was known. But what was the speed of the highest field of the sun they could not see? Advancing further at the known rate of decrease in speed, it had to amount to more than 30 days in any case. They could only guess how much more. For this reason they put their best mathematicians to work on this riddle. Maybe they could also find a correlation with the forthcoming super-storm. The fact is that a brilliant mathematician had found a possible connection between the magnetic fields of the sun and those of the earth. A simple comparison could probably describe this, but then one had to know the speed of the rotation of the highest field!

It is still a riddle for me how they finally solved this problem, but it will become clear in the next chapter that they succeeded.

10.
THE DRESDEN CODEX AND THE EGYPTIAN ZODIAC DECIPHERED

At the end of this book you will find the deciphering of the most important parts of the Dresden Codex of the Maya and the Egyptian Zodiac. Venus played the main role in the Mayan codes, which describe the movement of Venus during countless cycles. Furthermore, there is a correlation between five Venusian years and eight terrestrial years. According to the Maya they were equal. Researchers acknowledge this fact, but up to now they couldn't go beyond some suggested similarities. What would happen if we took this point of view literally, I wondered? Instead of some vague similarities, perhaps more precise numbers would show up? I had been able to break the primary codes of the Atlantean civilization that correlated with the numbers of Venus. Were they perhaps hiding something? Could they help me complete the long-searched-for decoding?

I started to work and to my astonishment I advanced quicker than I could ever have imagined! I broke the millennia-old codes as quick as lightning. The display of my calculator rapidly showed very exact figures, correlating to the orbit of the earth around the sun. And I mean exact figures—up to four figures after the decimal point! This means that 10,000 years ago, they were able to calculate these numbers with hardly any mistakes compared to our calculation. Their calculations were as accurate as that! When you decipher further, you can only conclude that they could calculate even more precisely. It is impossible to reach a more sensational conclusion! This result is bound to knock all astronomers and mathematicians from their pedestals. But I will tell you more about this in a separate chapter.

These calculations are the basis of the deciphering of the Dresden Codex. Without this discovery it would have been a hopeless case. By sticking to the same way of thinking, it is possible to find a fantastic number of codes. Mathematicians will have a splendid time with them. For those readers without a mathematical turn, I am willing to disclose that the all-prevailing main code concerns the sunspot cycle. After an extremely long calculation you will decipher this. It is difficult to estimate how much time the Maya spent on designing this phenomenal and outstanding astronomical masterpiece, it is so brilliant and complicated at the same time!

The shifting of the Zodiac was for the Egyptians the central

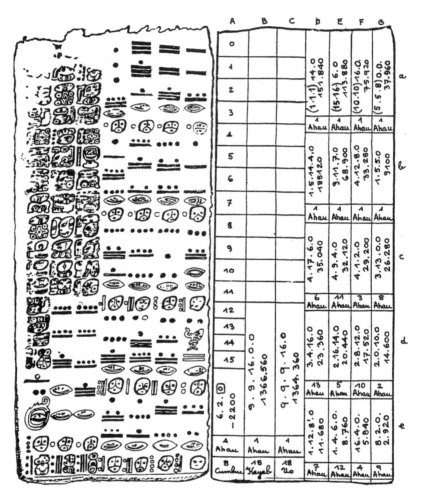

Figure 37. The Dresden Codex with its super-important numbers. Once deciphered, they point to a science far more advanced than ours!

point in their way of thinking. At first glance, these matters seem to concern something totally different. I say "seem" because, after studying the sunspot cycle so extensively, I soon suspected that it had been known by both civilizations knew of it. It is most remarkable where I found the key to this riddle. The Egyptians gave a different time period to the different ages of the Zodiac. I started to search systematically. After a year of intensive work, I finally succeeded in cracking the first simple codes. Although I was going fast, it would take me nearly two years to finish the job. We should keep in mind that hundreds of Egyptian and Maya codes are still hidden and waiting to be revealed. But well, you cannot do everything at once. My findings up to now were, in one word, shocking. The Mayan codices and the Egyptian Zodiac are both crown jewels of mathematical and astronomical mastery. Crown jewels of pure gold, inlaid with super-bright diamonds of the highest quality. When you see the groundwork behind their codes, you simply cannot deny it.

The Dresden Codex

In Figure 37, you see the part of the Dresden Codex that led me to reveal the biggest Mayan secrets. I had been looking for this codex for some time, and it fell into my hands by accident. I was at Gino's house one evening. Our discovery of the Labyrinth in Egypt was in the newspapers. Because of this, the observatory of Hove had contacted Gino asking him to give a course in archeo-astronomy. It was also mentioned that Antoon Vollemaere, a specialist on the Maya, would be giving a course on the Maya through this same organization. I immediately called him and sent him some information. After a few telephone conversations we made an appointment.

It appeared that Vollemaere had done research on the Maya for more than 10 years. He assured me that they were very highly evolved astronomers and that their knowledge is extremely underestimated. Of course, I could only agree with him. A couple of hours later I was convinced that this contact would give me very useful information. A few days later a photocopy of the Dresden Codex was in my mailbox, together with an explanation and all the interpretations that Vollemaere had found. More than curious, I started to read the papers, which at first glance seemed very, very complex. They contained a lot of numbers of Venus and drawings of Mayan gods. I studied 20 pages of the 74-page manuscript carefully. My head almost exploded with the information it contained. It would certainly take me years to calculate all the numbers behind the codes. For this reason, I decided to concentrate on the page copied here in Figure 37.

It contained a number that made Cotterell suspect that the Maya had already known about the sunspot cycle he had discovered. This photocopy is split in two parts. On the left you can see the Mayan method of calculation, together with hieroglyphs. On the right are the numbers transformed in our denary scale. I studied the whole in detail. I was absolutely convinced that the Maya knew our denary scale and that they used it, but very few were allowed to know it. Only the priests could use the scale to make their secret calculations of the position of the planets and the sunspot cycle. In that way they could bamboozle thousands of researchers, but not me! Now, where to begin? Which numbers were their long-lost secrets hiding behind?

The Secret Denary Scale

Here, I have to make an extremely important remark. The Maya did not use the same scale as we do. Numbers were indicated by lines and points.

The zero was noted as a sort of eye. They used points to write numbers one to four, and a line to write number five. Number six was a line with a point on top of it, and so on. When you look at the drawing you will understand it immediately. It is very logical. But, now comes the big "but." For numbers above 20 the Maya used multiples of 20. This was called the Uinal. Number 40 was indicated by two Uinals, 100 by five Uinals, and so on. From number 260 they called it Tonalamatl. So 300 is equal to 1 Tonalamatl + 2 Uinals. For higher numbers there are other different names.

Now, try to make a deciphering like those in previous chapters using this scale. After quite a long time, you will have to admit that it is a hopeless cause! However hard you try, it comes to nothing. And, to their astonishment, mathematicians too will have to admit that it's absolutely impossible to make a deciphering on the basis of such a notation! Of course this will have far-reaching consequences. We can decide from this that the Maya knew our denary scale and also used it in addition to this one. There is no other conclusion, and scientists will again have to acknowledge that the Maya were definitely far more intelligent than they thought possible up until now.

The Super-Code Cracked

My intuition told me that a super series of codes was hiding behind these two large numbers: 1,366,560 and 1,364,360. It was just a matter of finding them. This did not disturb me—I had gathered a lot of experience in breaking the codes, so it had to be something simple that would lead to a complicated decoding.

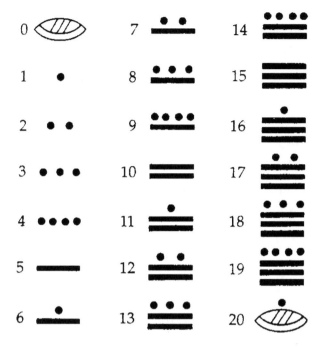

Figure 38. Mayan numbers.

I subtracted one number from the other and saw that this amounted to 2,200 (1,366,560 - 1,364,360 = 2,200). The identical number stood above it, though preceded by a minus. Using their way of thinking, this meant that this was a serious hint. Following this clue, I divided both numbers by 2,200. At first the outcome didn't mean much to me, but later I found that it fit easily into the whole. Therefore I decided to divide by 2,200 the number that Cotterell had found for the long sunspot cycle: 1,366,040 ÷ 2,200 = 620.92727. My heart instantly started to beat faster. I had seen this number in my earlier calculations. It is equal to an important value of the sunspot cycle. In the back of this book you can find the math. After finding this code, it was a piece of cake to break the second one.

Divide the largest number by 2,200: 1,366,560 ÷ 2,200 = 621.163636. Subtract the previous number and you will get: 0.2363636. When you multiply 0.2363636 by 10, the result is exactly the number of circles that the polar field of the sun needs to complete one cycle: 2.363636! If this doesn't amaze you, I'll be hanged!

I resumed my astonishing discovery trip with renewed energy.

The most surprising facts came up in rapid succession. Hours later I was totally amazed by my own findings and I couldn't go to sleep. I decided to continue working the whole night, and it became the most fruitful night during my research into Mayan secrets. In a continuous series of decipherings I could crack the Dresden Codex. I was so shocked that more than once it was very hard to continue. Several additional codes were often hiding behind just one number. But I grasped this after going ahead with hundreds of calculations that gave no satisfying result. Then, the moment I found the link a quick revelation appeared. This enormous progress in the deciphering proves that Maya codes were much more complicated and amazing than scientists admit nowadays. They unveil codes that are incredibly shocking, but also majestically beautiful. It is very clear that our knowledge of the Dresden Codex is patchy. Also, we still know very little of all the other things the Maya knew. This teaches us a lesson: our knowledge is simply a rediscovery of old values. But the most shocking fact is that the Dresden Codex indeed concerns the sunspot cycle, about which our present astronomers know nothing!

The panorama that my deciphering of the codes is unveiling shows a grim view of events that will spare very few human beings. Our lives and the continuity of mankind depend on these secrets being revealed. For most people the decipherings will seem too complicated, but they will surely understand its astonishing revelations. In scientific dissertations, a real deciphering has to contain a bit more than just a hunch. It has to be convincing and should be supported by consistent principles. Besides, the whole has to follow a certain predictive line of reasoning. Mathematicians have the greatest respect for theories that are developed on a strict mathematical basis. Well, this deciphering is such. It contains results and comparisons that enable further decoding. Anybody who can add, subtract, divide and multiply can confirm this. There's no need for more complicated operations. The numbers prove that the Maya knew and used our denary scale. Whoever studies carefully the decoding will have to admit it. And with this, we come to an esthetical, indestructible theory, simple and at the same time magically elegant. These extra properties will turn the scientific world upside down, and will consequently be widely accepted.

Shocking Proof

The Dresden Codex is without any doubt shocking. According to the present line of reasoning, the Maya could not have possibly known the theory of the sunspot cycle. They were not clever

enough for that, or so modern researchers say. But I am not expressing myself correctly here. Present day astronomers are indeed clever enough, and yet they do not know this theory! It was an amateur astronomer, Cotterell, who found it. With the aid of a not-too-difficult integral calculation, he came to a sensational conclusion in his comparisons of the sunspot cycle. When he found a clearly similar number in his lengthy calculations using the Dresden Codex, he started his quest. After years of research, he collected some evidence showing that the Maya must have known the sunspot cycle that he discovered. However, he couldn't produce decisive facts. Yet my decipherings offer the long-searched-for evidence. No mathematician or astronomer whosoever can put this aside, it is that convincing. So I urge everybody to accept this shocking proof as soon as possible. Only then can we start the necessary survival operations to secure the existence of mankind.

To draw up the sunspot cycle you need two important basic data. They are the orbits of the magnetic fields. At the equator the orbit is about 26 days and at the poles, 37. The orbit of the field of the equator can be calculated on the basis of the sunspots. If you follow the speed of a spot until it is back in its place, you will count 26 days. For this of course you need to know the orbit of the earth around the sun as well as space-geometry.

When I talked about this with professor Callebaut of the University of Antwerp (he is a world-renowned authority in the field of sunspot cycles) he told me that he was not irreverent of these ancient scientists, and he admitted they could have known this theory. He also admitted that he didn't know the sunspot theory, but that it looked quite promising.

After he had studied the theory, we had the following conversation:

Callebaut: "I understand that they were able to determine the orbit of the equator field, but they could not possibly have known the orbit of the polar fields! You need a satellite for that, and they didn't have one!"

Geryl: "What do you mean?"

Callebaut: "Sunspots don't appear until they are close to the equator. They don't occur in higher areas. Therefore it is impossible to determine the orbit of the sun at higher altitudes! Worst of all, from the earth you cannot even see the polar fields of the sun!"

Geryl: "Isn't there another possibility to determine the speed of the polar fields?"

Callebaut: "Not that I know of. I will send you an article I wrote with two Russian colleagues, which supports the theory of

the sunspot cycle. Perhaps it can help you."

During our conversation I noticed something that made me prick up my ears. Everything was easy to understand up to a certain point; then suddenly a shocking thing showed up: how could they have known the orbit of the polar field?

Two days later I found the article with the difficult name "Long-Term Variations of the Torsional Oscillations of the Sun" in my mailbox. The authors: Professor Dirk K. Callebaut, Valentine I. Makarov and Andrey G. Tlatov. I read this article more than once. It was published in "Solar Physics 170," 1997. The authors investigated the sunspots at different latitude degrees from 1915 until 1990. This showed that the sunspots at the equator take

Figure 39. A drawing that shows the limits of the visibility of sunspots on the sun. Sunspots appear at 45 degrees from the equator. Above this latitude they are not visible! How did the Maya know the orbit speed of the polar field of the sun, which is completely invisible from the earth?

approximately 25.75 days to turn completely around the sun. If you go further away from the equator, this rotation becomes a bit slower. At 40 degrees it is approximately 26.6 days. From 45 degrees upwards it rises to 27 days (the field moves 13.33 degrees per day). For higher degrees of latitude the professors do not have any information, because in that area sunspots are hardly seen or do not appear all!

It was simply impossible for them to determine the declining speed of the rotation of the sun! Again, the top researchers of the sunspot cycle are totally incapable of measuring from the earth the declining orbit of the sun in the higher regions!

More than Astonished

I was more than astonished; I was totally dazzled. This was a difficulty that I had not even thought of. Cotterell had built his theory on the basis of a satellite orbiting around the sun, which measured the orbit speed of the polar fields. But the Maya didn't have any equipment like a satellite. Therefore professor Callebaut had correctly questioned: "How did the Maya know that the polar

field needs 37 days to circle around the sun?" Were they counting back with the help of their theory? Was the sun in another place in those days, so that they could see the polar fields move? Or were there other factors? The answer will probably never be found. But that they did know is 10,000 percent certain as was discovered in the Dresden Codex. We need only guess how they did it.

The possibility of a backward calculation with the help of the theory should not be excluded. When you study the sunspots over thousands of years, you get exact astronomical numbers. You should be able to determine on that level alone the maximum and minimum of the cycle. And, as it appears from professor Callebaut's article, the field at the equator moves quicker when the sunspot cycle reaches its highest point. You don't need computers to ascertain this. You just have to follow the sunspots attentively; the whole Maya culture shows us that they did. All their numbers, calendars and buildings are based upon the principle of the sunspot cycle of 68,302 days, for which they chose the code number 68,328. Only the priests were allowed to know the real numbers. The non-initiated were kept in the dark—until the moment I stumbled upon their formula of calculation and could reveal the secret numbers. This shocking theory proves without any doubt the biggest mathematical and astronomical question of all time.

Astronomers need to research the sunspot cycle urgently, with the help of Cotterell's theory. Just like the Maya and the Old Egyptians, they should then be able to calculate the fatal date again. Then we will not only be certain of what is awaiting us, but we can also take the necessary measures to rescue mankind. The fatal date that the Maya gave us must be taken extremely seriously. Besides the fact that they worked with round Holy Numbers, they also knew with wild accuracy the number that nobody was allowed to know. When you understand this point of view, then you will succeed in decoding. You know and realize that they worked with essential numbers. But even more important is the explanation of the numbers. To crack the Dresden Codex, I had to use the number 27. Fortunately I had found its origin earlier.

Sirius, the Great Pyramid and the Number 27

In several calculations I had stumbled upon the number 27. At the beginning it didn't make sense to me. And yet, to the Masters of the Numbers and Measures, every number has a meaning. For more than a year I racked my brain over the number 27. I couldn't make heads nor tails of it. Later on it appeared very logical, but when you do not know, you search like mad. I finally found the solution in the book *The Atlas of the Universe* by Patrick Moore, I

read the following: "Not one group of sunspots can be observed for more than two weeks without an interval, because the sun rotates around its axis. As a result, a group of spots moves from one side of the solar disk to the opposite edge, a 'crossing' which in total lasts 13.5 days at the equator of the sun. Subsequently the groups remain invisible for 13.5 days at the backside of the sun, after which they return to the side where they started."

There seems to be a mistake here, because 13.5 x 2 = 27 and not 26. But because the earth is moving around the sun at a speed of 29.8 kilometers per second, it seems that, seen from our planet, the rotation of the sun's axis takes 27 days. There you are! And with that, I got a step closer to the revelation of the biggest riddle in the astronomy of ancient times. The number 27 was hidden in several calculations related to the sunspot cycle. But it had taken me more than a year to figure out this essential fact.

Of course there was a meaning behind all this. The ancient scientists did not do this just on a whim. Every important number hides several data. Not long thereafter, I saw a book at Gino's house. The authors had measured the pyramids of Gizeh and reproduced them with a construction software program. One of the most frequent angles appeared to be 27 degrees! On this basis you should be able to recover the codes. Just the essential ones, that was clear. But where did I have to look for them? Then a coincidence occurred. I read in an old book that Sirius makes an angle of 27 degrees with the North Star. Sirius, of course, was super-important to the Egyptians. I immediately started to investigate this. It had to be something simple. The pyramids are here as homage to the victims of the catastrophe—there had to be a relation to it.

Conclusions

1) The pyramids of Gizeh form a fantastic archeo-astronomical complex. The corners are hiding codes that lead to the solution of the riddle of the Egyptian civilization. You need for this the period between the two crashes. From there, you can get back all the important Egyptian numbers.

2) Through logical reasoning, you can calculate one thing on the basis of another. This shows an undeniable relation between the Maya and the Egyptians. They knew the secrets of Atlantis, as well as the Atlantean way of calculating what is to occur in 2012.

3) You can recover these numbers in many ways. This proves the remarkable brilliance of their software program. Contemporary computer programmers couldn't have made a better one. They must have worked on it for a very long time.

4) The angle of 27 degrees reveals a hidden clue to Sirius.

Sirius was extremely important to the Egyptians. After 1,461 years a new Sothic cycle started. The angle between Sirius and the North Star amounts to 27 degrees. Furthermore, Sirius differs by 27 degrees at the declination from its real position.

5) Sunspots appear at a 45-degree latitude from the equator. On the equator these spots need about 27 days to rotate completely around the sun. At the end of this book you will see that the number 27 shows up many more times.

6) The decoding of the sunspot cycle of the Maya is of essential importance! It plays a main role in many calculations. That is why I absolutely wanted to show you how I finally got to this. Thanks to this discovery I could uncover several more in-depth correlations. What I have shown here for this number, I could also show for another: 576.

Venus and the Riddle of the Number 576

One evening Gino, with whom I discovered the Labyrinth in Egypt, called me. I told him about my problems solving of the code of Venus: "I still do not understand how they were able to calculate exactly the synodic period of Venus."

"Oh," he answered, "it's not so difficult. Venus is clearly visible for a long time. When it is positioned at the east side of the sun, it is visible at night above the west. Venus then becomes a night star. It's so brilliant that it attracts everybody's attention. But when it is on the west side of the sun, then it is a morning star. In summer you can hardly see it. But as the morning star in November, December or January, it does catch everybody's eye."

"Didn't know that; I'm happy you told me. But what does that have to do with the orbit of Venus?"

"Venus appears 263 days as a morning star and 263 days as a night star. Furthermore, for 50 days it is not visible, and it disappears for eight days behind the sun."

"Wait—not so quick. I haven't noted it down yet!"

"I repeat: it is for 263 days a morning star, and for an equal time an evening star."

"That makes 526 days together, right Gino?"

"That is correct; and then it is not visible for 50 days."

I quickly added this number to the previous one. "But that makes 576 days!" I yelled into the phone.

"You're right! Why didn't I think of that before?"

"This mysterious number from the Zodiac is there to point out the code of Venus!"

"Without a doubt; it explains so much all at once."

I jumped with joy—this conversation had brought us a long, long way further in our search. In fact, without this

simple information I probably would never have succeeded in deciphering the Mayan codex. I could never have found the correlation between this number and the computer program of the previous crash. As you will probably remember, there was a difference of 576 days between the calculated value of the period of Venus' orbit and that of the earth. This remarkable difference put me on the track for further investigation along this line.

I will go through the points once again:

1) The number 576 stands for Venus and was used as a code number in the Egyptian Zodiac. In my previous book I could have proved this, but at that time I didn't know the meaning of this number. From a mathematical point of view, this proves a correspondence between the shifting of the Zodiac and Venus.

2) After 584 days, Venus is again positioned in the same spot in the sky where it hides behind the sun for eight days. The number series is clear. It shows the connection between Venus and the sun. In his book *The Mayan Prophecies* Cotterell had found a few such connections. I did not only confirm them, but also found additional ones. More data had to be found. It was just a matter of searching. So I found them! By using the number 576, I was able to decipher important codes from the Dresden Codex and the Egyptian Zodiac as well.

3) With the help of Venus, I could prove that the Maya knew incredibly accurate astronomical numbers. This is earth-shattering, because their precision is better than ours! Furthermore, I could prove with it the origin of the number 0.6666 (576 ÷ 864 = 0.6666).

4) When you look very closely at the two previous catastrophes in Chapter 6, you will see the number 576 twice. It is connected with the Zodiac. After the catastrophe of 21,312 BC, the earth remained in the sign of Aquarius for 576 years. Before the catastrophe of 9792 BC, it remained in the sign of Leo for 576 years. More than once, this code number of Venus has proved to be of utmost importance for this planet!

5) The difference between the real synodic orbit of Venus: 583.92 and 576 is 7.92. This is a code number in several different calculations, but then a hundred times bigger. This put me on the track for the deciphering of the Dresden Codex.

6) The Maya and the Egyptians used three calendar rounds. When you multiply these by 576 you get 1,728, which is an essential number to calculate decodings related to the precession cycle. It was one of the first codes I found that led me to explain the shifting of the Zodiac.

For mathematicians: see Appendix.

11.
COMMON CHARACTERISTICS
OF THE DRESDEN CODEX AND
THE EGYPTIAN ZODIAC

After studying all the decoded messages carefully, some similarities caught my eye. I found that Mayan numbers can be used to decipher ancient Egyptian codes and vice versa. Even more sensational was the fact that after consolidating all the code numbers, one decoding followed the other. I can only conclude from this that these masterpieces from ancient times complemented each other beautifully and formed one whole! The two most striking characteristics of these primal astronomical masterworks are the planet Venus and the sunspot cycle. This becomes clear when you go back to the events of almost twelve thousand years ago. According to Mayan tradition, a new sun shows up in the sky at the beginning of each new era. They named these eras after events that occurred under each of the successive suns, which were called: Sun of Water, Sun of Earthquake, Sun of Hurricane and Sun of Fire.

The first era was ended by water in which all but a few chosen beings had perished. They called it *Apachiohualizltli*, or Sun of Flood. Some claim that only one couple could escape death. Others say that seven couples were able to save their lives and that they re-populated the earth after the continual rainfalls. Next, in the era of the Sun of Earthquake the earth fell to pieces when it cracked in many places. Many existing mountains crumbled while other mountain chains appeared out of the blue. A horrifying, otherworldly storm put an end to the ruling era of the Sun of Hurricane. And finally, after a flood of blood and fire caused by the Sun of Fire, the survivors starved. In these four eras, fire, earthquakes, hurricanes and all-devouring inundation covered our planet and extinguished our race. The most important, common element of these global calamities was that the sun was responsible for the destruction of the earth. The Maya were convinced of this, and therefore based their faith on it.

In comparison, the holy book of the Buddhists also speaks of "World Cycles": "When a long period had passed since the rains stopped, a second sun appeared. In the meantime the world was wrapped in darkness." Their using the sun as an indication for successive epochs that collapsed in an overall destruction makes

much clear to us. Without any doubt they were telling us that an exterior change of our light source put an end to every cycle.

Ancient Myths and Obsessive Mathematics

Now, we also now have mathematical proof at hand for this conclusion. The Maya knew the formula of the sunspot cycle. With the help of this theory, they could make calculations about the behavior of our sun. Long before the actual event, they knew if intense solar activity was going to occur. From the expected intensity, they could calculate whether it would have any consequences for the earth. Their hang-up with numbers was quite obsessive, because they knew that many secrets of nature could be explained by using them. It was their conviction that when the original numbers of the events were rightly understood, it would be possible to calculate successfully the moment these events would occur.

Using the same pattern of thinking, I could keep up with their clever number game. The Maya were thinking rationally in their own manner, and converted everything into what became Holy Numbers. In their thought processes the same numbers explained everything. They knew the exact values, but hid these behind a whole series of codes. From then on, with the help of their Holy Numbers, the Maya as well as the Old Egyptians could retrieve the right numbers. For this reason we have to consider their calculations and old myths to be exact. They knew things that we still do not know. Their calculated date for the End of the Fifth Sun is undeniably correct, however incredible their science may appear to us. Therefore, we should take their prophecy about the End of Times very seriously.

The crown jewel of the Maya codes was their so-called "long calendar round," or "Long Count." It started thousands of years ago in the Age of the Gods on 4 Ahau 8 Cumkun: August 11th, 3114 BC. It will end after 1,872,000 days when the world is destroyed in the year Katun Ahau 13: December 21, 2012 AD. This encoded system demonstrates their ability to calculate long cycles, and it also gives them the ability to predict cycles of destruction and the creation that follows. From the beginning, they literally counted down the days to their fatal end. We already know that they had incredible accuracy and that their countdown is a coded system. According to the Mayan code system, a sunspot cycle equals 68,328 days; furthermore, a Mayan solar year lasts 365 days. When you calculate the period of a sunspot cycle using these data, it amounts to 187.2 years. And a multiple of that number—1,872,000—leads to the countdown to world destruction in 2012 AD! Why?

At the time I wrote my first book, I still hadn't broken the

final code. Now, three years later, after having studied for many months hundreds of thousands of bits of the sunspot cycle, I am able to answer the above question. The end will come as a thief in the night, at the height of a great sunspot cycle. You will read about that in one of the next chapters.

The easiest way to imagine their "Holy Count" is to envision a calculator that is counting up intertwined magnetic forces, again and again. And just when the crucial point has been reached, the calculator will destroy itself in one gigantic flash. By now, the colossal forces that will put an end to our civilization have already accumulated in the sun. In the remaining years, only a fraction of the forces already accumulated will be added.

The Aztecs, who supplanted the Maya, were also aware of the impending destruction of the earth. However, in the Aztec period the method for calculating the end fell into oblivion. Due to the lack of essential information, they sacrificed humans in the belief that through performing rituals they would be able to postpone the forthcoming catastrophe. They fed the sun god Tonatiuh with the blood of their sacrificed prisoners. Tonatiuh was depicted with a wrinkled face and an eager tongue showing his hunger for hearts and blood. By feeding him regularly, they believed they could keep him alive. The same conviction, that the sun god could be placated through sacrifice, was shared by all the large civilizations in Mesoamerica. Such beliefs were contrary to the knowledge of the Maya, who had *calculated* the end date to occur in the Fifth Sun era. Their whole culture and all their holy numbers revolved around this event. Using their sunspot cycle theory, they calculated the moment an intense outburst of energy from the sun would, all at once, finish the ruling civilizations of earth.

The Relation with Venus

Venus, the second planet of our solar system, is related to this. How? What logical relation could there be between the end events and Venus? A so-called Venus cult had the maturity of a technically advanced, albeit unidentified, civilization. A lot of information has been lost, yet you can infer a lot of things by thinking logically and doing some research. All nations of Central America ascribe huge symbolic importance to this planet. The Egyptians, too, understood that Venus was a "morning star" as well as an "evening star."

When decoding their Zodiac you come across the number 576 that symbolizes Venus. This number allows us to decode an astonishing series of things, bequeathing us with an immeasurable inheritance, most of which has been lost in the mists of time.

Thus, a very long time ago events had taken place that connected Venus with previously occurring disturbances on the sun. But what mysterious events could these have been? What was so miraculous that caused such turmoil in the minds of the priests? Why were they including some sort of relation with Venus in their predictive astronomical science? What terrible memories of the destructive tidal wave could be related to this? The solution had to be evident somewhere. I started to think logically, trying to reconstruct the millennia-old events. It is known that Venus has a thick layer of clouds. Maybe this had something to do with it?

During the previous catastrophe the sun spat out innumerable amounts of electromagnetic particles. Auroras set our atmosphere alight. "That is it!" zoomed through my head. Just like that of earth, the atmosphere of Venus was set alight! Only the effects on Venus were more intense, because of its close proximity to the sun, and the particles hitting it were many times more concentrated than what reached the earth. Old scriptures declare that a "second sun" appeared in the starry skies. But there was more. When the sunstorm reached Venus, its power hadn't diminished. From Venus' uppermost atmospheric layers, gas-like substances were ripped off and lit by a sort of "Celestial Bengal Hell Fire," forming a magnificently illuminated comet tail. Very ancient Mexican scriptures describe these phenomena. First, they say, Quetzalcoatl, a snake-like celestial body, attacked the sun; thereafter the sun refused to appear for several days. The world was robbed of light. Countless met their death while this disaster raged on earth. Then the snake-like body changed into a star. It appeared for the first time in the east and kept the name Quetzalcoatl, the name for the planet now known as Venus.

In Velikovsky's *Worlds in Collision* you read the following: "Then appeared a big star. She was named Quetzalcoatl. The sky, to show her wrath made a huge number of people perish; they died of hunger and pestilence." A bit further on you read: "It was then that the people, again calculated the days, nights and hours." It is quite peculiar that time is measured from the moment of the appearance of the morning star. Tlahuizcalpanteuctli or "morning star," appeared for the first time just after the earth had been swept by tidal waves and experienced convulsions.

You can derive from the following text from *Worlds in Collision* the fact that the presence of Venus in the sky caught everybody's eye in the sky. It proves that a sunstorm can greatly change the face of a planet like Venus enormously. The planet looked like a monstrous snake. "This snake is decorated with feathers: therefore she will be named Quetzalcoatl. One sees her appearance the moment the world starts to resurrect from the chaos of the big

world cataclysm." The plumage of the snake-body represented red-hot flames.

The birth of the morning star was a widely popular motif in the popular legends of eastern and western nations. Time and time again the image appears in the same way. A burning star interrupted the visible movement of the sun, and became a morning-evening star, and caused a world-fire. In Babylon the morning-evening star was called Ishtar, the "Star of Lamentations." The following is from Langdon, *Sumerian and Babylonian Psalms*, 1909:

> Because I make the heavens tremble and the earth shake,
> For the glow that illuminates the sky,
> For the flames of fire that rain upon the hostile country, I am Ishtar.
> Ishtar I am, because of the light that rises in the sky.
> Ishtar, the celestial queen I am, because of the light that rises in the sky
> That is my fame.
> I conquer the mountains completely
> That is my fame.

In Polynesia, until recently, people were still sacrificed to the morning star Venus. Boys and girls were sacrificed to the Arabic morning star, the celestial queen "al-Uzza," until modern times. Such faith in the destructive powers of this planet could not have been invented without reason. This "Second Star" made the earth tilt, harassed it with fire, boosted the wind to destructive speeds and made the water rise to catastrophic heights. In short, Venus was a very vivid image that remained in the minds of those who survived the catastrophe. That is why the Atlanteans and their descendants converted the numbers of Venus into codes and included them in their calculations! After the sun, Venus was the most eye-catching celestial body in the starry sky of those days. When the forthcoming catastrophe occurs, Venus will shine again and will be a painful reminder of myths related by almost all nations of the world.

The discovery of the link between Venus and the catastrophe irrefutably explains a lot of things. It logically confirms my findings related to the Egyptian Zodiac, the Egyptian Book of the Dead and the Dresden Codex of the Maya. The complexity of the Mayan calendars can also be derived from it. Those that created the advanced Mayan calendars had discovered a means to integrate the movement of Venus with the orbits of other planets. From these calculations it appeared that the Maya were aware of the fact that Venus required an average of 583.92 days to

reappear in the same place. With the help of these special numbers I was able to decode the Dresden Codex. Add to that another remarkable fact, that they had also interwoven the holy Mayan year—the Tzolkin of 260 days—with Venus' movement. Further investigation made it clear that 260 was an essential number in the sunspot cycle theory.

In fact, we are looking here at mathematical relations between Venus and the sunspot cycle. But these are not the only relations that exist. Venus also makes retrograde movements, forming loops in the sky. In 2012 Venus will make a perfect loop above Orion, one of the reasons my previous book was titled *The Orion Prophecy*. A peculiar fact, however, is that this retrograde movement of Venus is mentioned in the Book of the Dead as the code of the reversal of the magnetic field of the earth. However, the Old Egyptians were not the only ones who relied only on this. Dorsey, in his book *The Pawnee Mythology*, states the following:

> The elder ones tell us that the morning star said that when the moon became red, people would know of the forthcoming end of the world.
>
> Furthermore, the morning star said that at the beginning of all things, she had put the Northern Star in the north, and that at the beginning of all things she would allow the Southern Star to come a bit closer—once in a while—to watch the Northern Star and see whether she was still in the north. Should she still be there, she would have to return to her place.
>
> The order to end all things will be given by the Northern Star, and the Southern Star will execute it. When the End Time dawns, new stars will fall again upon the earth.

In the story of the Pawnee Indians you recognize the retrograde movement of Venus. It follows a whole circle. Venus was therefore thought to be capable of reversing the position of the South Pole and the North Pole by making this planetary loop. Similar to many other nations, the Pawnees believed that the future destruction depends on the planet Venus. At the end, the North Pole and South Pole will change places. It is clear from their actions that they took this very seriously. When Venus rose shining very brightly, or in years when a comet was in the sky, a human was sacrificed. It happened as follows: The hair of a girl taken prisoner was dyed red by her guard. His face and hair were also dyed red and in his hair he wore a fan-shaped headdress of twelve eagle feathers, because the morning star appeared like that in their visions. Four

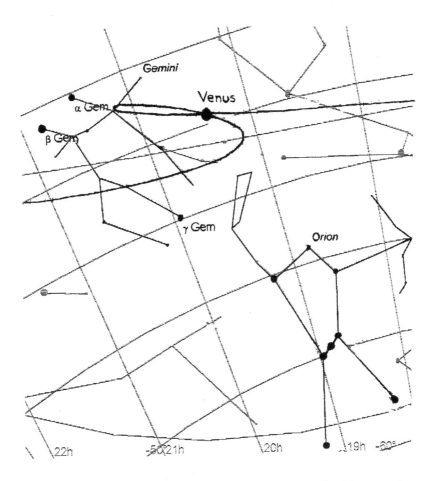

Figure 40. In 9792 BC, the year of the previous catastrophe, Venus made a retrograde planetary loop behind Gemini above Orion.

stakes served as scaffolding, and were placed in the direction of the wind. Then, through the stakes the morning star was ordered to stay upright "so that Thou will always carry the skies." At the moment the morning star appeared, two men stepped forward holding burning sticks. The men cut the girl's chest open and tore out her heart, after which four bundles of burning sticks were put on the northeast, northwest, southeast and southwest sides of the scaffolding to set it on fire.

Since we know now the relation between Venus and the world cataclysm of almost twelve thousand years ago, the meaning of these ceremonies becomes clear. Venus is a link between the deadly gyrations that hit the earth before and those that will hit it again. The directions of the wind will reverse and a period

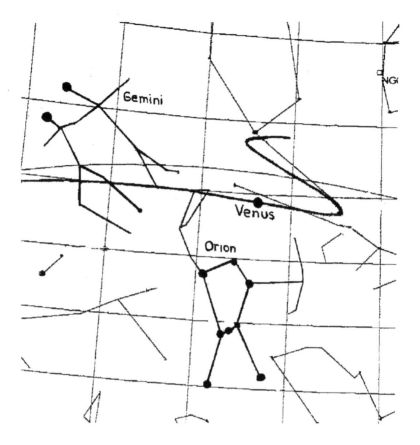

Figure 41. In 2012 Venus will make a retrograde planetary loop above Orion, portending a pole reversal on earth.

of darkness will torment the skies. From then on Venus will herald a new era. By means of old scriptures and the rest of the astronomical remnants of the Old Egyptians and the Maya, one can retrieve a whole bunch of elementary data. The mathematical relations prove the old myths, and the old myths in turn prove to us what happened. I was able to conclude that my working hypothesis was painfully exact. The Old Egyptians and the Maya share common characteristics related to the catastrophe that is going to hit us:

•The Mayan codes mainly concern Venus. In the Egyptian Zodiac the number of Venus is hidden and used many times. The deciphering shows this quite clearly. In my previous book, Gino and I discovered that Venus gives the main code for the reversal of the magnetic field of the sun. In the year of the previous crash, 9792 BC, Venus made a planetary loop during several months

behind Gemini on the left side above Orion. In 2012 Venus will make a similar movement, but this time exactly above Orion, and the earth will start turning the other way round after the reversal of the poles. This discovery proves that this is not coincidental, but indeed a brilliant processing of common codes.

•Both civilizations incorporated the sunspot cycle in their calculations. In the Egyptian ones, this was more difficult to decipher than in the Mayan ones. The Zodiac and the precessional eras were more important to the Egyptians. After researching for a very long time I finally succeeded in proving that the sunspot cycle theory was hidden in their astronomical Zodiac. The calculations that will convince you of the Egyptian way of encoding are at the end of this book.

•Before deciphering the sunspot cycle that is hidden in the Dresden Codex, you must have all the essential Egyptian decipherings at your disposal. These prove the origin of the codes. The sunspot cycle concerns the magnetic fields of the sun and the sunstorms, while the Egyptian Zodiac shows their consequences for earth.

• Additional deciphering shows that the precession of the zodiac is also hidden in the Mayan sunspot cycle. When the magnetic field of the sun changes, the influence on earth is catastrophic. As you know from my previous book, the earth landed in another age of the Zodiac after each cataclysm! And with that our circle of evidence is complete.

Conclusion

In the year 2012 AD the magnetic field of the sun will change. A catastrophic sunstorm will hit the earth, resulting in the reversal of the earth's magnetic poles, after which the rotation of our planet will reverse. Furthermore, the earth will be catapulted into another age. The code of Venus correlates with this moment in time. For several months, Venus will make an apparent retrograde movement above Orion. With their prior calculations and clever encoding of this event, the Maya as well as the Old Egyptians proved their advanced knowledge!

12.
666—THE NUMBER OF THE BEAST

In his book *The Supergods*, Maurice Cotterell puts the temple of Palenque under severe scrutiny. He asks countless questions such as:

•Why does the temple have nine floors, but only five staircases? It would have been much easier to make shorter stairs.

•Why did the second staircase have twenty-two steps?

•Why did the temple have 620 inscriptions?

Through his familiarity with the sunspot cycle, he started to research the temple in a new way. After a very thorough study he found a logical unity. The temple with its artifacts was constructed in such a way that we would, out of curiosity, ask questions and it would give us encoded messages, all pointing to the sunspot cycle. So far this is logical proof of his earlier theory, which proposed that the sunspot cycle was not only universally valid, but also known to the Maya in the way he had calculated it. But further research produced an unexpected and sensational result.

He had initially reconstructed a number series. He found, for example, five objects. Then he encountered five double signs, five signs of objects that showed the number three, and so on, up to five signs of subjects with nine as the basic number. The list was complete, except for the fact that the three objects for the number six were missing: 666, the number of the beast. This intrigued him extremely, but he couldn't find a solution. The Bible contains a strange story that refers to this number. It predicts a coming apocalypse and total destruction. Nobody knows what this refers to, because it seems so strange and mysterious. Chapter 13 of the Book of the Revelation tells about a beast rising from the sea. It has seven heads and ten horns and on its head can be read the message: "Here is wisdom, let he who has knowledge count the number of the Beast, for it is the number of a man and his number is 666."

Almost everybody knows about this number and that it is related to the end of times. Complete series of books have been written about it, with all kinds of possible interpretations. To date, nobody has succeeded in finding any plausible clues as to its meaning. Intrigued, I read this chapter over and over. We do not know much about this part of the Bible; how it came about or the person who wrote it—all we know is that this story of the Apocalypse was written by a Jewish Christian who called himself

John. The meaning of the word "Apocalypse" is "revelation." The Book of Revelations was written between 56 and 95 BC on the island of Patmos, off Turkey. In his preface, John says that God gave the Apocalypse to him through an angel. Quoting from the book, "And I saw an angel that spoke in loud voice: 'Who is worthy to open the book?' And no man in heaven or earth was able to open the book, least of all have a glimpse at it." But there wasn't a barrier for John. He was allowed to look at it. But he did not have to read it. He saw everything happening before his eyes. It becomes really interesting at the opening of the sixth seal. This concerns the pulse of the universe.

According to John, "stars fell on the earth" and "heaven behaved like a papyrus that was rolled up." Before the opening of the seventh seal, there was a short silence and a change in the chronological events. As if in a movie, John was moved forward and backward in time between heaven and earth. The "servants" of God, the 144,000 members of the 12 tribes of Israel, were marked by a "seal" on their foreheads. This would protect them during the forecast Judgment of God. After opening the seventh seal, there is a delay for some reason. John tells us the following: "There was a silence in heaven of approximately half an hour." Then starts a whole series of surrealistic events. Seven successive trumpets come first, representing the number of opened seals. With the first sound of the trumpet, the earth is bombarded with hail and fire, mixed with blood. A third of the planet burns. The second trumpet changes a third of the oceans into blood. A third of organic life is wiped out and a third of all ships destroyed. Together with the sound of the third trumpet, a "star" falls on the earth, poisoning a third of the rivers and lakes. The fourth trumpet announces the partial extinction of the light of the sun and the moon. The fifth opens an abyss in the earth from which strange animals with human heads emerge. At the sound of the sixth trumpet, four angels are released leading a cavalry of two million. They have colored shields and horses with lion heads. They have to see to it that through several plagues, a third of mankind will perish. During this slaughter, so says John, the rest of humankind refuses to give up their gods, made of gold and silver, which "cannot see, nor hear nor talk."

Again there is an interlude before the sound of the seventh trumpet. During this period John receives a papyrus from an angel, which is known in "the earth and the sea," who orders him to eat it. It will taste sweet in his mouth, but bitter in his stomach, the angel assures him. The moral lesson is that the fruits of materialism are not worthwhile, but form a bitter pill to swallow. Thereupon, John was given a measuring rod and was asked to

measure God's Temple and count the number of churchgoers. Furthermore he was told that two witnesses, symbolized by two olive trees and two lamps, would launch their prophecies on earth during 1,260 days, together with plagues and the changing of water into blood. These, however, would be beaten by the Beast of the abyss. Then the famous words follow: "Here is wisdom, let he who has knowledge count the number of the Beast, for it is the number of a man and his number is 666." Before going deeper into this, I will first continue with John's story.

Christ appears before him, together with the 144,000 chosen ones. Angels make several announcements, emphasizing that the churches have to be populated in the honor of God, warning the ones that are marked with the sign of the Beast. Seven angels bring seven plagues in the last hours of humankind. The fourth and the fifth are the most important ones. They say that the sun will scorch human beings with its beams, after which a period of darkness will follow on earth.

After reading this, I started to look for possible links. The story contained elements of a polar shift and the number of the Beast was connected to it. And then, slowly, I began to see the light. Without doubt, the number 666 was supported by several sources. The Egyptians and the Maya knew it. There was also a connection with the sunspot cycle. So, it had to be the basis of the forthcoming destruction of the earth. Another remarkable fact is that the number seven is mentioned 54 times in total in John's story about the Apocalypse. The number 54 is an important code number in deciphering the Dresden Codex, and it is also directly connected with the Egyptian Zodiac. Not a negligible clue. The book consists of 22 chapters, which is the main code number to decode the Dresden Codex. "What could this mean, I wondered?" In the meantime, I had made long calculations of Mayan numbers, which could conceivably put me on the right track.

Again I read the chapter on the number 666 in Cotterell's book. But this time I took a better look at the numbers in his scheme. Five times the number one, five times the number two, five times three up to five times nine. Only the multiples of the number six were missing. This was an almost incomprehensible and utterly difficult starting point. Once more I went over the points, reading the questions that Cotterell had written down and trying to find any possible connections. He had been able to give a place to some numbers, and his decoding revealed the sunspot cycle. But he had not solved one of them: why did the second staircase have twenty-two steps? I knew the answer, because you need this number to decipher the Dresden Codex. Then my eye caught something that was possibly hiding a solution. It concerned nine series of five.

The pyramid also had nine floors and five staircases. Something important was hidden here. Multiplying five by nine you get 45. I had noticed this number before, but where? I started to look quickly at my calculations. There it was! In a sunspot cycle of 187 years there are five deviating cycles that contain nine bits, a total of 45 bits (9 x 5)! All other cycles contained eight bits, a super important number for the Old Egyptians. So far, so good. Now it was a matter of finding a mathematical relation between these deviating cycles and the number 666. Everything is exposed in codes. Probably there was a relation with the rest of the important numbers of the Dresden Codex I had deciphered. I took my calculator and decided to gamble on some guesses to unveil the riddle.

Three numbers are important for deciphering the Codex: 2,664, 1,872 and 1,944. These numbers also relate to the Egyptian Zodiac. And let's not forget: these numbers form multiples of 36. After some reflection, I was able to make the connection between the numbers I needed to decipher the Mayan codex and the precession cycle, the sunspot cycle and the number 666. A couple of minutes later I approached with rapid strides the solution of a riddle more than 1,000 years old.

Subtract the three numbers above from the total precession cycle and divide by 36:

$$25,920 - 2,664 = 23,256 \div 36 = 646$$
$$25,920 - 1,872 = 24,048 \div 36 = 668$$
$$25,920 - 1,944 = 23,976 \div 36 = 666 = \text{number of the beast!}$$
$$668 - 646 = 22 = \text{solution Dresden Codex!}$$

Now I was a hundred percent sure that the number 666 was an indicator of the end of the world. When you look carefully at what I have deciphered, you can follow my line of reasoning. 25,920 is the number of years that the earth needs to complete a whole Zodiac cycle. From the book *Le Grand Cataclysme* we learned that this could never happen, because in the meantime a catastrophe will take place, through which the earth will find itself in a new age and the cycle of the zodiac will have to start over again because everything in the sky, from the view of the earth, will have changed position. The three code numbers of the Dresden Codex relate to this because you have to subtract them from the precession cycle. When you divide the result by 36, you find essential numbers because the three code numbers of the Codex also have to be divided by 36 in order to find the code behind it. And in this way you come across the number of the Beast.

In the Mayan pattern of reasoning the number 666 disturbs the movement of the earth in the Zodiac. So far, I could not imagine

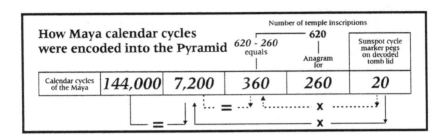

	1	1	1	1	1
	Pearl in seashell	Female skeleton in antechamber	Single long bead on necklace	Single long bead on necklace	Single long bead on necklace
	2	**2**	**2**	**2**	**2**
	Holes in paving slab	Holes in paving slab	Holes in paving slab	Holes in paving slab	Plaster heads on tomb floor
	3	**3**	**3**	**3**	**3**
	Clay plates in stone chest	Red shells in stone chest	-sided tomb door	Jade beads (1 in each hand, 1 in mouth)	-tiered jade necklace
	4	**4**	**4**	**4**	**4**
	Steps down into tomb	Jade rings on left hand	Jade rings on right hand	Sets of holes in paving slab	Cylindrical plugs in sarcophagus
	5	**5**	**5**	**5**	**5**
	Pyramid stairway landings	Temple doorways	Male skeletons	Ceiling beams	Sarcophagus sides
	6	**6**	missing **6**	missing **6**	missing **6**
	Temple pillars	Sides to tomb lid	+	+	+
	missing **7**	**7**	**7** =13	**7** =13	**7** =13
	+	Necklace beads	Necklace beads	Necklace beads	Necklace beads
	8 =15	**8**	**8**	**8**	**8**
	Necklace beads ●●● ▬▬	Dash-dot beads ●●● ▬▬	Dash-dot beads ●●● ▬▬	Dash-dot beads ●●● ▬▬	Dash-dot beads ●●● ▬▬
	9	**9**	**9**	**9**	**9 / 9***
	Bottom steps of pyramid	Pyramid levels	Top steps of pyramid	Lords painted on tomb walls	Codes on left / right sides of lid

Decoding the clues of the Pyramid and Temple of Inscriptions

Decoding in relation to calendar cycles used by the Maya	9 x 144,000 +	9 x 7,200 +	9 x 360 +	9 x 260 +	9 x 20

$$= 1,366,560 \text{ days}$$

Figure 42. 9 x 5 = 45 = number of deviating bits in a sunspot cycle.

better proof of this. Without hesitation I divided 666 by 22 (= the main code in deciphering the Dresden Codex) which resulted in 30.272727. There had to be a connection building logically with my decoding of the Codex. The five deviating cycles of nine bits occurred to me. The solution had to be found there. From my decoding of the Dresden Codex I knew that a bit of 87.4545 days correlated with 3.363636 circles of the equator's field of the sun.

I multiplied 3.363636 by 9, which amounted to 30.272727. There it was! My long-sought-after solution!

This appears to be a deviation in the sunspot cycle! Further decoding proves it, so it does not merit further discussion. After the deciphering, I drew the following conclusions:

1. The number 666 stands for a deviation in the sunspot cycle. This causes important changes in the sun.

2. This deviation is also responsible for the reversal of the magnetic field of the sun. This deviation will cause an enormous sunstorm in 2012.

3. By indicating that we have to decipher the background of the number 666, the ancient scientists told us what is ahead of us!

4. Number of the beast = 666 = deviation cycle = enormous sunstorm = reversal of the magnetic field of the earth = super catastrophe!

666—the Number of the Prophecy
Incorporated in the Temple of the Sun

Again I found in this decoding the traces left by the cult of a long-lost civilization. They based themselves on Holy Numbers that they used again and again in their way of calculation. For thousands of years the secret science behind this was passed on to future generations. Thereafter it got lost for long dark centuries. But because of their remarkable method of working, I was able to revive the traces of this technically advanced civilization, wrapped in a shroud of prophecies, of esoteric and age-old codes. My thoughts turned to the way of reasoning of these pyramid builders. If the number 666 was hiding in the temple of Palenque, then it should also be found in other places. All their actions were, after all, based on the sunspot cycle. Other archeological proof could not fail to appear. I was more and more attracted by this possibility. Where else was the number 666 hiding in the buildings that mean an immeasurable inheritance of prophecy for us? It could be incorporated anywhere. The Maya were so incredibly clever that they raised their message to a higher level than the civilization that gave them this knowledge. With it they inherited memories of terrifying earthquakes, falling stars, a bright

burning sun and a destructive tidal wave. They interwove all of this in their magical buildings with the urgent message: "It has happened before and it will happen many more times again."

With renewed courage and interest I started to nose through earlier works. There had to be another connection somewhere. In Velikovsky's *Worlds in Collision* we read that the old annals say: "In this age everything was destroyed by a rain of fire coming from the sky and the surging of lava." The symbol of the present era is the Sun God himself. The Maya knew that the sun had already proceeded far in its cycle and that it was almost dead. Its features are wrinkled by age and its tongue sticks out eagerly in its hunger for blood and hearts. The number 666 plays a large part in this. Through this deviation in the sunspot cycle, the cycles of the sun are shifting. A total magnetic field reversal is awaiting us. When will this catastrophe take place? At the exact moment when all deviating cycles have pushed the sun's magnetic fields to its maximum. According to the old masters this corresponds to December 21, 2012 AD.

Their temples and pyramids are not products of superstitious minds, but designs of extremely skillful architecture. And through this basic principle I was able to find another connection with the number 666. In Teotihuacan stands a huge building, which is the Pyramid of the Sun. This pyramid contains a direct allusion to the sun and its hidden deviating cycles. During both the vernal and autumnal equinoctial points, exactly at noon, the south-to-north shining sun causes a phenomenon: a completely straight shadow gradually disappears over one of the lower floors of the west face. And now comes the fantastic thing! The passage of the shadow into complete light takes exactly 66.6 seconds! This provides an undeniable relation with the number 666. The Maya used our time chronology of 86,400 seconds. This enabled them to assimilate the number 666 in their design. To carry out this masterly example of scientific thinking, you need an incredibly large amount of astronomical and geodetic knowledge. Once more the visionary masters of ancient science baffle us. It is an example of a powerful and permanent myth from primeval times, a memory of a horrifying global disaster.

This architectural vision survived thousands of years, as well as the mathematical codes hiding in it. The unimaginably precise mathematical relation between the sun and its deviating cycles is a good example of that. This re-discovery of data from the dawn of our civilization should make us humble. In those times pioneers knew and performed things of which we don't have any knowledge. But their scientific findings are now forcing themselves upon us like echoes in our dreams. And our dreams

Figure 43. The tower of Palenque, located close to the Temple of Palenque. How many more secrets are hiding in it?

are leading to a non-stop approach of a world disaster. After a certain number of deviating cycles, the most catastrophic disaster in the history of mankind will take place.

Suddenly, I had a thought. Five deviating cycles symbolized by the number 666 appear in a sunspot cycle of 187.2 years. Dividing 187.2 by 5 results in the average period between these deviations: $187.5 \div 5 = 37.44$ years. Multiplying this number by 100 results in a well-known Mayan number! Again I had found an essential code. When I divided the period between the previous and the coming crash by this number, it amounted roughly to a total of 315 deviating cycles.

Logical Conclusions

These results show where the Maya got their essential numbers. They are based on approximate "Holy Numbers." Those who carefully study the decoding of the Dresden Codex in the back of this book will quickly recognize the importance of the values found. This particular way of calculation forms the essence of their thinking pattern. They liked to play with numbers, and preferably always with the same ones. On this basis they could get certain outcomes, which approximated reality very closely. After a couple of other calculations they could come closer and closer to the real value, until they achieved the most incredible accuracy. A phenomenal example of that is the period of a solar year, which they accurately calculated to a countless amount of figures after the decimal point (see Chapter 14)! Of course a lot more of these codes are hiding behind their way of calculation.

While I am writing this, my mind is racing. One flash of intuition can make the difference between further deciphering or getting stuck, a feeling I knew well by now! I have to stop thinking for months, until I can approach the challenge again using a fresh perspective. I find out all of a sudden how to continue with the breaking of the codes and go on to solve many riddles. And this time it will happen too. And it will be shocking enough, as it will lead us to the predicted end of times. After having finished my book, I had another eye-opener. I will mention it here, but I will come back to it in my next book: $666 = 315 + 351$ (315 is an anagram for 351)

You have seen earlier that the sunspot cycle contains 315 deviations of nine bits between the previous and the coming catastrophe. In other decipherings I found the important number 351, which led to important findings in the Dresden Codex. The numbers 315 and 351 are anagrams for each other, meaning that they have the same figures arranged in a different way. Numerous essential calculations are examples of this. It forms a unique part

of their little game with numbers. With the help of the number 351, I had now succeeded in calculating the exact number of days between the previous and the coming crash. We can conclude here that there is a significant relation between these numbers. I originally intended to include the explanation in this book. But it is quite complex and a rather long story, so it will have to wait.

Epilogue

You will find further evidence for a polar shift in the last chapter of the Apocalypse of John. He described in it the New Jerusalem, the holy city of God, after the Last Judgment. The city is a perfect cube whose foundations are decorated with twelve precious and semi-precious stones. In fact these stones are the same jewels that the high priests were wearing when God gave them the specifications of the Tabernacle, during the Exodus with Moses. The plastron (torso body armor) was carried on top of a colorful garment. The stones on the plastron represent the twelve tribes of Israel, but were associated with the twelve signs of the Zodiac. The twelve stones and their corresponding zodiacal signs are the following:

1. Amethyst (Aries)
2. Aquamarine (Taurus)
3. Chrysoprase (Gemini)
4. Topaz (Cancer)
5. Beryl (Leo)
6. Chrysolite (Virgo)
7. Sardius (Libra)
8. Sardonyx (Scorpio)
9. Emerald (Sagittarius)
10. Chalcedony (Capricorn)
11. Sapphire (Aquarius)
12. Jasper (Pisces)

And now we arrive at a shocking conclusion, because in John's list the stones are mentioned in *reversed* order. Another special proof of a pole shift, because after the reversal of 9792 BC the Zodiac moved in the opposite direction!

Summary

By incorporating the number 666 in their buildings, the Maya taught us the principle that would destroy our civilization. Besides this, we stumbled upon other numbers the Maya were using. They created a masterpiece that is based on their inheritance from a superior civilization that once ruled the earth. With the help

of their incredibly accurate calculations, the earlier high priests could predict the following: the universe will fall apart in great disorder and will make the planets change their course. After the catastrophe, the sun, the moon and the stars will start moving in opposite directions. The earth will shake and tremble and the waters in its bosom will rise with great violence and will destroy the existing civilizations. The Old Egyptians give us the same message. And it is up to us whether we deny these age-old truths, or treat them with respect.

For mathematicians: see Appendix

PART III

MYTHICAL NUMBERS AND THE FORTHCOMING DISASTER

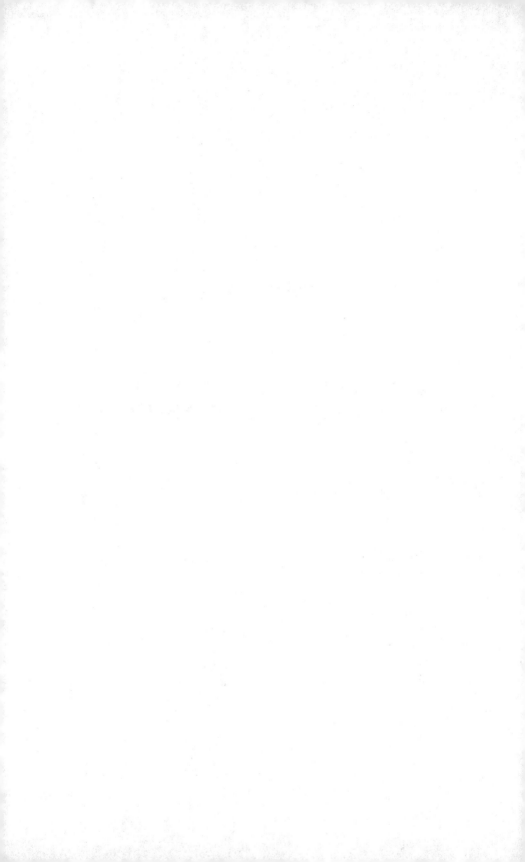

13.
THE REVERSAL OF
THE SUN'S MAGNETISM

March 2001. With the help of a Microsoft Excel file I had partly imitated the theoretical sunspot cycle of Cotterell. But it appeared a long and difficult process, because I hadn't taken lessons on Excel Advanced yet. So I had to calculate and reproduce every bit, which was frustrating and time-consuming work, particularly after finding a stupid mistake I had made in the beginning. This meant that I had to re-do all of my calculations. For that reason, I decided to let it rest for a while and to study carefully Cotterell's cycle once again. In his book *The Mayan Prophecies* the cycle from 187 years was depicted graphically. In the past I had looked at it countless times, but this time I would do it more thoroughly, and I would also write down meticulously all my strange findings. Later on I would research them extensively.

Anomalous Charts

As Cotterell had stated after his research of the sunspot cycle, most charts appeared to exist of eight bits. In a complete cycle of 187 years, though, there were five with nine bits. For some reason I started to suspect that there was something behind this— something through which a riddle could be solved. Furnished with a pencil, I started to check the charts. I carefully counted the number of bits. I started with chart one and counted undoubtedly eight bits. I continued further up to chart ten, which, according to Cotterell, existed of nine bits. I ran into my first problem at chart fifteen. Its last bit shot straight up as if it concerned the first bit from

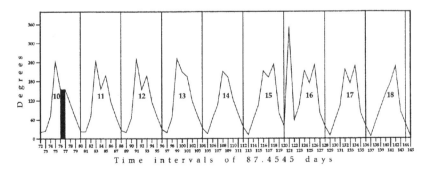

Figure 44. If you study Charts 15 and 16 thoroughly, you will come to the conclusion that both can be based on seven or nine bits. All the other charts are based on eight bits. Why?

155

chart 16. But if that were the case, then chart fifteen would only exist of seven bits! This would mean that chart sixteen consisted of nine bits! "How on earth is that possible?" I wondered. All the other charts existed of eight bits, and eight was a Holy Number in Egypt! In what way could charts 15 and 16 be built up from seven and nine bits? You will find below a picture of this dilemma:

Thereafter I stopped counting for a while and started to think. Did chart fifteen exist of nine or of seven bits? Why was the chart shooting up so impudently at its end? Was there a hint here? Why were these charts so different from the previous ones? Whatever way I looked at it, I couldn't make heads nor tails of it. That it concerned something very special, I was only too sure. I marked this deviation with a red pen, and went on counting the numbers of bits on the other charts.

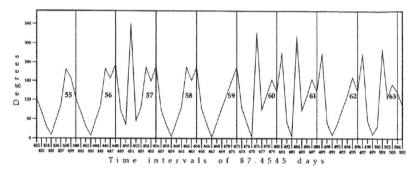

Figure 45. You see again that charts 56 and 57 can be based on seven or nine bits. Once again we are faced with the question why, especially considering the relation to the number 666.

I didn't find any discrepancy whatsoever in charts 17 to 29. They all existed of eight bits. The following chart, number 30, gave me trouble. According to Cotterell, this chart existed of nine bits. That was correct. But at the end the chart shot up straight up again. Yet chart 31 counted eight bits. So here it really concerned a deviating cycle of nine bits, the second deviation up to now. After verifying this several times, I continued with my task. Nineteen charts further, on chart 49, I stumbled across another deviating cycle of nine bits. This coincided with Cotterell's findings and so far it was the third deviating cycle I encountered. Up to this point, I hadn't been able to catch Cotterell in one contradiction. It sustained the brilliancy of his research.

Two days later I started to count again, without getting far, because charts 56 and 57 were again making a strange couple with a peak-shaped bulge in the middle. In the meantime I was strongly convinced that the super secret was hiding behind this

peak. And this was the second such oddity I had seen. My eyes ran immediately to the previous strange chart, which I have reproduced above. They were suspiciously alike! I felt that I was on the right track. Why hadn't I thought of this before? How was it possible that I should have overlooked this for years? See the charts in Figure 45.

After having marked this deviation in red, I continued counting with extremely focused concentration. Eleven charts further I arrived at chart sixty-eight, which existed of nine bits. This coincided with Cotterell's findings. Up until that point, I found my research to be reassuring and alarming at the same time. I had discovered that Cotterell was right, but that there were also prevalent deviations that he hadn't mentioned. Why hadn't he seen them? And would I find more? What strange function did these deviations have in the sunspot cycle? My interest in this strange phenomenon got stronger by the minute; I looked and compared, after which I did not have to count much longer. Charts 71 and 72 popped out easily. They showed a peak in the middle. They were similar to the charts I had earlier noted as being odd, yet charts 71 and 72 had some tiny differences. I will show you the drawing, because riddles are there to be solved, and especially since it concerns the end of our civilization.

Figure 46. In the sunspot cycle, charts 71 and 72 are the last ones that can be based on seven or nine bits. What is the secret behind this aberration?

Due to my experience with the charts, the counting now went more quickly. On chart 88 I encountered nine bits for the last time. Then I was done with deviation charts. What I had discovered up to now was mainly a confirmation of the statements Cotterell had made in his book. A cycle of 187 years contains five charts with nine bits. All the rest have eight bits. I could agree with that, except for those three abnormal charts; I couldn't say whether they existed of seven or of nine bits. What millennia-old secrets were hiding behind this?

This definitely concerned some chaos theory: a recognizable mathematical pattern in a chaotic surrounding. But how could I break the code? Where could I find my long-searched-for answers? I had to let these pressing questions rest, because my knowledge of Microsoft Excel Advanced, a computer program that would soon prove very helpful, was not sufficiently developed just yet. Also, the English publication of *The Orion Prophecy* required my attention. And thus, valuable time slipped by, the clock ticking off the seconds in the countdown to 2012.

The Sunspot Cycle Reconstructed

A couple of months later, I started my lessons in Excel Advanced. After the second class, I had at my disposal the theoretical knowledge I needed to do the job. It even appeared to be quite easy: just fill in a simple function, after which the program automatically runs the differential calculations. Now I would be able to break the code quickly! That was what I was hoping, anyway. First, I made a comparison of the orbit of the earth around the sun, linking it with the comparison of the sun's magnetic fields. Together they have a cycle of 87.4545 days. I next converted this into degrees. Then I calculated the corresponding bits of the polar and the equatorial fields and converted the results again into degrees. Finally, I calculated the absolute value from this. Full of excitement I studied my brand new charts. When I saw that everything was correct, my head started to throb.

Cotterell's Theory

Cotterell had studied these charts most carefully. He concluded that these rough data showed a random indication of the (relative) relation between the magnetic field of the sun and that of the earth, with an interval of 87.4545 days. Six of these microcycles (equaling 48 bits) formed a longer cycle of 11.5 years. This seemed to compare with the average sunspot cycle of 11.1 years, which had been recorded by means of observation. Furthermore, he claimed that the cycles with nine bits had something to do with the curved neutral plane of the sun. Just like any other magnet, the sun has an area around the equator where two polar magnetic fields are exactly in balance, so that neither the force of the North Pole nor that of the South Pole dominates. The result is a thin, neutral plane between the two magnetic zones. But because of the complexity of the magnetic field, this interface isn't a flat plane; it has a curvature. Apparently, as Cotterell assumed, the neutral plane shifts a microcycle every 187 years, through which a shiftbit moves through the whole series of 97 microcycles over a period of 97 x 187 or 18,139 years.

158

If this theory were correct, the periods between the cycles of nine bits would show the number of years in which the magnetic field is positively or negatively charged. You have read before how I carefully counted these bits. Between the first chart having nine bits and the second chart you encounter with nine bits (from the tenth up to the thirtieth chart), 20 cycles occur. From the thirtieth chart up to the forty-ninth, there are 19 cycles, which is the same number of cycles you count between the forty-ninth and the sixty-eighth chart. From the sixty-eighth up to the eighty-eighth you find 20 cycles again. And finally, there are 19 cycles from the eighty-eighth up to the last chart. According to Cotterell's reasoning, the cycle would start running at the end, and in the following periods the polarity of the magnetic field of the sun should have to reverse:

1) 19 x 187 years = 3,553 years = 1,297,738 days
2) 20 x 187 years = 3,740 years = 1,366,040 days
3) 19 x 187 years = 3,553 years = 1,297,738 days
4) 19 x 187 years = 3,553 years = 1,297,738 days
5) 20 x 187 years = 3,740 years = 1,366,040 days

I buried myself many times in this theoretical estimation, but I couldn't make any sense of it. It didn't seem logical. And, moreover, it did not explain the reversal of the magnetic field of the earth I knew would take place in 11,520 years. See for yourself: 3,740 + 3,553 + 3,553 = 10,846 years. Why did this calculation not even come close to 11,520 years? How were ancient scientists able to accurately calculate their end to the exact day with the help of this theory? Was this correct?

There was only one way to solve this riddle once and for all: all the bits of the second sunspot cycle of 187 years had to be studied piece by piece and researched for a possible deviation that Cotterell had overlooked.

Cotterell was Wrong

I copied the charts to my computer. According to Cotterell, some shifts had to occur somewhere. This seemed reasonable, because the second cycle of 187 years showed a slight deviation compared to the first one. It was indeed quite possible that something was shifting. But where could I find it? Since this meant the ultimate search for proof of the "End of Times," I decided to research the charts both graphically and numerologically. You never know, do you? Some things are more visible when they are printed out. It is easier to decide with the naked eye whether exact numbers have shifted. Therefore, I chose this double tactic. My work would proceed a bit slower, but I was sure that in this way I would find it.

I started to research each following long sunspot cycle. Each cycle consists of 781 bits = 97 charts = 68,302 days = 187 years. I put the chart from the first cycle on the one of the second and looked for possible deviations. But there was absolutely nothing to see. They seemed almost identical. How was this possible? Would I be able to find the solution after all? Thousands of doubts were creeping up on me, undermining my confidence. Was this correct? Could this possibly be true? I gave up, exhausted. It was already morning after all.

That night I threw myself at the problem even more seriously. Was there a deviation or not? Hours and hours later I still hadn't found a thing. Didn't this show that, in fact, there was nothing to find? But Cotterell had to be wrong! There had to be another deviation. It couldn't be otherwise. I decided to research the third cycle of 187 years meticulously, and after more than an hour I finally succeeded! It appeared that chart 30, with its nine bits had shifted forward to chart 29! I looked at it in disbelief, but after repeated calculations I couldn't ignore it any longer. The nine bits showed themselves more than clearly in chart 29! They had shifted one chart forward!

How Do the Bits Shift?

Each long sunspot cycle of 187 years (equal to 781 bits), appears to be directly followed by a similar-looking cycle of the same size and duration. However, bit one from the second cycle (which would be bit 782 in the overall picture) opens at a *lower degree* than the first bit in the first cycle. This is the reason why the first microcycles from the second long cycle have fewer degrees than the microcycles in the first long sunspot cycle of 187 years.

Due to this mechanism, some microcyles are shifted forward—some more than others. The cycles having the smallest change in degrees to make will shift first. These shifts can happen anywhere in any of the succeeding 187-year cycles.

This can be demonstrated with simple mathematics. Let's say that bit 16 in long cycle one equals 17 degrees, and that long cycle two opens 10 degrees lower. Bit 16 in long cycle two would then equal seven degrees (17-10). Long cycle three opens, and is again 10 degrees lower. Bit 16 of cycle three would then be negative 3 (7-10 = -3). This is of course impossible; therefore, the degrees will be shifted forward to bit 15.

Excited by my discovery in chart 29, I quickly checked the other deviating charts in long cycle three. Another one appeared to have shifted. The nine bits of chart 88 were now in chart 87! Because I wanted to be absolutely sure of my discoveries, I started to count again, but I didn't find any more deviations.

Not completely sure of myself, I repeated the whole procedure of counting and comparing, but however hard I tried, I couldn't find any other deviations.

I took up my work again the next night, shifting gears to the fourth sunspot cycle of 187 years, thus checking the years from 561 to 748. For hours and hours, I stared intently at the screen, but strangely enough, nothing showed up in the whole cycle giving the slightest impression of a deviation! Frustrated, I shut down my computer. That same night I had a nightmare of the forthcoming events of 2012. I saw the magnetic field change, and the sun suddenly seemed to explode, and the whole world population panicked and tried to escape to the harbors. Filled with the images of that night, I delved back into my research making a thorough study of the fifth cycle. It was here that I detected that the nine bits of chart 49 had passed to the previous one. Now that I knew where to look, things started moving along rapidly. The sixth long cycle of 187 years didn't show anything, but I noticed in the seventh that the nine bits of the tenth chart had shifted forward to the ninth chart. I had looked at thousands of charts countless times, but I decided to go through the points one more time.

What I had found was totally different from Cotterell's statements! In fact, my findings were contradictory to his! I felt I was uncovering the real theory of the reversal of the magnetic field, but I still had a lot of questions. Why were the charts starting to deviate from the original ones? Were there other deviations that I hadn't seen? What was it, then, that I had to detect? Disturbed by these new uncertainties, I decided to do nothing more for two days, and then study and count once more. I had to be one hundred percent sure; otherwise no one would believe me. Forty-eight hours later I sighed in relief. My new calculations were undeniably correct. I felt reassured, and the next day, went on to research the eighth cycle. I was now more than 1,300 years from my starting point. After a meticulous study of these charts, I found that the bits of chart 68 had shifted to chart 67. Although I still hadn't the faintest idea of what this actually meant, my excitement over these discoveries started to rise.

I therefore counted further with finicky precision. In the following cycle, the ninth, I again found nothing. The tenth, however, revealed something that I had at first overlooked. In accordance with the previous principle I had seen at work here, the nine bits of chart 29 shifted forward to chart 28. It seemed as if I had found nothing else, but after checking it for the third time, I noticed that the value of bit 8,035 was exactly equal to the one of bit 8,036, namely 22.3558 degrees! This is after 1,924

years since the beginning! Why? Were secret codes hiding behind this? Had I overlooked these similarities before? I felt compelled to subject the more than 8,000 bits to even more research! I spent more than a week investigating this issue, for I knew that I could not overlook one single thing. However, this intensive search produced nothing at all. I started, frustrated, to have another look at the tenth cycle. I counted out loud the number of degrees, and that was my good fortune! At bit 8,037 I suddenly recognized the number I was saying as being equal to bit 8,034. I exposed the following series of mirror-image values:

8,031 = 8,040 = 201.2021
8,032 = 8,039 = 203.5094
8,033 = 8,038 = 111.7789
8,034 = 8,037 = 67.0674
8,035 = 8,036 = 22.3558

This was something very peculiar that Cotterell had never mentioned. This had to have something to do with the correct solution! But did it end with this? Were there not more deviations to be found? Only further research could reveal this.

The Super-Secret Revealed

I had learned only too well where to turn my attention. In the eleventh cycle I saw that the nine bits of chart 29 shifted into chart 28; it showed no further abnormalities. After carefully studying the twelfth and thirteenth cycles, I concluded that there was nothing odd to be found there. But sometimes I saw strange things happening—some of the charts which rose straight upwards were losing the bulge, while others without one suddenly had one! What was this supposed to mean? Why hadn't I noticed this before? Did I have to do everything again?

I decided to simply continue on with my research. In the following cycles I saw another couple of charts shifting bits forwards. I carefully noted down these data. In the end I would surely know where all this was leading. Or was the track I was on completely wrong? Had I made a stupid mistake? No, that was impossible, because I had checked everything only too well, sometimes even ten times. Everything I had found had to be right. And then the big "day of discovery" arrived, washing away all my uncertainties. In the twentieth cycle, at bit 16,071, I suddenly stumbled across 360 degrees. According to the mathematical principle, however, this should be zero! When something has completed a circle of 360 degrees it is right back at its starting point. In other words, zero. I quickly looked at my differential comparison and saw that I had programmed this mistake. Zero

was equal to 360 degrees! A negligible, small mistake, but still—I had encountered this nowhere else in more than sixteen thousand bits. Therefore I changed the figures. Should 359.999 degrees or more appear, it would be automatically changed to zero. With high expectations, I pressed the Enter button and the change was made. Like an arrow I went back to this highly peculiar value. What could this mean? Had the whole sunspot cycle been reset to zero in the middle of it? How was that possible? Was it feasible that a new cycle would start from this point?

I plunged into the numbers and immediately found the most peculiar series I had seen up to now. Bit 16,071 was equal to zero. The bit previous and the bit following it (16,070 and 16,072) had equal values: 44.7116 degrees. After having found this, I remembered a similar instance occurring in the tenth cycle, and thereupon I revealed the following extremely peculiar series:

16,061 = 16,081 = 87.1159
16,062 = 16,080 = 42.2043
16,063 = 16,079 = 2.3073
16,064 = 16,078 = 47.0189
16,065 = 16,077 = 91.7304
16,066 = 16,076 = 223.5580
16,067 = 16,075 = 181.1536
16,068 = 16,074 = 225.8652
16,069 = 16,073 = 89.4232
16,070 = 16,072 = 44.7116
16,071 = 0

In other words, bit 16,071 was equal to zero. And the ten bits previous to 16,071 were a mirror image in value of the ten bits coming afterward! Opposing bits having equal values, with bit 16,071 as their center. According to this, the reversal took place at the zero point! So the magnetic field was changing here! I had found it!! This was without any doubt the ultimate solution to a long-researched riddle! I didn't need to look further, because the series repeated itself from here to infinity!

The Reversal
When you study the previous findings, you will know that the sunspot cycle, after 16,071 bits (or 3,848 years), starts over again. But this fact is more than strange, even totally illogical. This information indicates that one bit beyond halfway through the twentieth cycle, this particular cycle would have to start again from zero! But was this possible? Wasn't this in contradiction with the findings up to now? Before I could answer this, I decided to investigate the turning point again.

Bit 16,071 of the overall sunspot cycle is bit 451 of the twentieth cycle. I realized I had noticed bit 451 of the twentieth cycle before. I looked back through the anomalous charts I had marked, and there it was—a spike between chart 56 and chart 57 (see Figure 45)!

This was undeniably it! Excited as I was, I calculated the next turning point. It fell in the forty-first cycle on bit 121, corresponding with the spike between the fifteenth and sixteenth chart! My earlier intuitive searches were confirmed again. After my discovery, it was easy to calculate the cycles. The next start of a sunspot cycle would be between the seventy-first and seventy-second chart of the sixty-first cycle. And… bingo! This appeared to be correct! My former findings were not only confirmed by this, but in a convincing way. Immediately I knew that the drama of the reversal of the sun and the earth was hiding behind this recurring cycle!

The Maya Super-Number 1,366,560 of the Dresden Codex and the Reversal

Because bit 16,071 ended at zero degrees, I decided to calculate the total number of degrees traveled since the beginning. Therefore I multiplied 16,071 by the number of degrees that the earth travels, equivalent to one bit (= 86.197498 degrees). The outcome appeared to be 1,385,280. And through this calculation I had deciphered another super secret of this age-old wisdom cult. Because, when I subtracted this number from the super number from the Dresden Codex, it amounted to the following: 1,366,560 – 1,385,280 = 18,720 days = magical cycle of 52 Maya years! Then I started to search further in a simpler way. I divided 3,848, the number of years up to the turning point, by 52. The outcome was 74, the main code number to decipher the Dresden Codex! And instantly I had the solution for the Dresden Codex!

74 x 52 = 3,848 = reversal of the sun's magnetism

Subtracting 52 from 74 results in the sunspot cycle of 22 years:

74 - 52 = 22 = total period of a sunspot cycle (after 11 years the North Pole of a sunspot changes into the South Pole, and 11 years later the pole returns to its original place for a total of 22 years)

Further relative mathematical calculations result in the following:

74 ÷ 22 = 3.363636 = speed of equatorial field of the sun
52 ÷ 22 = 2.363636 = speed of polar field of the sun

Later calculations will confirm this. Once more I had found

irrefutable numerological proof that the Maya knew this theory and used it for counting down to the end! Together with all my previous findings, this is alarming enough that it should throw the whole world into commotion!

Third Time's a Charm

Everybody knows the old saying "Third time's a charm," but where does it come from? Nobody seems to know. But I am of the opinion that I have found more than enough proof to provide the answer. When you are studying new cycles, you encounter several surprising things. When you multiply 3,848 years (the period until the zero point occurs) by three, it results in 11,544 years. This is extremely close to 11,520 years, the period between the previous crashes. "Would this lead me to the long searched-for answer?" I wondered. Was there something special to retrieve from the third cycle?

I started to count patiently. In one long cycle of 187 years there are 97 charts. As the zero point is reached in the twentieth cycle, it has to be multiplied by twenty, which results in 97 x 20 = 1,940 charts. Then, in the twentieth cycle the zero point is reached at the 451st bit. This happens after fifty-six charts. Neatly adding everything, I get the following number of charts: 1,940 + 56 = 1,996. In order to go from one zero point to the other, causing a big pole reversal, 1,996 charts have to be passed. So far, so good. Now I needed to divide this in a simple way by the number of charts that correlates with a short sunspot cycle of 11,567 years (see the calculation in the Appendix). Because a sunspot cycle correlates with six charts, it means that the zero point will be reached after 332 cycles (332 x 6 = 1,992 + *another four charts*). Four charts are equal to 66.6% of a cycle. The zero point therefore does NOT correspond with the beginning nor with the end of a sunspot cycle of 11,567 years! Why not? What was the meaning of this? Was this the answer to my questions?

666 and the Reversal of the Magnetic Field of the Sun

I started to think about this. After two-thirds of a sunspot cycle (or four charts), a new long cycle starts on a deviating cycle of nine bits! This was exactly what I had suspected in the chapter about the number 666! But, there was another correlation, because the turning point is reached at 66.6% (!) of a sunspot cycle of 11,567 years. This not only refers strongly to the number of the beast, but also to other encodings related to the solar year. But, could that be theoretically possible? What were the consequences of this turning point? It had to be something simple, so I started with elementary knowledge. Everybody knows that when a

Figure 47. Together with the pole reversal of the earth, immense earthquakes, volcanic outbursts and storms will torment the surface of the earth. During these apocalyptic events almost all human beings will die.

sunspot cycle starts again, the magnetic field of the spots changes, involving some considerable solar activity. Suppose that a huge reversal comes, intercepting the current one, because it starts after two-thirds of a cycle. In that case there's no option: the reversal of the field is either extremely powerful or is eventually broken off! Indeed, there are already a lot of sunstorms and activity, but we have seen nothing like that big, all-demolishing magnetic doom cloud that can destroy the magnetic field of the earth!

When I was sure of this starting point, I continued counting carefully. I found out that the next breaking point comes after 665 cycles and a third (= 33.3%). Again the magnetic field reversal is crossed—a broken-off reversal, so to speak. Building on this principle, you arrive at the third cycle. This would then be at the exact beginning of a new sunspot cycle, after precisely 998 cycles of 11,567 years. Herewith, I had definitely solved the riddle!

As the priests of this old wisdom cult studied the sun attentively, they must have seen clearly the two previous broken-off reversals. Nobody could have failed to notice such intensified activity. Having this theoretical formula at their disposal, they had only to project the data into the future in order to calculate the next point. This is how they were able to calculate the exact date, foretelling the end of their civilization in 9792 BC! They were totally convinced that this would be accompanied by a huge amount of cosmic violence. After all, the third reversal coincides with the normal one of a sunspot cycle. This implies that the forces are amplified many more times, instead of being crossed! Hence perhaps the expression: "Third time's a charm."

Thousands of years later, the descendants of this wisdom cult calculated the forthcoming pole reversal of 2012. But because all this superior knowledge has been lost, we didn't get an official

warning, meaning that we are going blindfolded towards our end. However high our technology could have evolved, a pole reversal will lead to the loss of all our knowledge—the "Armageddon," the definite end of humankind.

Summary

Theoretically, after 1,924 years one can see a first deviation in the tenth long sunspot cycle. This could provoke an increase of the solar activity. After doubling this period to 3,848 years the deviation becomes clear. It concerns the reversal of the magnetic field. Because the reversal takes place after two thirds (66.6%) of a sunspot cycle of 11,567 years, it doesn't involve a fierce or even a broken-off reversal. The same holds for the next change. Not until the third reversal can we speak of an all-demolishing change, because then it coincides with the reversal of the corresponding sunspot cycle. At that moment the sun's energy will increase its force of radiation and send a gigantic cloud of plasma in the direction of the earth.

For mathematicians: see Appendix

14.
INCREDIBLY EXACT
ASTRONOMICAL NUMBERS

I am writing this chapter in astonishment, because I found out that the Maya were better at counting than our present astronomers with their computers! How did I come to this conclusion? A hunch, and some calculations. Not so difficult, really. You just have to hit on it. And with it, I could make many interrelated connections and decipher ancient codes concerning the solar year. But it took a lot of blood, sweat and tears, because at the very first I was missing many decipherings. What did I discover? Unbelievably accurate numbers. If I hadn't recognized them myself, I would never have believed it—the Maya were very knowledgeable about the orbit of the earth around the sun.

The Period of a Solar Year

At the end of this book, I explain further how I broke the hidden Maya codes. Passionate researchers and mathematicians should study this most carefully. They will possibly find even more codes and unveil other secrets of the Maya and the Egyptians. To what devastating conclusion this can lead, you will find out in a minute. However, I want to make here an important remark. Some readers, who find everything more or less exciting but too much focused on mathematics, should absolutely try not to give up. The conclusions that I will show you after some more calculations are worthwhile. They will turn our world of time measurement, mathematics and astronomy totally upside down, and deliver the super-shocking proof of the accuracy that the Atlanteans had achieved. Their measurements were so extremely accurate and correct that I was baffled after discovering this. It concerns the manifestation of the highest peak of a super civilization searching for an explanation of the "End of Times."

As you know, the exact orbit of the earth around the sun lasts 365.2422 days. The number 365 is mentioned in the Mayan codes, but without any figures after the decimal point. In several calculations I was able to prove that the Maya, as well as the Egyptians, knew four figures after the decimal point. When you think about this more intensely, you have to come quickly to the conclusion that there are codes hiding behind this. Therefore I multiplied the number after the decimal point, 0.2422, part of a day, by the 86,400 seconds contained in one day: 86,400 x 0.2422 = 20,926.08. I studied this number closely. Do the same and you will

see the number eight after the decimal point. Was some secret of the encoding hiding here? Something told me this was the case, but which discoveries did it encode? And how? Did it have to do with their mathematical insight? If that was the case, I would surely be able to break their codes, for I had adjusted myself already to their way of thinking.

The Egyptians and the Maya gave a special meaning to the number eight. In his book *Le Grand Cataclysme*, the French author Albert Slosman states very clearly that the Egyptians had a special affection for number eight. He gives several examples. Eight was the Holy Number in Egypt, the figure of the Celestial College. At the same time eight was both the Number of Perfection and of Justice. He included several calculations with the number eight in his book to show how important this number was for them. Through this he found series of eights.

Their sunspot cycle was of the highest importance for the Maya. If you study it thoroughly, you will see that it consists of successive cycles of eight bits. Furthermore, Venus disappears for eight days behind the sun. That thought set a bell ringing, and I repeated word by word what had gone through my mind: Venus disappears for eight days behind the sun. Therefore, for those eight days, you could not see Venus! And in a flash I suspected that they could calculate even more accurately than we thought possible. For that reason, I left the figure eight out after the decimal point—made it "disappear." Then I divided this newly discovered number by 86,400 and found the following orbit of the earth around the sun:

$$20,926 \div 86,400 = 0.2421990741$$

The current value, calculated with atomic clocks and super computers is: 365.242199074. Amazing! Superior brains must have made such brilliant calculations. It shows great skills and deep insight into mathematical patterns.

Besides being excellent calculators, the Maya were psychologists of the highest rank. All their buildings radiate mysticism, fear and apocalyptic visions. And the same phenomenon occurs with the Maya esoteric numbers and symbols, which contain a great number of cosmic correlations. The designers of this symbolism knew exactly what they were doing. They created a fascinating design for a riddle that could be solved only by extremely curious people who would search for their hidden science. The result of their collective imaginative power is undeniable. They succeeded in passing on their baffling knowledge to me. And now it's up to you, dear reader, to hand down this knowledge to others, thus honoring their ambitious achievements. The Maya would

surely have wanted this. All their mental powers were focused on tempting future researchers to unveil their secrets, however dark and remote the period would be in the meantime. They were counting on infinite enthusiasm, nothing more and nothing less. Overwhelmed by so much beauty, the feeling settled on me that I was in direct contact with the designers of the pyramids, the unequalled master builders of the past who had created these miracles with telltale intentions, as if it were no trouble whatsoever to do so. In the same way they had juggled the transcendental numbers of the precession of the Zodiac, the orbit of Venus, the period of the solar year, etc., and incorporated them in the construction of their creations. In the Great Pyramid of Gizeh, the angle of the ascending corridor is 26 degrees, half the inclination angle of the sides of the pyramid, which is 52 degrees.

Liturgical scriptures tell that the pyramids served to help pharaohs rise to the stars in order to join the gods somewhere beyond the Orion system, where many new stars are born. Were they using these numbers for their eternal journey in the cosmos to a nebula as exponents of their knowledge? Who can tell? You find the same numbers with the Maya. There are so many correlations with their numbers and buildings that I would need pages and pages to describe them. However, this wouldn't change a thing in my arithmetical evidences; therefore I returned to reality and, for further revelations on this fantastic journey of discovery, I grasped at already-found values.

Total Astonishment

The evidence given above of their knowledge of the earth's orbit around the sun conclusively shows that they had unbelievably clever equipment at their disposal! With this equipment, they were able to calculate the period of orbit up to a fraction of a second. Our super computers and atomic clocks cannot do any better! You can easily prove to yourself that the margin of error is less than 1/10,000 second. To do this you have to add 1/10,000 seconds to the higher value:

$20,926 + 0.0001 = 20,926.0001$
Divide this by 86,400:
$20,926.0001 \div 86,400 = 0.2421990752315$

This result is further from the real value than their calculation, which means they were well within the margin of error! An error less than one ten thousandth of a second in a whole year is baffling. Yet this rough calculation didn't seem enough. The exactitude of their estimation is many times higher than ours.

When you try calculating to one hundred thousandth of a

second, it is not enough, even by approximation! If you compare their outcome with the real value, then you inevitably have to conclude that the error is less than one millionth of a second per year! Only atomic clocks can work with such precision! The totally amazing conclusion is that they had superior devices! There's no other explanation. Or did they calculate this in some other manner that we overlooked up to now? Were such devices indeed the basis of this way of calculation? If not, how did they do it, and where did this amazing accuracy come from? And why did they convert everything into codes? I will explain here the "why" of this last question, which they have answered themselves.

In their society, only the high priests were allowed to know the extremely accurate numbers. This knowledge was taboo for everyone else, because otherwise the priests would lose a great part of their power. In the past, the eclipses of the moon and the sun would have been terrifying events for ordinary mortals if they had not been informed beforehand. Thanks to the knowledge of the high priests they were warned, and therefore the priests not only gained power, but were also acknowledged for it. However, there is more. Their codes contain a universal language that is comprehensible only to a technically well-developed civilization. You have to search for codes and reveal them with a scalpel. I have been able to revive this language, this esoteric mathematics of the denary scale, thousands and thousands of years after its coming into existence. And through this journey of discovery I can link this eternal language of mathematics to time: glorious and transient time. Since the coming into existence of these codes, thousands of kingdoms have risen and perished. Despite all these countless frictions, the coded messages have survived unscathed for centuries, simply and solely through the existence of some important papyri and codes of the Maya. They show more than clearly that they used our time chronology—the many detailed correlations are too clear and carry the recognizable traces of an elaborate design.

The Effect of Deceleration

Critics will remark that the rotation of the earth diminishes, and that the solar year was therefore shorter in earlier times. For this reason this deciphering cannot be correct. This, however, is a completely wrong point of view. Indeed it is true that every year the earth's rotation diminishes a bit, because of the gravitational pull that causes a friction. Due to this effect the day becomes longer at an average of 0.00000002 seconds in twenty-four hours. This isn't much, but it becomes noticeable in longer periods. Nevertheless it has no influence in the period of a solar year! The

proof can be quickly found. Over 10,000 years (3,652,422 days) a day becomes 0.073 seconds longer. For one year this amounts to 0.073 x 365.2422 = 26.66 seconds. Calculated in our *present* seconds, a year lasts 26.66 seconds longer. But—and this is important—the average solar second is defined as 1/86,400 of an average solar day, which changes over time. Calculating the second within 10,000 years, dividing a day by 86,400, then you will have another value for a second! A second of 10,000 years ago lasts 1.000000845 *present* seconds. Calculating the solar year with this second, then, paradoxically enough, it remains unchanged with respect to the present value! The Maya must have realized this, and therefore they considered this fact in their codes!

That they must have known this effect of deceleration becomes clear from the following reasoning. Taking the average between one thousand years ago and the present results in a day that has been on average 0.5 x 0.0073 second = 0.00365 second shorter. Calculated over 365,242.2 days this results in an error of 365,242.2 x 0.00365 = 133.3 seconds. A calculation of the moon position in the past, based on the present length of a day, therefore gives an erroneous outcome. The moon seems to have moved too quickly—that is to say, it seems to have traveled an excessively long distance. The Maya and their predecessors of the worldwide cult of ancient times must undoubtedly have noticed this and added a correction in their calculations. But if this was the case, how could I prove it? In what way had they coded this singularity? It couldn't be so difficult, and I had a hunch.

The Mayan value for a solar year differs by 0.0002 days from the exact value. The deceleration of the rotation of the earth is 0.00000002 second per day, which suggests a code. For this reason I started to recalculate and I immediately I got the prize! Filling in the Mayan value for the solar year in the previous calculation, I got an undeniably recognizable mathematical pattern: 365.242 x 0.00365 = 1.3331333! Here was the number 1333 repeating on my screen! I had already encountered the series 1.3333333 several times in other calculations. That convinced me that this deciphering had to be correct. That this is the case is apparent from the fact that when leaving out the decimals, 0.00365 is equal to a Mayan year.

Absolutely Incredible Accuracy

Then I started to suspect that there was much more to be discovered. With refreshed inspiration I dove back into their strange world of codes, and it wasn't too difficult to uncover several more irrefutable mathematical correlations. Their obsession with numbers was unrivalled. I did not trust the calculating device I

had programmed to keep up, so I resorted to manual calculation. In that way I had many more figures after the decimal point, and I obtained the following result for the earth's orbit around the sun:

$$20,926 \div 86,400 = 0.242199074074074074074074074$$

The endless series of 74 popped out immediately! A code number I had found many times before! This could not possibly be a coincidence. The Mayan solution had to be the correct one; especially since *74 is a main number in deciphering the Dresden Codex! Even better than that: the number of pages in this codex is 74!*

I found rather quickly the evidence clinching this as indeed the right solution. To calculate this we take the Mayan value of 365.242 days for a year. Multiply 0.242 by 86,400 = 20,908.8. Subtract the last eight. Divide this outcome by the number of seconds in a day: $20,908 \div 86,400 = 0.241990740$... Study this number most carefully. What do you notice? These long numbers are completely identical, except for the fact that the real value has one more two! Just like the correlating value 0.2422 has one more two than the Maya value! It couldn't be more astonishing, and it made me think of another thing. Earlier, I had been able to make complete series of decipherings with the number 0.666666, which is related to the Maya solar year. Now I could prove where they had found this number. It is directly connected with their incredibly accurate way of calculation!

You will find the number 0.6666666 or 66.6 or 666 as follows:

$$0.00000074074074074 - 0.000000074074074074 =$$
$$0.0000006666666666$$

I was able to crack the computer program of the previous crash by multiplying this number by the solar year! It is therefore quite logical that they should have converted this into their codes, because it was hiding in their phenomenally exact calculations of the earth's orbit around the sun! This proves even more clearly that the astronomers and mathematicians at that time were cleverer than our present ones!

I felt completely knocked out by such complicated beauty. The codes are indeed more than clear. This calculation of a long-lost civilization is absolutely correct up to an infinite number of figures after the decimal point! Now I panicked because of their announcement about the end of the world. The software programs of these old scientists are cleverer and more advanced than several present programs! They are full of super-clever mathematical games. Everything fits in; you find an answer to everything. An amazing building, bright and shining in its magnitude, was designed by mysterious ghosts that dreamt of eternal life after

death. The burning fire of their passion for numbers emanates so immensely, that there are no words to describe it. All the key elements you saw in previous calculations fit into refined and advanced formulas. When classifying the rows of numbers using the same logic, you stumble upon an enormous instrument. This complicated system gives almost appallingly beautiful results, full of mystical and spiritual mysteries, and at the same time functional and efficient. It was constructed to fulfill a task, demanding in a stylish way the complete attention of researchers.

In the meantime I had calculated that they had reproduced the period between the previous and the coming catastrophe quite accurately in mathematical terms (to be discussed further in my next book)—accurately up to one day! And now you are able to prove along with me that indeed they were able to do that. Thus, my complicated calculation was not a coincidence at all and was in fact correct! And finding that terrifying precision gives me cold shivers. It proves that as a consequence of wars, incredibly crucial knowledge can completely vanish. Such exactitude is almost unimaginable for a civilization that has disappeared. These exciting things can only push you to continue breaking the codes. There has to be more proof in their brilliant game with Holy Numbers. I found some too, and I refer you to the mathematical sections at the end of this book in order to have a look at them yourself.

In those sections, I prove without a doubt that the Sothic cycle contains a coded message: its deciphering leads to the exact orbit of the earth around the sun. The Egyptians honored Sirius for certain reasons: thanks to this star the high priests were able to deduce many valuable astronomical and other key numbers in a simple way. These decipherings stunningly prove that the Egyptians had achieved a much higher level of knowledge than present scientists might ever suspect. You will find a special reference to the Sothic cycle in the history of Manetho, a priest from Heliopolis. He wrote extensive lists about the early pharaohs of Egypt and the historical dynasties of even older periods. Manetho claimed that from the age of the gods until the end of the thirtieth dynasty, the civilization was 36,525 years old. When you carefully look at this number, you find in it twenty-five cycles of 1,460 Sothic years and twenty-five cycles of 1,461 calendar years of 365 days. These are the code numbers you also encounter with the Maya, which are directly correlated with the extremely accurate orbit of the earth around the sun. Those numbers are the driving force behind their myths. Only because of their phenomenal degree of accuracy were they able to calculate the previous reversal with such great certainty.

Figure 48. The countdown of the Maya to the end date of 2012 is more precise than we ever thought possible. Ten thousand years ago they were able to calculate the astronomical positions of planets with an accuracy that equals or even exceeds that available at present!

For these reasons we can be sure of the arithmetical abilities of the Maya and the Old Egyptians, who situate the next catastrophic end date in 2012. The turbulent events from a far past were so terrifying that our ancestors would do anything to get answers to their questions. And this super accuracy, passed on to their descendants, is one of the remarkable outcomes of their thinking and calculations. For the time being it is still a riddle how they did this, however I do see some possibilities for further research. I will let everybody know should I ever figure it out, but it gets more unlikely every day. It still intrigues me terribly—their knowledge of astronomy and the progression of time must have been boundless. They had excellent instruments somewhere, amazingly advanced tools for this incomprehensible accuracy. That's the point of this message: everything they measured and built radiates the same obsession for extreme exactitude, as if their lives depended on it. And they did. On the basis of the orbit of the earth around the sun, they were able to define the period of the magnetic fields of the sun up to several figures after the decimal point. Once you know these values and the sunspot cycle theory, then you can make predictions about the behavior of the sun. It must have been a small thing for them to calculate, thousands of years in advance, the moment when

the magnetic field of the sun would reach a crucial point. At that particular moment the magnetic field will collapse and reverse, accompanied by phenomenal solar flares. Shortly thereafter, the earth will be hit by a sunstorm that will demolish everything in its path. An endless stream of magnetic solar elements will finally break the magnetic field of the earth. It will reverse in one titanic movement, and the nucleus of the earth will start rotating in the opposite direction, which will result in catastrophic consequences for all life on this planet.

Millennia back in time, super mathematicians and extremely intelligent and efficient astronomers recorded all of this information, resulting in the evolution of the codes and calendars left behind by the Maya. They are infinitely more correct and complicated than was thought up to now. You only need to master their way of thinking to understand this. When you are on the right track, the ability to follow their calculations should pervade down to your deepest core: the Maya left us all an incredibly correct message, warning us that an all-demolishing geological disaster will torment our land. A worldwide catastrophe unequaled by anything any of us has seen. It's up to you whether to heed this warning and take the necessary measures for your survival and the survival of humanity. If you do not (and that is my fear), it will mean the end of mankind.

For mathematicians: see Appendix.

15.
THE ORIGINS OF OUR
TIME CHRONOLOGY

We come now to a crucial question, as we proceed on from the previous chapter. When you ask scientists to detail the origin of our time chronology, they cannot give an answer. They don't know, but they do agree on various historical facts. Our present Gregorian calendar, which is named after Pope Gregory XIII who instituted it in March 1582, is not the most accurate that has been used by civilization. Although our calendar is quite "refined" it is not as accurate as the one the Maya used thousands of years ago. The Gregorian year is a bit too long. The error amounts to three days in ten thousand years. The Mayan year was too short, but the error was only two days in ten thousand years. However, please note the devastating proof I have put forth showing that the Maya were able to calculate much more accurately than our scientists think possible. In fact, their mistake was nil in ten thousand years!

Such a revolutionary science is absolutely baffling. It sheds a totally different light on their civilization. The Mayan reckoning of time was covered with a magical mysticism. They were of the opinion that events moved in a circle, represented by returning cycles of service for every god. Days, months and years were all members of shift-relief-teams marching through eternity. The priests were able to calculate the combined influence of all the marchers, and in this way predict the fate of mankind. It was expected that every 260 years, history would repeat itself in certain circles. This mixing of intuition with time may appear strange to us. Yet quite intelligent ideas were behind it.

More than once, I have proved that they knew much more than most scientists have uncovered. Therefore you must not reject their pattern of behavior too lightly. However clever, though, the Maya did not set the basis for our modern time chronology. You need to have a look at the Middle East, especially at the Babylonians. They created the fundamentals of our present seven-day week, for their astrology was based on the sun, the moon and the five planets they had discovered. This does not seem so sensational, but when you remember that the partition of the hour dates back to those times, some bells should start ringing. The Babylonians divided their time chronology in a sixty-fraction scale. An hour was divided into sixty minutes, and a minute into sixty seconds! Later, in 1345 AD this system was implemented to determine the

period of a lunar eclipse. It did not involve a real time chronology, but indeed a theoretical one. Given the movement of the celestial bodies, they calculated the length of the eclipse, based on earlier data. But doesn't this all prove where our time chronology really originated? That, in the Middle Ages, they founded their time chronology on thousands-of-years-old data from the Babylonians? And, also, that they in turn had gained their knowledge from the Egyptians? And therefore, the knowledge of the Old Egyptians finally came to us?

Sophisticated water clocks from the days of the pharaohs prove this basic principle. In the Amon temple of Karnak, not far from Luxor, a complete specimen of a miraculous water clock was found. I visited this temple and I am able to speak from experience. The temple is overwhelmingly beautiful, but I didn't find the water clock there. It was in the nearby museum. Water streams down from a cask, whose inner walls are carved to depict the time. These marks do not coincide with our present time chronology; it is much more complicated. The marks were carved in the cask according to the different seasons. Winter nights and summer days were the longest of all. The clock was based on this principle: the hours changed with the length of the days. On the equinoxes of spring and autumn the day lasts eleven hours and fifty-six minutes, and the water clock shows this with remarkable accuracy. What cannot be explained, however, is that the length of the days of the winter and summer solstice don't correlate with each other. This intrigues me endlessly. Knowing the old scientists, I am sure that some codes are hiding behind this. I started to think and count, but to date I haven't been able to explain it. What I could show with a great deal of certainty is that they had incredibly accurate numbers. So accurate, that they impressed and baffled me. Furthermore, I can state with great certainty that the Old Egyptians used the number of hours, minutes and seconds in one day to show the precession cycle. I had found the mathematical evidences for this that I have explained in my previous book. In addition to many other things, our time chronology is a legacy from the Atlanteans. It is easy to predict what additional codes are hiding behind the time chronology and remain to be broken:

• Relations between the sunspot cycle and the number of seconds in one day and one year.

• Correlations between the precession, the calendar round of the Maya and the Egyptians, and the number of seconds in one day and one year.

Knowing the old scientists, it must be full of codes. These decipherings are not really necessary anymore for my arguments,

but it is nice to note them. Mathematicians and puzzlers can start with the data present in this book. For the time being, I am too busy to investigate further, but it will probably be important for my third book on this subject.

Maps and Time

It is evident in maps that you can admire in several libraries around the world that the ancients dealt with an excellent time chronology. The Mercator map from 1569 gives an accurate picture of how the coasts of Antarctica must have looked without ice. Mercator must have based this map on much older documents, made before the previous pole shift! This actually means that this inherited knowledge must be at least 12,000 years old. Without an exact time chronology and a fairly accurate clock, you cannot make such a map. The required technique is based on having knowledge of the meridians. In modern history, only in the eighteenth century did such a breakthrough occur, which resulted in the invention of a clock that kept on working despite the movements of the sea, the salty water, extreme heat and cold, etc. After two months, a chronometer, made by the English clockmaker John Harrison, appeared to be only five seconds slow. With it one could adequately determine the degree of longitude. Captain James Cook used it during his third journey. He was able to map the Pacific Ocean with impressive accuracy. Cook's maps with their correct degrees of longitude can be considered jewels of modern cartography. They prove that you not only have to be a good mathematician in order to depict the coordinates on scale, but that the use of a high standard chronometer is required. This, of course, begs the question: where did scientists thousands of years ago find their knowledge of the earth? Reasoning logically, you have to accept the following: they were highly-advanced explorers, brilliant mathematicians and they had high-quality chronometers at their disposal. Otherwise it is impossible to explain how these much older maps depict degrees of longitude and latitude with modern precision. And now we have reached our most important conclusions. Entire series of books will have to be amended. The history of mathematics, as well as of astronomy, will be seen in a completely different light. The above-mentioned discoveries prove the following:

1) A highly developed civilization that ruled the earth long ago really was capable of making ultra-long calculations of planetary orbits, not only the earth's, but also those of Venus and other planets. Also, they were able to calculate an amazingly accurate value for the speed of the polar field of the sun, although it was impossible to see it from the earth.

2) Their accuracy was better than ours! The error they made hardly exists in practice. This is not only unbelievably baffling and fascinating, but also alarming. Because they could count so well, they were able to determine the position of the earth around the sun at a point thousands of years ahead of time. Their calculations were so precise that, 12,000 years beforehand, they could predict a solar or planetary event almost to the second!

Figure 49. Thanks to their accurate measurement of time, the Atlanteans could sail the oceans. Atlantis appears in the middle of this map. It represented, so to speak, "the navel" of the earth.

3) They converted everything into codes and "Holy Numbers," which is the reason present researchers are still in the dark. To determine the orbit of the earth around the sun, they used three approximation numbers! It is very confusing, and it is not hard to see how they have misled scientists, who describe Mayan astronomy as "advanced," while in fact it should have been valued as "super-brilliant." It is infinitely more difficult to write a complicated program using approximated numbers than it is to find the real numbers. And the discovery of the real numbers is in itself a phenomenally daring exploit!

4) The Maya, the Egyptians and the Atlanteans knew the number zero, and they used exact figures after the decimal point. Neither the Greeks nor the Romans did this. In the eighth century of our era the Arabs discovered the number zero through an astronomical work from Indonesia. Only in the twelfth century did the Muslims introduce this in Spain. It would take two more centuries before the whole of Europe could use it. Knowing this

makes the enormous knowledge of the Maya, the Old Egyptians and the Atlanteans ever more impressive.

5) The most amazing thing of all is that the "Holy" calculations of the Maya and the Old Egyptians were supported by our presently-known denary scale! When you look at their calculations, you discover this immediately. The similarities emanate from the present way of adding, subtracting, dividing and multiplying. This means that our present system is an inheritance from the Atlanteans, and that it has been passed on to us through the survivors. With this, the list of Atlantean legacies becomes quite long. Besides the time chronology (seconds, minutes and hours), the Atlanteans gave us astronomy (360 degrees, pyramid volume, etc.), the sunspot cycle, architecture, the art of writing and, now, the denary scale. This is quite a performance for a completely forgotten civilization.

6) The main conclusion is that the Maya and the Old Egyptians knew that their sunspot cycle was just a rough approximation. They knew the exact figures, but only insiders were allowed to use them. With these exact figures they could calculate the moment of the violent reversal of the sun's magnetism. It is up to us to solve this riddle as soon as possible. Only in this way will the world be convinced of the approaching calamity.

16.
THE RAPIDLY
APPROACHING DISASTER

When I started my search for the background of the forthcoming world cataclysm in 2012, I had only about seventeen years left. After writing *The Orion Prophecy* and this book, this period of time had diminished to a bit more than seven years. We are approaching the biggest catastrophe humanity has ever known at a terrifying speed. And up until now I have noticed only a slight interest in this super-challenge. My discoveries have been neglected. As true ostriches, people bury their heads in the sand, completely blind to what is awaiting them. However, the message of the old super-scientists is more than clear: the magnetic field of the earth will reverse in one go and completely destroy our civilization. The people who discovered this sent us a message in an international language, summarized in mathematical and astronomical codes. By projecting myself into their world of thinking, I was able to decipher the biggest part of it. I revealed mystery after mystery, because the whole was based on a meticulous scheme, an immeasurable whole comprising series of numbers, overlapping and complementing each other. To my utter amazement I also discovered that the Maya and the Old Egyptians used our denary scale. The complicated aspect of the Maya number scale was nothing more than a curtain of mist.

Thanks to this discovery I could further expand the whole to other discoveries. In several cases I was able to prove clear correlations between the technical terminology they used in their codes and myths, and its manifestation in their architecture. I found with it a sort of synergy, an all-embracing whole. As if the design of the pyramids and temples called into being the myths, the calendars, their esoteric knowledge, even the life after this life, and more. Through the deciphering of their coded messages I could uncover complex astronomical cycles. That discovery shocked me tremendously. I was absolutely convinced of the fact that our present scientists were the cleverest that ever lived on earth. But this seems untrue.

I was very upset for months. It was as if I had been told that I did not have much more time to live, which was, in fact, the case. In a tearing rush, we are storming ahead to our Armageddon, the world fire. No movie star, however well paid, can save the world from its downfall. On the contrary, considering the wealth and resources they have at hand, they will be the first to try to

save themselves—if they believe that this cataclysm is coming in our direction. But since the press is hardly interested in me, the chance for even that will be very small.

Monuments as a Warning

Many number series and codes of their myths seem to have been converted into their monuments. I want to share here a quote from old Gnostic texts of the Nag Hammadi Library: "Build monuments as a representation of the spiritual places ... and to enlighten the people with important knowledge about the future." In other words, the pyramids, the Sphinx and many other miraculous buildings from a distant past are standing here to warn us and arouse our curiosity, so that we start the search for the "why." In his book *The Orion Mystery*, Bauval proved that the pyramids were built according to the Orion constellation as it appeared 12,000 years ago. Together with Gino Ratinckx, and with the help of a recently developed astronomical software program, I could prove that the construction of the pyramids is related to the precession of the Orion constellation in 9792 BC, the year of the previous catastrophe. In those times the Sphinx was looking at its celestial counterpart. As you might know from my previous book, the last pole reversal took place in the age of Leo. Therefore we are here confronted with a sky-earth dualism, a serious warning about what happened then and what is awaiting us now. Even worse, the precession of those days is identical to the one of 2012, the year of the next pole reversal. This is not the only similarity. Venus meant everything for the Maya. Exactly as it did in 9792 BC, Venus will make in 2012 a perfect circular retrograde loop above the Orion constellation. In the Egyptian Book of the Dead this code is denoted as the movement that foreshadows the end. Here we have again an incredibly serious warning, because this year correlates with the end of the Mayan calendar. In order to display their technical advancement, the Maya built their temples in such a way that they exactly indicate the vernal equinoctial point. And they incorporate other features that show there is an irrefutable relation between their incredibly exact astronomical knowledge and the construction of these temples.

After my further intensive research on the Dresden Codex, I came to the world-shattering conclusion that it concerns the sunspot cycle—a theory that our present astronomers barely know! You can discover this only by means of accurate observations of the sky, consistently carried out over thousands of years and with the help of very advanced mathematics. How highly developed must their mathematical knowledge have been? Very highly, indeed. Much higher than we thought up to now! To describe the

Figure 50. After thousands of years of observations, the ancestors of the Maya and the Old Egyptians could make wide use of the incredibly exact astronomical numbers. They carried out extremely accurate calculations with them in connection to planetary positions.

sunspot cycle theory in mathematical language, you need to know an incredible amount of information about space geometry (the volume and surface of spheres, for example), the calculation of ellipses, and have a great number of other complex arithmetical skills. Egyptian papyri and the deciphering of the Dresden Codex prove that they had this knowledge. And more sensational than that, they also knew integral and differential equations; otherwise it is impossible to calculate the sunspot cycle!

Having so much knowledge at their disposal, it is quite logical that they also should have known the laws of Kepler and Newton! In general, you can discover them with much less knowledge. For that reason I am one hundred percent sure that they knew them. When you do further extensive research on their buildings and way of encoding, you stumble across the number 666, the number of the Apocalypse. Through my extensive research I was able to find the origin of this number which has eluded searchers worldwide for ages. It concerns a deviation in the sunspot cycle. With that I cemented an irrefutable connection between what we know from religion, and the knowledge of the high priests of ancient times.

A Forgotten Wisdom Cult

Where did this knowledge come from? It came from their ancestors, the inhabitants of Aha-Men-Ptah. Why am I so sure of that? The Egyptologist Albert Slosman translated the story of the temples of Dendera, Edfu and Esna. On the basis of the numbers mentioned in the story I was able to make concise decipherings. By consequently using the same way of thinking, I stumbled upon a labyrinth with identical codes and I was then able to decipher the Dresden Codex of the Maya. This gave me the absolute certainty that the story wasn't invented, and that it came from something man had left behind in the night of times—the legacy of a lost civilization that had disappeared during a catastrophic disaster. The key question is now: can part of this inheritance be regained? The implicit answer to this is "yes." The artifacts on which they based their myths and Holy Scriptures are lying in the legendary Labyrinth, as described by Herodotus. Besides this, you can find there the scientific records upon which they based their disaster theory. Retrieving this knowledge alone will cause a world revolution. It reveals the software of the computer program that leads to the exactly calculated date of the "End of Times," the likely definitive "Apocalypse" for humanity. The consciousness of this "End" was at the base of their ambitious projects of sky-imitation: they mirrored on the ground what had happened in the sky or what will happen again. This was the basis

of the whole religion and spiritual thinking of the Maya and the Old Egyptians. They wanted to save the following generations from total annihilation, from the complete disappearance of their knowledge, caused by the magnetic short-circuit on the sun with its super sunstorm. Their obsession with handing down this information intact survived for millennia, but finally their overwhelming knowledge about pole shifts was lost, due mainly to wars. However, they left so many clear clues that it is absolutely impossible to disregard their superior science any longer. Both civilizations knew the precession and the sunspot cycle, and the fatal consequences of a super-deviation in the magnetic field of the sun. In their codes you find the same numbers, like 72 and the numbers of Venus, 576 and 584. If you use the synodic time period of Venus, known by the Maya, you can confirm the story of the legendary Atlantis. Reasoning further on this case, you can decipher the Mayan calendars and the Dresden Codex. These decodings form the undeniable proof that the knowledge of the Maya and the Egyptians comes from a common source. And with this, our collection of proof is complete.

Figure 51. Will we be able to excavate the necessary knowledge from the Labyrinth in time?

Once there was a prosperous country that is now lying under the South Pole, due to a major shift in the earth's crust. Scientists with unparalleled knowledge of astronomy, geometry, mathematics, etc., were part of it. After thousands and thousands of years of research, they discovered a relation between the magnetic field of the earth and that of the sun. Two hundred and eight years before the fatal date, they urged their fellow countrymen to prepare for an exodus. The rulers at that time started a punctilious program that had to secure their escape. Hundreds of thousands of unsinkable Mandjits were built. Despite the disbelief of many people, the fatal disaster took place on the exact day that had been calculated so many years before. In the ensuing chaos, the

greatest part of the population died. And yet, thousands escaped and started their wisdom cult again in different regions of the world. Thanks to them we know today what is awaiting us.

Mobilization or Total Extinction

Somewhat more than twelve thousand years after the previous mobilization, it is now up to us. There is hardly anything more important or urgent than this task. We need to inform humanity as soon as possible that the so-often predicted "End" is really very near. Loads of preparations have to be made, accompanied by numerous sacrifices. We are not individually important, but the continued existence of humanity is. We therefore need to close down the nuclear power plants by the time the fatal date dawns. Should this not happen, survival will likely be impossible: we will die as a result of a nuclear holocaust. Everybody should be aware of this. And that is not all. Since 1915, a huge number of chemical weapons have been produced in Russia, two thirds of which contain nerve gases. It is the largest concentration in the world, and according to chemists this arsenal could kill the whole world population almost 200,000 times! And this does not even include the chemical weapons stockpiled in other countries. If these stocks are not destroyed in time, they will be released in one go in 2012! I think we can all picture what the consequences would be.

Most importantly, the inevitability of the forthcoming disaster needs to infuse your mind. Everything that presently seems important to you, like building a house, having children, etc., pales in light of the total destruction that is awaiting you. A lot of what you want to achieve has absolutely no use. What are you going to do with your beautiful house when it is left in ruins by super-earthquakes, and after that swallowed up by an immensely high tidal wave?

Think and consider carefully all the things you are planning to do. Little withstands so much violence of nature. Only boats, food supplies and survival equipment are of primary importance. Those who do not have them at hand may forget it. In one day this super-catastrophe will cause the loss of thousands of years of work. It is up to you to take up this challenge, the biggest you can ever accept. Maybe then you can play a main role in the next generation of myths about human "super gods" that tempted the violence of nature, and founded a new civilization after the turbulent earth calmed down.

Harmony Regained

The mystery of death and the possibility of eternal life

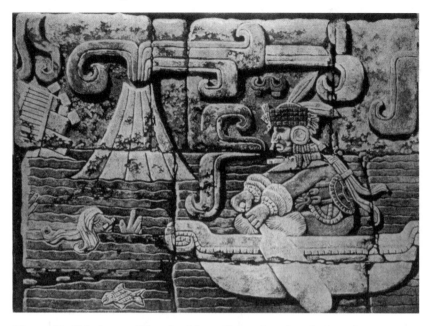

Figure 52. This is a well-known Maya illustration that depicts the previous pole shift. You can see a pyramid collapsing and a volcano bursting out, while the land sinks. Many escaped, as shown by the figure in the boat.

fascinated the ancient world. A science of immortality was related to it. A comprehensive theory was completely developed, and was based to a great extent on fundamental questions about life and death. Nowadays we seldom meet people who believe in an inner order that is based on spiritual insights of great religions from the past. The Egyptians derived their strength and operating capacity from their faith in Ptah. It was for them a useful system of belief, because it gave them goals and rules from which they could build up intense experiences. To them, life consisted of service, and all their doings were focused on the life awaiting them after death. This efficient system ruled their whole life; it gave purpose to it and preserved them from chaotic ideas. Their scientific knowledge about man and the universe revealed to them the relation between humanity and its destiny. Through this understanding they had superior insight into the origins of social control mechanisms, their feelings, hopes and fears. This belief system pushed them in the direction of meaningful goals from which they got their strength. They knew answers to questions like: "What is good and what is bad?," "Why do we live?," "What powers are ruling our lives?," "Why are there cycles in nature that overrule our lives?" They culturally expressed this in their myths and buildings. It is up to us to bring back this long-lost

knowledge. Then, like them, we will be able to reunite ourselves with our surroundings and the meaning of life. This faith, based on the catastrophe cycles, acknowledges the laws of nature. It pushes our spiritual energy in the direction of meaningful targets, because the belief system is based on the scientific knowledge of man and the universe and the expected "End." It develops as if it were an integrated interpretation of all earlier developed knowledge related to humanity and its inescapable destiny. It is useless to connect our dreams and desires to nature without bearing in mind its laws. When we acknowledge the limitations of our civilization and its inevitable end, and again accept a humble place in the universe, we will start to feel like the prodigal son or daughter who finally comes home after years of wandering. If the aim of humanity is united with these values and experiences, the problem of the meaning of life will be solved. Billions of people will then experience the forthcoming catastrophe as liberation, and sacrifice themselves voluntarily to a higher purpose: the continued existence of humanity, and the rediscovery of an overpowering God image.

An Identical Scenario?

The last years of Aha-Men-Ptah had passed in chaos due to the civil war. Before its outbreak, importation and exportation had already come to a standstill, because all attention had been turned to the construction of Mandjits, the unsinkable boats that had to secure their survival. It is often said that history repeats itself. Well, there are alarming parallels with our present situation. As in those days, people at present do not believe a in a supernatural being anymore. Let me describe our possible future in the following paragraphs.

After the overload of stock exchange excesses of the late 20th century and the beginning of the 21st, the world was in an economic recession during the last years before the "End." Despite these difficult economic times, I had succeeded with a bit of luck and perseverance in digging up the Labyrinth with its "Circle of Gold." As a result, the discoveries of earlier wisdom cults were on the front pages of newspapers all over the world. In great disbelief, people were looking at the 36 hieroglyphs with their calculations of the previous catastrophe date—and the next date being in 2012. To many people this was not unexpected, but it had a catastrophic effect on the masses of the world population. The fear of the forthcoming polar shift petrified the thoughts and actions of many.

Soon thereafter the world economy collapsed. The prices of goods reached rock bottom, and then sunk lower. Shortly

before the catastrophe, the economic recession changed into an unmatched depression. Neither politicians nor economists were able to change things for the better. Many branches of economy simply collapsed, for instance, construction. What was the use of building, many wondered? Our world has no future. Others, who in previous years had planned to have children, decided to postpone this indefinitely. The production of goods decreased alarmingly. The continents were tormented with hunger and social unrest. The number of suicides and murders increased tremendously. Stock shares stayed at a low point, far below their historic highs. However, there was bright spot on the investment scene. In ancient civilizations, gold and diamonds had always proved their value. After the reversal of the earth's polarity, money would be worthless, everybody realized. So they all threw themselves en masse into gold and diamonds, which resulted in a sharp spike in the prices of these goods. In a world where there was no more hope, this was one of the few targets left to occupy peoples' enterprising minds. For the rest, lawlessness and anarchy ruled.

In the meantime, protests against the nuclear power plants, chemical factories and oil installations reached a climax. A flood of people raised their voices against the sites that would change the earth into a nuclear holocaust and chemical dump.

Already several plants and factories had been shut down because of the collapsed economies. And yet, a dramatically large number were still operating, too many to keep the world safe from Armageddon. Finally, after massive pressure, just before the catastrophic date, these were shut down too. For a couple of days millions of people were thrown back into the Stone Age, but of one thing they were certain. The world would continue to exist. Maybe not with them, but they were reconciled to this. For them, the prophecy of a "Total End" was unacceptable. Hence their nearly endless drive of self-sacrifice.

Epilogue

Only the future can show what will come of this stream of thought. It could also end as I described in my previous book— only a few believe it and will make an attempt to survive, while the rest of the world population will die during the apocalyptic events. Anyway, I will in any case make an attempt to help humanity to continue to exist. Even with a small group of determined people who have the primary knowledge of as much sciences as possible, this has to be possible. Why couldn't you be one of them? After the catastrophe life will be terribly difficult. There will be no electricity. Even if one is able to revive it, it will

not have much use because all electronics and electrical motors will be destroyed after the reversal of the magnetic field. This means that we have to start again at zero. That is what it comes to. You therefore need to be very motivated. Only a few will meet the requirements. Surviving has little use when you cannot deal with the life after the catastrophe. It will take tens to hundreds of years before you can lead a somewhat comfortable life. Therefore it will not be so for you, but eventually, it will become so for your descendants. Only the ones who properly understand this can make the attempt.

You have no idea of how bad and difficult it will be. Even in the worst war you are able to find some water and food if you are a bit handy. After the catastrophe it will be much more complicated than that. The chemical dump will be unimaginable, the nuclear holocaust horrifying. Billions of liters of oil will not only make the world's seas uninhabitable, but also cover huge parts of land with dirty, polluted residues. Worldwide, food and water supplies will be destroyed, possibly for many years. Famine and numerous diseases will be the result. At present you are not exposed to anything like this; you are leading a luxurious life, and the least infection can make you sick. Despite my good intentions I am afraid of the worst for many. But that is the price you will have to pay for your survival. Should you want to take the chance, I wish you the best of luck. In any case I am your man.

In *The Sibylline Oracles* you can read the following: "And the whole firmament will fall upon the divine earth and on the sea, and then there will be an endless sea of angry flames, and land and sea will burn, and the celestial firmament and the stars and the creation itself will be poured into one melted mass and thereafter completely dissolve. Then there will be no more sparkling eyes of the celestial light, no night, no day, no daily worries, no spring, no summer, no winter, no autumn."

The catastrophes from the past should warn us: nothing is everlasting. Oceans and landmasses exist only temporarily. In an ever-revolving cycle they are destroyed. In one day humanity will know its last, and crash into the abyss. In only a few hours, great nations, beautiful buildings and highly-developed cultures will stagger and completely collapse. This fate is awaiting us and nobody will be able to escape from it. Except those who take the necessary measures—those who are willing and able to take on the responsibilities of being the next "Noah."

PART IV

ASTRONOMICAL AND
MATHEMATICAL PROOF

17.
VENUS, THE KEY
TO ALL MYSTERIES

In the Maya culture, we see that Venus appears abundantly in their literary and architectural creations. In Egypt, on the contrary, we barely find any references to this planet. The reason is that the high priests of Egypt kept this knowledge to themselves. As a result, we were hitherto deprived of many references concerning similarities between the Maya and the Old Egyptians. But now that we know that both cultures have their roots in Atlantis, it cannot be difficult to unravel the codes that link them.

After finishing my previous book, I was still left with numerous questions, which I will try to answer in this publication. In the previous chapters I uncovered several secrets. In this one, I want to pay full attention to the planet Venus. As you know, it takes Venus 243 days to make an entire circle around the sun. With this number many codes can be broken. My intuition drew me straight to the number that shows the shifting of the Zodiac. I divided this number by the orbit period of Venus and came to this amazing conclusion:

$$25{,}920 \div 243 = 106.66666$$

There was 0.6666666 again, a number I have already discussed in Chapter 12, relating to the computer program of the previous crash! Finding it here was not coincidental. This was a good sign. That number, of course, needed further investigation. But before I continued my search, I felt there was still something else. Suddenly I remembered my last conversation with Gino.

"I presume there is something strange about the number series 66666, for it shows up in my calculation schedule," I said. Gino answered, "You are a hundred per cent right. I have a book here in which four different bibles are compared with each other. It says that your number series is the calculation that leads to the Apocalypse!" Gino went looking for his book, and opened it to the passages in question. He had even marked them in red. I was happy to confirm that my calculation schedule was leading to the solution. Still the mysterious number remained in my calculator. Without hesitation, I divided it by the number I found in my previous book about the unraveling of the Zodiac:

$$106.66666 \div 0.333333 = 320$$

The next division resulted in a number that I had seen in my previous schedules:

320 ÷ 0.33333 = 960

At once it became clear that I had to go on dividing. The next two results were familiar to me and to the faithful puzzlers who studied my previous decodings attentively:

960 ÷ 0.33333 = 2,880

2,880 ÷ 0.3333 = 8,640

I could now anticipate what the next result would be: the famous precession number that occurs over and over again.

8,640 ÷ 0.3333 = 25,920

The matter was clear now. I wondered how many calculations the people of Atlantis had to make in order to obtain this wonderfully perfect result! They must have been searching for it for thousands of years. Only the most competent among them were allowed to do this kind of work, and here I was breaking their brilliant logic. In fact, it had been waiting to be accomplished by a logical and simple computer schedule. At school I got used to mental arithmetic; the multiplication tables have always been a real challenge for me. Nowadays, pupils barely learn to work with them. But working out a schedule like this is impossible without them. You cannot decode simple logic with supercomputers or complex differentials. You have to go back to the basics. I think to have proved this more than adequately. I had to find other numbers of course, by continuing in the same way.

25,920 ÷ 320 = 81

25,920 ÷ 960 = 27

25,920 ÷ 2,880 = 9

25,920 ÷ 8,640 = 3

When I divided the interval between the crashes by these numbers, the results were:

11,520 ÷ 320 = 36

11,520 ÷ 960 = 12

11,520 ÷ 2,880 = 4

11,520 ÷ 8,640 = 1.33333

The number at the bottom indicated the code of the Zodiac. Thirty-six and 12 are very important code numbers, but number four isn't. I decided to multiply the numbers in the opposite direction with the solutions I found earlier.

81 x 1.3333 = 108

27 x 4 = 108
12 x 9 = 108
36 x 3 = 108

This was the very same number I would find a little later. Now I knew it would be easy to continue. If things were in accordance with my previous discoveries, the number 0.44444 had to appear several times in this code. In that case I would prove that they used the same countdown to the final date. This had to be easy!
11,520 ÷ 25,920 = 0.44444

This is identical to the countdown to 2012. The number of years between the last crash and the next is:
11,804; 11,804 ÷ (117 x 227) = 0.44444

Then all of a sudden I found two more connections that proved the previous hypothesis.
243 x 0.4444 = 108
11,520 ÷ 108 = 106.66666

I found it! This was exactly what the bible predicted. The number 66666 indicates that the end of an era has been or will be reached. And Venus is the main code in it! When I looked through those above-mentioned codes, another message from the ancient scientists appeared.
243 x 0.33333 = 81
81 x 0.333333 = 27

When I divided the number of the precession by 27, I got:
25,920 ÷ 27 = 960
11,520 ÷ 960 = 12

I immediately decided to multiply the number 576 by 0.33333 and I got:
576 x 0.3333 = 192
192 x 0.33333 = 64
64 x 0.3333 = 21.333
21.333 x 0.3333 = 7.11111

I didn't have to search long to find the correlation with the number I discovered at the beginning of this chapter.
106.6666 x 0.6666 = 71.111111

So when I meet this same number again in a future context, I will know that it concerns the code of Venus. I figured I would

find other codes to confirm this. But not only numerical proofs will show up; astronomical facts will appear abundantly too. First of all I had to come up with more proof, in order to convince nonbelievers. This would not be difficult; all I had to do was to follow the well-known procedure for code breaking.

11,520 x 360 = 4,147,200
11,520 x 365 = 4,204,800
11,520 x 365.25 = 4,207,680

I divided these numbers by the above-mentioned "Holy Number":

4,147,200 ÷ 106.6666 = 38,880
4,204,800 ÷ 106.6666 = 39,420
4,207,680 ÷ 106.6666 = 39,447

I came close to several solutions. Months before, this schedule had puzzled me, but now the solution was easy. However, don't underestimate the power of these numbers. They are not just some boring bookkeeper calculations; they were born in the scientific minds of a high-standing culture. They are connected with the life and death of billions of people. For this reason alone they deserve to be treated with respect. I divided the numbers I just found by a number series I had repeatedly used before.

38,880 ÷ 160 = 243
39,420 ÷ 162.222 = 243
39,447 ÷ 163.333 = 243

These number series were indeed the proof that 243 was a code number. I considered this thoroughly, and found the "Holy Codes" of the Maya and the Egyptians:

38,880 − (18,720 x 2) = 1,440 (1,440 x 27 = 38,880)
39,420 − (18,980 x 2) = 1,460 (1,460 x 27 = 39,420)
39,447 − (18,993 x 2) = 1,461 (1,461 x 27 = 39,447)

That was enough for one day. Thrilled by these discoveries, I decided to take a walk around Antwerp.

A Coincidental Mistake?

This was during the summer of 1997. It was warm outside. Life would be so beautiful, if there weren't an apocalyptic threat hanging in the air, making a mess of everything. All of a sudden it started raining cats and dogs. I took shelter in a bookshop nearby. I strolled through the Astronomy department and looked at a few books that were at hand. In one of them, my attention was drawn to a chapter about the period of the orbit of Venus. I thumbed

through it—maybe I could discover something interesting, you never know! Suddenly I felt as through I had been struck by lightning. "Damn it," I cursed. What had I seen that upset me so suddenly? What I saw that the period of the orbit of Venus was not 243 but 224.7 days. The number 243 was mentioned beneath the orbit period, and involved the number of days Venus needs to rotate on its own axis. Our earth only needs one day to do this, but Venus takes a lot more time. It turns so slowly that it takes over a Venusian year to make one rotation—the Venusian day is longer than its year! How could I have been so stupid? But this led me to discover something incredibly important; you will understand what in a minute. In my previous book I had made a mistake in the calculation of the number of years between the last crash and the following one, but thanks to this mistake I finally came to the right solution! Was it possible that good fortune was once again on my side?

Perplexity

I stared at the numbers in disbelief, but there they were, simple and undeniable. And besides, there are other problems in determining find this number. Venus is covered with an opaque layer of clouds. That is why the mountains and valleys on the surface of this planet cannot be seen. Even the most sophisticated astronomical telescope cannot catch a glimpse of its surface. No matter how long you observe it, it is impossible to measure its rotation time using the normal approach of noting the amount of time it takes for a recognizable feature to reappear. However, since 1964, radar observations have provided another point of view, proving that the rotation lasts 243 days and runs backwards! They have discovered several spots which show an abnormal reflection of the radar waves, resulting in a rough map of the surface underneath the clouds. But now I was coping with an enormous problem. When I thought I had solved the riddle, it seemed only to have grown bigger. I will summarize my findings:

1) The codes prove that the number 243 is important and was well known by the people of Atlantis.

2) The number 25,920 shows us the precession of the earth. This means that after 25,920 years the earth has made one retrograde rotation around its axis. Each year, the earth rotates 3.333 seconds less around its axis, which amounts to 86,400 seconds (or one day) after 25,920 years. This is a similar code to the one of Venus because the movement of Venus is opposite of the earth. It takes Venus 243 days to turn around its axis in reverse mode to the earth. That is the reason why these 243 days were found amongst their code

calculations. The earth and Venus have a common point of contact: the orbit period lasts one day in 25,920 years in earthly time and 243 days in Venus time! They couldn't have chosen a more brilliant point of departure!

3) The orbit period of Venus can only be registered by a sophisticated technological apparatus. Did the people of Atlantis have such equipment? If they did, the implications are enormous, but I cannot find any other explanation. Furthermore, we know now that they had knowledge about solar magnetism and the sunspot cycle, for which you need at least telescopes and probably other equipment. And what is more, you need a precision clockwork to measure the orbit period of Venus and the earth, as well as to fix your position on earth in order to make accurate maps. And they did all this! At this point, I turned completely mad. I had started out to prove that the prophecies they made were the result of simple measurements. But I was stuck here. Whatever I did I found no solution, not even after days of research. My perplexity was complete! I decided not to dwell on this unsolved matter, and to go on working with my previous calculations. And this is what I found. I subtracted the "Holy Numbers" of the Egyptians from the previous number series and the result was:

$$38,880 - 1,440 = 37,440 \ (1,440 \times 26 = 37,440)$$
$$39,420 - 1,460 = 37,960 \ (1,460 \times 26 = 37,960)$$
$$39,447 - 1,461 = 37,986 \ (1,461 \times 26 = 37,986)$$

I was obviously on the right track. To start with, look at the number right in the middle. It is a most important number for the Maya! Every Maya specialist should become excited looking at it, as did I. The Venus table in the Dresden Codex gives us a clear view of the ritual Maya calendar, showing the positions of Venus in the sky. This Venus table refers to 65 cycles of 584 days, which means 37,960 days all together, equal to 146 of the total number of cycles of 260 days of the Maya calendar, as well as to 104 of the Maya solar years of 365 days. Could there be a more convincing proof than this? I decided to go on with my searching, and I soon discovered this:

$$37,960 - 37,440 = 520$$
$$37,986 - 37,960 = 26$$

Both results are extremely important. They show the number that is to be subtracted from excessive sun cycles, in order to obtain the length of a normal and a long sunspot cycle. (See Chapter 24, "The Dresden Codex Decoded," further on). Besides, I rediscovered another number I had already used to decode the computer plan leading to the crash in 2012. You have to divide the

number of days between the previous crash and the one to come by the numbers mentioned above, and you will get this result:

4,249,440 ÷ 37,440 = 113.5
4,308,460 ÷ 37,960 = 113.5
4,311,411 ÷ 37,986 = 113.5

113.5 x 104 = 11,804 = the time between the previous and the next crash.

Herewith I wanted to show that the same numbers might be used over and over again. With a feeling of satisfaction about my discoveries, I decided to continue working with the above-mentioned numbers. I divided the number of the Dresden Codex referring to the switching of the magnetic field by my series:

1,366,560 ÷ 37,960 = 36
1,366,560 ÷ 37,440 = 36.5

This result matches perfectly again; 36 and 36.5 refer to 360 and 365 days. Hoping for the best, I divided the numbers referring to the sunspot cycle by the ones mentioned above. Have a look at the curious result:

68,328 ÷ 37,960 = 1.8
68,302 ÷ 37,440 = 1.8243055555
Subtract these two and you get 0. 0243055555.

When you subtract the number series 55555 the result is simply 243! This cannot be a mere coincidence. This has been mixed into the scheme on purpose, believe me!

18.
FURTHER DECIPHERING
OF THE NUMBER 576

A few simple calculations show us the relation between the duration of the previous catastrophe and our important code number:

11,520 ÷ 576 = 20

The number 20 occurs regularly in the Maya culture, and also in my calculations. For instance, every twenty years the Maya threw away their kitchen utensils and replaced them. This, of course, was not done just for fun. Other well-defined calculations based on this cycle are the next ones:

18 x 20 = 360
360 x 20 = 7,200
7,200 is a Katun in the Maya and 360 is a Tun.

Another important reference is the Tonalamatl:

13 x 20 = 260

And this is not the end. You can find the number 20 in the calculations of the solar magnetism: 68,328 x 20 = 1,366,560 = code number Dresden Codex for the Maya sunspot cycle.

68,302 x 20 = 1,366,040 = the number that refers to the 20th cycle in which the sunspot cycle switches poles. All these numbers show us very clearly the source of this number 20. In case you still don't believe me, divide 576 by 50 invisible days and the result is:

576 ÷ 50 = 11.52

When you now multiply this by 1000, you get the exact interval of the previous crash! Of course, it doesn't stop here. Take my last book; look at the chapter about the Zodiac. Take a look at the duration of the different signs of the Zodiac. There you will find the number 576 twice in the calculation of the former crash, at the beginning and at the end! This indicates that Venus—astronomically—shows us a certain code. We have already discovered this same code, as well as a second one. The Egyptians actually did everything in duplicate, and probably the inhabitants of Atlantis did the same. How could it be otherwise? It was then obvious to me that I had to go on looking for more codes.

There were still the eight days during which Venus disappears behind the sun. When I multiplied eight by the small "Holy Numbers" of the Maya and the Egyptians, I obtained the number of the shifting of the Zodiac and the orbit period of Venus. Now I know that both numbers refer to Venus.

72 x 8 = 576
73 x 8 = 584

Once again this proved that the codes were related to each other. The period of eight days when Venus disappears behind the sun indicates that Venus and the sun are closely connected. Venus refers to the bygone switches of the magnetic field of the sun, and also the big one to come, which will cause the catastrophe on earth.

I found one additional connection: Venus makes 13 orbits around the sun in eight years. This was once more a remarkable reference to the previous numbers already known.

13 x 8 = 104. 104 is a well-known Mayan number, seen above.

After making all these surprising discoveries, one after another, I took a break. Thanks to logical reflection and obstinate persistence, I had recovered many codes in the calculations of the interval between the crashes. Nobody could deny that—the connections are too obvious. So I resumed searching. I looked more closely at the number of the orbit period of Venus (= 225). Would there be a correlation with our major number? The answer was given by a simple subtraction.

576 - 225 = 351

This needs no further explanation. I used the number 351 several times to hack other codes. I got there by logical reflection: it is equal to 117 x 3. So I decided to go on playing with the number 225.

25,920 ÷ 225 = 115.2

Again, the duration of the previous crash appears. Can this be a coincidence, I ask all skeptics? Further additions and subtractions resulted in:

243 – 225 = 18
225 + 243 = 468 = 26 x 18 = 13 x 36

You now see at once where the Maya got their basic numbers of 18 and 13. It's all coming from Venus! This encouraged me to go on calculating for a while, and I bumped into some wonderful similarities.

468 + 18 = 486 (27 x 18 = 486)
486 – 18 = 450

Both numbers are separately referring to a code number.
486 ÷ 450 = 1.08

I had already discovered the number 108, so this was a simple statement. The next one came out of the following calculation:
25,920 ÷ 450 = 57.6

Here is our glorious number 576 again! Don't think that I am trying to impose this upon you; continuous investigation confirmed everything. The numbers 18 and 13 are very important. You can easily find them again.
351 = 13 x 27
486 = 18 x 27

Here is another number I rediscovered, which is connected with the switching of the magnetic field of the sun:
351 – 18 = 333
576 – 243 = 333
333 = 37 x 9

The polar magnetic field of the sun completes an orbit in 37 days. I proved as follows that this is correct:
576 ÷ 243 = 2.37037037

Also the number 486 refers to the switching of the magnetic field.
11,520 ÷ 486 = 23.7037037037

I can show you now that the numbers 24, 5, and 184 are important.
106.6666 x 243 = 25,920
106.6666 x 225 = 24,000
106.6666 x 486 = 51,840
And what is more: 576 x 9 = 5,184 (the multiplication by 9 is used several times).

19.
THE VENUS CODE
OF THE ZODIAC

Two days later, I decided to have another close look at the code of the Zodiac. More codes still had to be found. There was too much logic involved to ignore this. You know that there are only four possible timetables in the Zodiac: 2,592, 2,304, 2,016 and 1,872 years. I multiplied them by 36 and divided them by the code number of Venus:

$2,592 \times 36 = 93,312 \div 576 = 162$

$2,304 \times 36 = 82,944 \div 576 = 144$

$2,016 \times 36 = 72,576 \div 576 = 126$

$1,872 \times 36 = 67,392 \div 576 = 117$

I recognized at once three numbers I had already seen: 162, 144 and 117. The number 126 was unknown to me. Maybe I could use it some other time. Or did it not mean anything, for the number 576 (72,576) figured in the result? I made a few simple calculations:

$162 - 144 = 18$

$144 - 126 = 18$

$126 - 117 = 9$

When I add these three numbers, the result was 45:

$18 + 18 + 9 = 45 =$ the total number of deviating bits in a sunspot cycle of 68,302 days

So far, everything was going fine. So I continued working the easy way. Following are my next calculations.

$162 \div 18 = 9$

$144 \div 18 = 8$

$126 \div 9 = 14$

$117 \div 9 = 13$

The people of Atlantis always worked with number series. I soon found the connection.

$9 \times 8 = 72$

$14 + 13 = 27$

The same integers appeared in 72 and 27, but reversed. A multiplication resulted in: $72 \times 27 = 1,944$.

The lengths of time of the Zodiac divided by this number are:

$2{,}592 \div 1{,}944 = 1.333333$

$2{,}304 \div 1{,}944 = 1.185185$

$2{,}016 \div 1{,}944 = 1.037037$

$1{,}872 \div 1{,}944 = 0.962962$

The series 1.333333 made me think of the important number 0.33333. I was acquainted with 37, and so I continued calculating:

$0.333333 \div 37 = 0.009009$

$0.185185 \div 37 = 0.005005$

$0.962962 \div 37 = 0.026026$

I considered these numbers over and over again. They looked too beautiful. There had to be more about them! And soon I got the answer.

$9 \times 5 = 45$ (previously discovered)

$26 \times 45 = 1{,}170$

$26 \times 5 = 130$

$26 \times 9 = 234$

A few simple subtractions gave me deeper understanding.

$1{,}170 - 130 = 1{,}040$

$234 - 130 = 104$

$1{,}040 - 104 = 936$

So I ran into the number 936 again! It will soon be clear to you why they worked this number out separately in the Zodiac code number.

The Sunspot Cycle of the Maya

I ran into the number 8,424 in some of their calculations. A few quick calculations gave the relation:

$8{,}424 \div 117 = 72 \quad 72 \times 36 = 2{,}592 =$ the longest duration of a Zodiac age

$8{,}424 \div 162 = 52 \quad 52 \times 36 = 1{,}872 =$ the shortest duration of a Zodiac age

The number 8,424 is related to the big magnetic shift number of the Maya that you can find in the Dresden Codex:

$8{,}424 \times 162.2222 = 1{,}366{,}560$

The basic numbers in order to get this are 26 and 37. I decided to use them for the longest and the shortest duration of the Zodiac ages:

$2{,}592 \times 26 = 67{,}392$

When adding 936 to this result, I obtained the small magnetic shift number:

67,392 + 936 = 68,328 = the sunspot cycle of the Maya

Next, I multiplied the shortest length of the Zodiac by 37 and here is what I got: 1,872 x 37 = 69,264. I subtracted 936 and once again I bumped into the sunspot cycle of the Maya: 69,264 – 936 = 68,328. Of course this couldn't be a coincidence. I soon discovered why: 936 x 20 = 18,720.

This is not only a "Holy" Maya number, but—when divided by 10—it refers to the shortest time in the zodiac. Out of curiosity, I divided the already used numbers of the Zodiac by 72 and I got a very interesting result.

2,592 ÷ 72 = 36
1,872 ÷ 72 = 26
26 x 36 = 936!

You see that the same numbers always appear.

The Decoding of the Number 720

After discovering this, I soon found other connections. To start with: the series I already had from the beginning:

2,592 ÷ 162 = 16
2,304 ÷ 144 = 16
2,016 ÷ 126 = 16
1,872 ÷ 117 = 16

We had earlier obtained the number 45 in the same series, so I multiplied it by 16: 45 x 16 = 720, indicating the difference between the shortest and the longest duration of the Zodiac: 2,592 – 1,872 = 720!

Another sequence confirmed this remarkable discovery without doubt:

2,592 ÷ 45 = 57.6 57.6 – 51.2 = 6.4
2,304 ÷ 45 = 51.2 51.2 – 44.8 = 6.4
2,016 ÷ 45 = 44.8 44.8 – 41.6 = 3.2
1,872 ÷ 45 = 41.6

6.4 + 6.4 + 3.2 = 16!

I could also prove this in another way (look at the very beginning).

2,592 ÷ 18 = 144 144 – 128 = 16
2,304 ÷ 18 = 128
2,016 ÷ 9 = 224 224 – 208 = 16
1,872 ÷ 9 = 208

When you sort these numbers in another order, you get:

$224 - 128 = 96$ $96 - 80 = 16$

$224 - 144 = 80$

$208 - 128 = 80$ $80 - 64 = 16$

$208 - 144 = 64$

The last number, 64, is equal to 4 x 16. I had already found a series of 4 x 16. That is why I multiplied 64 by 45:

$64 \times 45 = 2{,}880$

This had to be a special number. Looking at it more closely, the following was revealed:

$2{,}880 - 720 = 2{,}160 \times 12 = 25{,}920$

$2{,}880 + 720 = 3{,}600 \times 7.2 = 25{,}920$

When I divided the time between the previous crashes by this number, I got an extremely remarkable result:

$11{,}520 \div 2{,}880 = 4$

One multiplication with the various calendars resulted in the "Holy Numbers" of the Egyptians.

$4 \times 360 = 1{,}440$

$4 \times 365 = 1{,}460$

$4 \times 365.25 = 1{,}461$

A simple calculation with the number 64 confirmed it.

$11{,}520 \div 64 = 180$

18 is a number that is used in many calculations:

$18 \times 1{,}440 = 25{,}920$

The Precession Cycle, Resulting from a Calculation with 576

A little investigation of the series I discovered before, revealed the next result:

$576 \times 162 = 93.312$ $93{,}312 - 82{,}944 = 10{,}368$

$576 \times 144 = 82{,}944$ $82{,}944 - 72{,}576 = 10{,}368$

$576 \times 126 = 72{,}576$ $72{,}576 - 67{,}392 = 5{,}184$

$576 \times 117 = 67{,}392$

$10{,}368 + 10{,}368 + 5{,}184 = 25{,}920 = \text{precession cycle}$

We had found the relation with Venus earlier; now was the moment to have a close look at its orbit period. As you know, the Maya used two numbers for the synodic cycle of Venus. The "Holy Number" 584 and the more precise value 583.92. After this period

Venus is again positioned exactly at the same spot in the sky. By subtracting these two numbers you get a difference of 0.08 days. Thorough investigation provides an important result. Attentive readers know that the number 117 has already been multiplied by 584. By doing so, you get a little oversized sunspot cycle of the Maya. When you multiply 117 by 0.08 you get 9.36. This is a very special number I have used before. With it, I was able to prove some important theses. For instance, when you divide the Maya super-number of the solar magnetism by 936, you get the "Holy Numbers" of the Egyptians. It cannot be a coincidence that it should show up again right now! I had cracked lots of codes by means of this number. Such striking similarities are just too obvious to be ignored. Besides, I encountered the numbers 117 and 936 in the chapter about the number 666. They refer to the time between the previous crash and the one to come!

A Formula for Essential Numbers

I got another striking result from the next calculation:
$576 \div 0.33333 = 1{,}728$

In my last book I rediscovered that number several times, and worked with it. It appeared to be time to use it once again. The period between the previous crashes was 11,520 years.

$11{,}520 \div 72 = 160$
$25{,}920 \div 160 = 162$
$11{,}520 \div 162 = 71.1111$

Which led me to the number series 0.8888888 I already knew from former calculations:
$72 - 71.11111 = 0.888888$

And so, the next step gave me the period of Venus around its axis.

$1{,}728 \div 72 = 24$
$1{,}728 \div 71.1111 = 24.3 \ (= 243)$
And this is the right answer: 243!

The next result confirmed my former quest completely. Previous calculations had already shown the number 1,944, which led me to some splendid evidence. This time it was easy to find it:
$1{,}728 \div 0.88888 = 1{,}944$

And this resulted in the next evidence:
2,592 ÷ 1,944 = 1.33333
2,592 ÷ 24 = 108
2,592 ÷ 24.3 = 106.66666

Finally: 108 – 106.66666 = 1.3333333!

Summary

When you decode the Egyptian Zodiac, you find the sunspot cycle of the Maya. And this leads you automatically to the number that shows us the amount of deviating bits in a cycle. More decoding numbers, such as 1,944, 1,728, 67,392 and 936 show up in the Dresden Codex as well. This deciphering proves that the Maya and the Egyptians had a common origin.

20.
THE SOTHIC CYCLE, THE ZODIAC AND OUR TIME CHRONOLOGY

I discovered a most interesting indication for the Sothic cycle in an old book titled *Eléments d'Astronomie* dating from 1860, written by Pierre Lachèze and edited by V. Palmé. I repeat literally what it says on three topics:

The precession of the equinoxes:

"The precession is a phenomenon which is caused by the slowing down of the equinoxes. Therefore, the sun takes more time to get into conjunction with the same star. In practice, this means that the sun takes longer to reach the same position in the sky."

The solar day:

"The solar day is the time between two successive mid-days, or in other words: two successive passages of the sun on the same meridian. This lasts exactly 24 hours."

The sidereal day:

"The sidereal day or sidereal revolution indicates the time which the stars need to complete an orbit, or to pass twice through the same meridian. This lasts 23 hours and 56 minutes."

The difference between the sidereal and the solar day causes the precession or shifting of the Zodiac. When you multiply the four minute difference by each calendar cycle, you get as a result:

$$365.25 \times 4 = 1{,}461$$
$$365 \times 4 = 1{,}460$$
$$360 \times 4 = 1{,}440$$

Divide 1,440 by 60 minutes in order to obtain the number of hours, and you get 24 hours ($1{,}440 \div 60 = 24$).

After 365 days you have 20 additional minutes left = 1/3 of an hour = 1,200 seconds. A complete year makes a difference of 1,260 seconds, which causes the precession.

$$1{,}440 \div 60 = 24 \text{ hours}$$
$$1{,}460 - 1{,}440 = 20 \text{ minutes}$$
$$1{,}460 = 24 \text{ hours} + 20 \text{ minutes (or 1,200 seconds)}$$
$$1{,}461 = 24 \text{ hours} + 21 \text{ minutes (or 1,260 seconds)}$$

After three years it shows a difference of:

$$24 \times 3 = 72 \text{ hours}$$
$$24 \; 1/3 \times 3 = 73 \text{ hours}$$

And after 72 years, the difference has increased to:
24 x 72 = 1,728 hours
24 1/3 x 72 = 1,728 + 24 = 1,752 hours

It is very important to have a close look at the number 1,728 here. I used this number of essential meaning in my calculations to decode the Zodiac. You will soon know its origin. When changed into seconds, the result is:
1,440 x 60 = 86,400
1,460 x 60 = 87,600
1,461 x 60 = 87,660

When divided by the number of days in one calendar year, you get a well-known number:
86,400 ÷ 360 = 240
87,600 ÷ 365 = 240
87,660 ÷ 365.25 = 240

Also, dividing by the number of degrees in a complete circle gives a well-known series (see Chapter 4).
86,400 ÷ 360 = 240
87,600 ÷ 360 = 243.3333
87,660 ÷ 360 = 243.5

Starting with these numbers, you can rediscover the Atlantean code of the precession.
243.3333 − 240 = 3.3333

3.3333 denotes the number of seconds that the earth shifts within the Zodiac in one single year. I decided to continue investigating this, because of the relation with the Zodiac code, which includes the number 576. If you follow my arguments, you will find some well-known series (see Chapter 17).
86,400 x 25,920 = 2,239,488,000 ÷ 576 = 3,888,000
87,600 x 25,920 = 2,270,592,000 ÷ 576 = 3,942,000
87,660 x 25,920 = 2,272,147,200 ÷ 576 = 3,944,700

From the result of the next calculations, we may assume that there are still more codes. The real length of a calendar year is 365.2422. The Maya counted with 365.242 days. Further calculations resulted in:
0.2422 x 86,400 = 20,926.08
0.242 x 86,400 = 20,908.8

When you subtract these numbers, you get a code:
20,926.08 − 20,908.8 = 17.28 = an important code number!

As I noticed that number eight appeared twice behind the decimal, I decided to divide by eight:

20,926.08 ÷ 8 =2,615.76
20,908.8 ÷ 8 = 2,613.6
2,615.76 – 2,613.6 = 2.16
216 = precession code! = anagram for 261.

It is even more fun to look at the whole. In the calculations you see the numbers 576 and 36 as 5.76 and 3.6.
576 ÷ 36 = 16 (16 appears after the decimal in the third equation above)

This discovery proves that the people of Atlantis had an incredibly precise time calculation. They were capable of detecting differences of less than 0.01 second in one year. This was without doubt superior astronomy! So I concluded there had to be more hidden codes: 20,926.08 seconds can be subdivided in 5 hours and a number of seconds. 5 hours is equal to 18,000 seconds. The remaining amount of seconds is:
20,926,08 – 18,000 = 2,926.08

We find the number eight after the point. Again there are codes to be discovered:
2,926.08 ÷ 8 = 365.76 (again 36 and 576!)

The code hidden behind this: 36 x 576 = 20,736.
Now add the square of 72 (72 x 72 = 5,184), and you get the precession number = 25,920.
So calculations with 72 should be found elsewhere. Here they are.
2,926.08 ÷ 72 = 40.64
2,926 ÷ 72 = 40.638888
40.64 – 40.63888 = 0.0011111 (11.1111 = precession code)
Another proof: 72 x 24 = 1,728 and 72 x 8 = 576

Division by eight gives the next results:
2,926 ÷ 8 = 365.75
365.75 – 365.242 = 0.508
2,926.08 ÷ 0.508 = 5,760 = code number

Dividing further by 60 seconds results in a number of minutes:
2,926.08 ÷ 60 = 48.768
2,926 ÷ 60 = 48.76666
Difference: 0.013333 = well-known code number (1.3333 x 27 = 36). The Hindus divided the Zodiac in 27 parts of 13.3333 degrees!

The remaining number of seconds is:
48 x 60 = 2,880
2,926.08 – 2,880 = 46.08
2,926 – 2,880 = 46

In this decoding you notice that the remaining Maya number—0.08—is missing.
46.08 x 8 = 368.64 (the numbers 36 and 864 are hidden here)
46 x 8 = 368
46 = anagram for 64, and 64 appears after the decimal
368.64 ÷ 64 = 5.76 (look above: 365.76)
368 ÷ 64 = 5.75 (look above: 365.75)

Incredible Accuracy

The fact that in many calculations the occurrence of number eight was so striking, and that 0.08 was missing in the decoding of the Maya number, made me think that they were able to calculate much more precisely than we could ever presume. I dropped the number eight after the point and found the following duration of a solar year:
20,926 ÷ 86,400 = 0.242199074074074074

This value is so incredibly precise! The present value, calculated with atomic clockworks and supercomputers is 365.242199074.
The Maya counted using 365.242 days. Further calculation results in:
0.242 x 86,400 = 20,908.8

When you drop the number eight after the decimal you get:
20,908.8 – 0.8 = 20,908

Divide as above:
20,908 ÷ 86,400 = 0.24199074074074

The resemblance to the present value is amazing. Only the number two is missing, just like in the Maya number where a two is missing. For that reason, more codes had to be found. Follow my thoughts, and you will find them easily. Skip the infinite series 74:
0.24199 x 86,400 = 20,907.936 (the number 936 after the point!)
0.242199 x 86,400 = 20,925.9936

Subtract the first result from the second:
20,925.9936 – 20,907.936 = 18.0576 (the number 576 after the point!)

This is remarkable because 576 ÷ 864 = 0.66666666 = supercode number!

When you drop the number 576 after the point and you divide 18 by 86,400, you get the difference between the Maya value and the real value for the orbit period of the earth around the sun.

920,926 – 20,908 = 18 (rounded numbers from above)
18 ÷ 86,400 = 0.00020833333
0.242199074074074 – 0.24199074074074 = 0.0002083333
18.0576 ÷ 86,400 = 0.000209 (x 100,000,000 = 20,900)
209 – 208.3333 = 0.666666
You can find the number 0.6666666 in the next calculation:
0.00000074074074–0.000000074074074=0.0000006666666666

I had already used this number to hack the computer program of the previous crash. It is logical that they should have used it, for here it is, hidden in the calculations of the orbit period of the earth around the sun!

The Sidereal Orbit Period of the Earth
In order to obtain the exact orbit period of the earth around the sun, we have used 20,926 as a value. For the Maya value we used 20,908. There is a correlation with the value 20,900 we decoded a moment ago:

20,926 – 20,900 = 26
20,908 – 20,900 = 8
20,926 – 20,908 = 18

Eight is a special number, and we have used it before in the calculations. Multiply eight by 18 and 26.

26 x 8 = 208
18 x 8 = 144

Subtract the second number from the first.
208 – 144 = 64

You also obtain 64 by doing the following multiplication:
0.000000074074074074 x 86,400 = 0.0064

Which leads us to the sidereal orbit period of the earth:
365.25 + 0.0064 = 365.2564!

Conclusions
1) Using the Sothic cycle, it is possible to decode the orbit period of the earth around the sun. The result is an incredibly precise number, which exceeds the currently-used value!

2) The Maya number for the orbit period of the earth around the sun confirms the decoding of the Sothic cycle. Once more, this proves the common origin of the Maya and the Egyptians.

3) Proceeding with the decoding, it became clear that they knew precisely the sidereal orbit period of the earth. I was grateful to make use of this knowledge in my further decodings.

PART V

THE DRESDEN
CODEX DECIPHERED

21.
THE MAYA
CALENDARS REVEALED

In Chapter 5 about the hidden code in the interval between the crashes, you have read that the Maya value of the synodic orbit of Venus led to the deciphering of super-important Atlantean code messages. I reasoned further from this starting point, and succeeded in deciphering the presently known numbers, and those of the Maya in exactly the same way. The Maya priests worked with a rather complex calendar for the Venus cycles. The series of my discoveries started with the Maya statement that five Venusian years are equal to eight terrestrial years. Besides that, there had to be a connection with the religious calendar of 260 days, a cycle that consists of a succession of 13 Holy Numbers plus a series of 20 named days. The final product of all this arithmetic was a Big Venus Almanac for 104 years that contained 54 Venus cycles and 146 Religious Almanacs. To break the codes, I started with the Maya proposition: 5 Venusian = 8 terrestrial years.

5 x 576 = 2,880
5 x 584 = 2,920
5 x 583.92 = 2,919.6

Multiply the various of the orbit periods of the earth by 8.
8 x 365.242 = 2,921.936 (the number 936 after the decimal!)
8 x 365 = 2,920
8 x 365.25 = 2,922
8 x 365.2422 = 2,921.9376
8 x 360 = 2,880

In two cases the numbers of Venus are equal to those of the earth. So what the Maya claimed is literally true. But the correlations do not end there. Subtract the orbit period of Venus from the corresponding Maya value for the earth:
2,921.936 – 2,919.6 = 2.336

Do the same with the exact orbit period of the earth:
2,921.9376 – 2,919.6 = 2.3376

Divide these numbers by eight:
2.336 ÷ 8 = 0.292
2.3376 ÷ 8 = 0.2922

You can see both numbers also appear above! This proves that the Maya knew the exact orbit period of the earth! Further calculations produce the following:

2,921.9376 – 2,921.936 = 0.0016
2,922 – 2,921.936 = 0.064

Leave out the decimal point in the number above, 2.3376, and divide it by 64 and 16:

23,376 ÷ 64 = 365.25 = orbit period of the earth around the sun
23,376 ÷ 16 = 1,461 = Sothic cycle

Repeat the same process for 2.336:

2,336 ÷ 64 = 36.5
2,336 ÷ 16 = 146 (= number of magical years; see below)

The proof can be extended to a sidereal year (= time period traversed by the earth, measured in relation to the stars, which amounts to 365.2564 days):

8 x 365.2564 = 2922.0512

Now subtract the value of Venus:

2,922.0512 – 2,919.6 = 2.4512

Leave out the decimal point and divide as above by 8, 64 and 16:

24,512 ÷ 8 = 3,064*
24,512 ÷ 64 = 383*
24,512 ÷ 16 = 1,532*
*These codes will be used later to break the Dresden Codex.

The Longer Maya Cycle:
Overwhelming Proofs for this Proposition

65 Venusian Years = 104 Terrestrial Years = 146 Magical Years

When I had the knack of the elementary decipherings, I was able to extend these to the Maya values as mentioned before. Multiply in the same way as we did in the previous argument, with the values of Venus:

65 x 584 = 37,960
65 x 583.92 = 37,954.8
Two values for the earth produce the following:
365 x 104 = 37,960
365.242 x 104 = 37,985.168

A first code is simple:
37,960 − 37,954.8 = 5.2

The difference between the orbit periods of the earth and Venus amounts to:
37,985.168 − 37,954.8 = 30.368

Dividing the well-known numbers produces the following (leave out the decimal point):
30,368 ÷ 104 = 292 (see the cycle of five Venusian years)
30,368 ÷ 1,898 = 16
30,368 ÷ 8 = 3,796 (x 10 = full cycle)
30,368 ÷ 52 = 584 (Venus number)

Further correlations:
52 x 0.08 = 4.16
30,368 ÷ 416 = 73
73 x 52 = 3,796

Now multiply the modern value of the orbit period of the earth around the sun by 104:
365.2422 x 104 = 37,985.1888

Subtract the Maya value for Venus:
37,985.1888 − 37,954.8 = 30.3888

Leave out the decimal point and magnify ten times the number above—30,368—so that it will become uniform:
303,888 − 303,680 = 208

A first calculation proves the correctness of this decoding:
30,368 ÷ 208 = 146 = magical years (146 x 260 = 37,960)

Further decodings produce the following:
303,888 ÷ 8 = 37,986 (= 1,461 x 26 and 37,986 − 37,960 = 26)
303,888 ÷ 208 = 1,461 = Sothic cycle
303,888 ÷ 16 = 18,993 = number of days in 52 years
303,888 ÷ 104 = 2,922 = (see 5 Venusian = 8 terrestrial years)

Just like the preceding calculation, this can be extended to the sidereal orbit period of the earth:
365.2564 x 104 = 37,986.6656

Subtract the value of Venus:
37,986.6656 − 37,954.8 = 31.8656

The division produces code numbers:

318,656 ÷ 104 = 3,064 = number to break the Dresden Codex
318,656 ÷ 383 = 832 = 52 x 16
318,656 ÷ 208 = 1,532 = number to break the Dresden Codex
318,656 ÷ 16 = 19,916 = 52 x 383

An even bigger Maya cycle shows the same phenomenon:
5,200 x 365 = 1,898,000 = 7,300 x 260
3,250 x 584 = 1,898,000

The Code for the Magical Year

A first code confirms the cycle of 260 days. Replace 584 by the correct Maya number 583.92:
3,250 x 583.92 = 1,897,740

Subtract this number from the known Maya value:
1,898,000 − 1,897,740 = 260 = magical year!

Other calculations produce the following:
5,200 x 365.242 = 1,899,258.4
1,899,258.4 − 1,897,740 = 1,518.4
1,518.4 ÷ 8 = 189.8 (x 100 = numbers of days in 52 years according to Maya cycle)
5,200 x 365.2422 = 1,899,259.44
1,899,259.44 − 1,897,740 = 1,519.44
1,519.44 ÷ 8 = 18,993 = cycle of 52 years of 365.25 days
1,519.44 − 1,518.4 = 1.04 = calendar cycle
1,518.4 ÷ 1.04 = 1,460 = Sothic cycle
1,519.44 ÷ 1.04 = 1,461 = Sothic cycle

The sidereal orbit period of the earth shows some interesting numbers:
5,200 x 365.2564 = 1,899,333.28

Subtract the value of Venus:
1,899,333.28 − 1,897,740 = 1,593.28
159,328 ÷ 8 = 19,916 = 52 x 383
19,916 − 18,980 = 936 = code number
1,593.28 ÷ 1.04 = 1,532 = number to break Dresden Codex

Further Evidence for the Maya Calendars

This argument is an extension of Chapter 14, "Incredibly Exact Astronomical Numbers." Intrigued readers know that Venus was not only used to determine the period of the sunspot cycle, but also to point out a cycle of 37,960 days (65 x 584). Following

their natural arithmetical instinct, they multiplied 65 by 0.08 and found 5.2. With this they uncovered an age-old code: the cycle of 52 years. And yet attentive readers will not leave it at that; they will start digging deeper, because one thing is related to another. Codes exist to be broken. They start typing the figures into their calculator. And when they—according to the Maya way—multiply the orbit period of the earth around the sun by 52, they will find the following strange outcome: 365.242 x 52 = 18,992.584. Seeing the figures after the decimal point, many will not be able to suppress a cry of joy, because it is the number 584. This is the orbit period of Venus, required for it to show up again at exactly the same place!

Further Deciphering

Take the correct orbit period of the earth around the sun: 365.2422 days. The difference with the Maya calculation is 0.0002 days. When you multiply this by 52, it produces 0.0104. Leaving out the decimals it results in 104. And with that the circle is complete. If you multiply 104 by the number of days of a solar year—365—it produces 37,960. This reveals the Maya calendar. To prove that this is correct, you can calculate with the numbers of the precession. You have found those in Chapter 14, "Incredibly Exact Astronomical Numbers":

5,184 x 52 = 269,568 ÷ 25,920 = 104
20,736 x 52 = 1,078,272 ÷ 25,920 = 416

When you look closely at the last two numbers, you will find the irrefutable proof that you are right: 104 + 416 = 520. A multiple of 52! You are now left with a number you don't know what to do with: 416. You will soon find the solution: 18,993 – 18,992.584 = 0.416.

What other mathematical revelations will we encounter? I looked attentively at the previous calculations, and soon I saw that the logic that was based on the "Holy Numbers" was screaming to be broken. Seen in a purely mathematical way, the following calculations produce an intriguing correlation with the ones above:

5.2 – 5.184 = 0.016
416 ÷ 16 = 26
104 ÷ 16 = 6.5

You know 26, but not the other one, 6.5. What can be the meaning of this? Well, you don't have to search long for that. You saw before the cycle of 37,960. And look! The miracle is taking place: 37,960 gives three calendars; the Venus, sun and

moon calendars. They are all together in this cycle. And the code numbers 26 and 65 are in it! Many consequences are connected with these findings. The mathematics of the Maya and the Atlanteans were more advanced than we suspected up to this day. They contain internal structures that lead to mysterious but well-chosen messages. The summarized formula is as follows:

Moon: 260 x 2 x 73 = 37,960
Venus: 104 x 5 x 73 = 37,960
Sun: 65 x 8 x 73 = 37,960

Once again, juggling the Maya figures makes everything fall into place. Don't forget, this is just a fraction of the stirring journey of discovery through their well-kept secrets. One by one, I have been able to dismantle the most important messages. And yet there are many more. That is just typical for a highly-developed civilization. Ours keeps many too, like the atomic bomb, the secret weapons, patented products, and so forth. However, none of them are as fascinating to me as those of disappeared civilizations like the Maya and the Egyptians. They radiate an immensely rich source of knowledge, and it is my most fervent wish to find out as much as possible about it. And why not—their knowledge is closely connected to a catastrophe that swept away the old civilization of Aha-Men-Ptah, and one that is threatening to do the same with ours.

Conclusions
On the basis of the found codes it is possible to make many additional decipherings of Maya numbers. The method is identical to the Egyptian one, and based on the Venus codes that were used by the Atlanteans. In quite a shocking manner they illustrate the extremely accurate astronomical numbers the Maya had at their disposal. Up to this day researchers think that the Maya knew the orbit of the earth around the sun up to three figures after the decimal point. The decodings presented above irrefutably prove that the Maya also calculated the fourth figure after the decimal point! Furthermore, they knew the sidereal orbit period of the earth. These discoveries will cause a revolution in the further interpretation of the knowledge of the Maya. And I am putting it very mildly. When you have a close look at the deciphering, you see that the magical year of the Maya—which was the source for their calendars—can be recovered with the help of the Maya value for the synodic period of Venus. It is an essential part of the whole, and an undeniable proof for the complete deciphering.

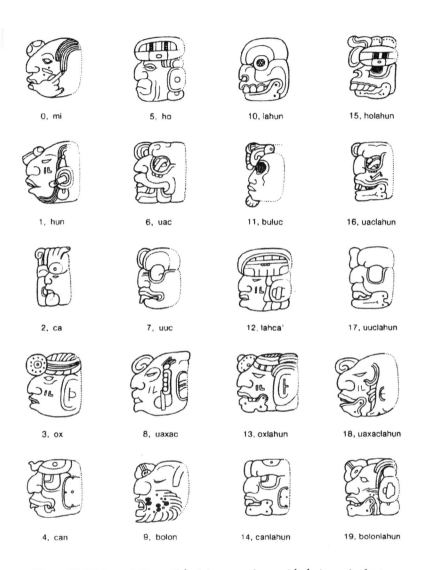

Figure 53. Main variations of the Maya numbers with their equivalent in spoken Yucatec.

22.
CODES CONVERTED
INTO ENDLESS SERIES

Since the Maya worked with incredibly big numbers, I decided to search for possible connections between long series. The number 1,872,000 was quite important for them. They used it, among other things, to count down to 2012. The first day was August 11, 3114 BC, and the 1,872,000 days end in fierce tectonic activity on December 21, 2012. I decided to use the finding I mentioned in my previous book. Please do the same, and use the three calendar rounds and their multiples. You will then use 1,898,000 and 1,899,300. Subtract the long cycle from the Dresden Codex from the first number. Then subtract the calendar rounds from the other corresponding two numbers. This produces:

$$1,872,000 - 1,366,560 = 505,440$$
$$1,898,000 - 1,385,540 = 512,460$$
$$1,899,300 - 1,386,489 = 512,811$$

The results you have found are equal to the multiples of the Sothic cycle and the code number 351:

$$505,440 = 1,440 \times 351$$
$$512,460 = 1,460 \times 351$$
$$512,811 = 1,461 \times 351$$

Here you see once again a connection between the Maya and the Egyptians. Three Holy Numbers of the Egyptians are converted into the outcome. Furthermore, you see 351, a result I spontaneously stumbled upon several times while breaking the computer program of the end of the world, leading to 2012 (I will discuss this further in my next book). Again no coincidence! Just take some time to look for them. With the aid of the known numbers of the solar magnetic fields you will again find several codes:

$$505,440 \div 26 = 19,440$$
$$505,440 \div 37 = 13,660.54054$$

1,994 is an essential number to decipher the Egyptian zodiac and to calculate the sunspot cycle. The number 13,660.54054 multiplied by 100 is practically equal to the super-long cycle of the magnetic field of the sun. Later it will be shown that this is not a coincidence and will reveal more codes:

$$1,366,054.054 - 1,366,040 = 14.054054 = \text{code number of the}$$
Dresden Codex

Several other codes are hiding behind the number 505,440. In the following deciphering of the mentioned Maya codex, the numbers 74 and 54 are also of importance.

505,440 ÷ 74 = 6,830.27027 = code number of the Maya codex
505,440 ÷ 54 = 9,360 = code number

Further on you will come across a nice little number game of the Maya:

505,440 ÷ 27 = 18,720
512,460 ÷ 27 = 18,980
512,811 ÷ 27 = 18,993

And with this the game is not over:

505,440 x 27 = 13,646,880
512,460 x 27 = 13,836,420
512,811 x 27 = 13,845,897

Multiply the number of the Dresden Codex and the related numbers by ten and subtract these numbers:

13,665,600 – 13,646,880 = 18,720
13,836,420 – 13,855,400 = 18,980
13,864,890 – 13,845,897 = 18,993

With this you have found an important clue as to why the Maya had such super-long numbers: they were hiding several codes. But I leave it up to the sleuths to "break" these further. I will give you a hint with an example of how they worked. A few lines above you see 351 in the calculations. This should intrigue you. With a bit of initiative, you will quickly find more codes in the sunspot cycle. Divide the period of the magnetic fields by 351:

68,328 ÷ 351 = 194.666666666
68,302 ÷ 351 = 194.592592592
 0.074074074 (26 ÷ 351 = 0.074074074)

Note: I will use this format in the following sections to show that, after making the first calculations, you then subtract the results.

Conclusion: you again find the endless number 74; knowing the Maya, some little games with numbers must be hiding in it. Further calculations confirm this finding:

68,328 ÷ 74 = 923.351351
68,302 ÷ 74 = 923.000000
 0.351351

A bit more searching produces:
68,328 ÷ 0.074074 = 922,428
68,302 ÷ 0.074074 = 922,077
 351

To make it sound you can do the following:
68,328 ÷ 0.351351 = 194,472
68,302 ÷ 0.351351 = 94,398
 74

Important Conclusion

The number 351 relates to the sunspot cycle, and is a main code number. I will go deeper into this in my next book. Because there are still more connections to be found, divide 351 by the period of the magnetic fields of the sun:
351 ÷ 26 = 13.5
351 ÷ 37 = 9.486486

Multiply these by the number of degrees that the two fields pass in one day, but in reverse order:
13.5 x 9.729729730 = 131.351351 (= above found series 0.351351)
9.486 x 13.8461538 = 131.351351

Divide a complete circle (360 degrees) by this number:
360 ÷ 131.351351 = 2.74074074 (= code number)

The following divisions are also equal to this fraction:
962 ÷ 351 = 2.74074074 (962 = 26 x 37)
74 ÷ 27 = 2.74074074

So there is a relation between 351 and the solar magnetism. Besides that, the numbers 74 and 27 are important, but you have already seen that. Once more, everything fits beautifully.

The following calculation proves the importance of the fraction number:
18,720 ÷ 2.74074074 = 6,830.27027027

Multiply this by 10 and the outcome is, with incredible accuracy, the sunspot cycle. Later it will become clear that a code is hidden behind this number:
68,302.7027027 − 68,302 = 0.7027027 = code number.

The Reversal of the Magnetic Field of the Sun
This is an extremely important proof!

When you multiply the found multiples of the Sothic cycle by the just-found code number the result is:

505,440 x 2.74074074 = 1,385,280
512,460 x 2.74074074 = 1,404,520
512,811 x 2.74074074 = 1,405,482

Mind! 1,405,482 = 3,848 years of 365.25 days = reversal magnetic field of the sun!

Again we find a correlation with the Holy Numbers of the Egyptians:

1,385,280 = 1,440 x 962
1,404,520 = 1,460 x 962
1,405,482 = 1,461 x 962

So the reversal is equal to:
1,405,482 = 1,461 x 962 = Sothic cycle x 962

After 3,848 years the magnetic field of the sun has traversed 2,103,840 degrees (16,071 x 130.9090909). This is equal to:
2,103,840 = 1,461 x 1,440 = Sothic cycle x 1,440

After 3,848 years the earth has traversed 1,385,280 degrees (16,071 x 86.197498). This is equal to:
1,385,280 = 1,440 x 962

These are the numbers found above!

Conclusion: *This deciphering proves the origin of the Sothic cycle and other important code numbers!*

Further Decipherings
Through further calculations you can recover codes to calculate the long sunspot cycle. The endless number 74 shows first:

1,385,280 ÷ 74 = 18,720
1,404,520 ÷ 74 = 18,980
1,405,482 ÷ 74 = 18,993

You may find the number of the Dresden Codex as follows:
1,385,280 − 18,720 = 1,366,560 = number Dresden Codex
1,404,520 − 18,980 = 1,385,540
1,405,482 − 18,993 = 1,386,489

Keep on playing, because there are still more correlations to find. You can calculate the following series:

1,366,560 ÷ 505,440 = 2.7037037 (the codes 27 and 37!)
1,385,540 ÷ 512,460 = 2.7037037
1,386,489 ÷ 512,811 = 2.7037037

Another series:

1,872,000 ÷ 505,440 = 3.7037037 (the code number 37!)
1,898,000 ÷ 512,460 = 3.7037037
1,899,300 ÷ 512,811 = 3.7037037

A further remarkable outcome is: 3.7037037 x 3 = 11.111111111. Attentive readers will recognize this as the square of the precession number!

Here is that calculation again: 3.33333 x 3.33333 = 11.1111111. This number is also equal to the average period of a sunspot cycle! In other calculations it comes back as a code number. Some simple calculations produce the following:

512,460 – 505,440 = 7,020
7,020 x 2.7037037 = 18,980
7,020 x 3.7037037 = 26,000
512,811 – 512,460 = 351= code number!
351 x 2.7037037 = 949
351 x 3.7037037 = 1,300
351 x 11.1111111 = 390

Here you see several code numbers that were used in other calculations to decode the Dresden Codex. A last and special series is the following: divide the number of days of the several calendar rounds between the crash of 9792 BC and the forthcoming crash in 2012 by the found series:

4,249,440 ÷ 505,440 = 8.4074074
4,308,460 ÷ 512,460 = 8.4074074
4,311,411 ÷ 512,811 = 8.4074074
8.4074074 x 3 = 25.2222222

Divide this by the code of the sunspot cycle:
25.222222 ÷ 11.111111 = 2.27

Another striking connection proves the correctness of the number of days between the two catastrophes:

227 ÷ 27 = 8.4074074074.

227 is the code number I used for calculating the end date of the catastrophe. There are 227 periods of 52 years between the

crashes (see my previous book). You see not only the number 227, but also the number 27 that appeared more than once in the calculations. Again a masterly example of how to calculate the end date with the help of the same numbers! You can also find the number 25.2222 in another way (in my previous book I had found that the number 227 is linked to 117):

$$4{,}311{,}411 \div 117 = \qquad 36{,}849.66666$$
$$4{,}308{,}460 \div 117 = \qquad \underline{36{,}824.44444}$$
$$25.22222$$

When you divide the numbers by their difference this results in the Holy Numbers of the Egyptians:

$$36{,}849.66666 \div 25.2222 = 1{,}461$$
$$36{,}824.44444 \div 25.2222 = 1{,}460$$

Again more codes were to be found. I soon discovered another connection with the Sothic cycle, the sunspot cycle and the code numbers, through which you can find the precession cycle:

$$1{,}440 \times 11.11111 = 16{,}000$$
$$1{,}460 \times 11.1111 = 16{,}222.22222$$
$$1{,}461 \times 11.11111 = 16{,}333.3333$$

These numbers, though a hundred times smaller, were used to calculate the end of a cycle! Dividing the number of days of the years between the previous crashes by these numbers results in the precession cycle. Concerning the countdown to 2012, these dividings produce the number 26,559, which is equal to 117 x 227 (see my previous and next book). There is more to find here, I thought to myself. And I soon found it:

$$16{,}000 \times 2.27 = 36{,}320$$
$$16{,}222.222 \times 2.27 = 36{,}824.444$$
$$16{,}333.333 \times 2.27 = 36{,}849.666$$

These are the numbers above! Who can still have doubts about the brilliancy of this software program? And yet my journey of discovery hadn't ended:

$$160 \times 117 = 18{,}720$$
$$162.22 \times 117 = 18{,}980$$
$$163.33 \times 117 = 18{,}993$$

23.
SUNSPOT CYCLE CALCULATIONS

An Important Cycle of the Sunspot Cycle
Through some simple calculations you again find the essential numbers of the sunspot cycle:

$68,302 \div 26 = 2,627$
$68,302 \div 37 = 1,846$

Subtract these numbers: $2,627 - 1,846 = 781$

781 is the number for the time periods (bits) that Cotterell found in a sunspot cycle. Divide the above found values in reverse order by the orbit periods of the magnetic fields, and the result is:

$2,627 \div 37 = 71$
$1,846 \div 26 = 71$
$71 \times 11 = 781$

A cycle consists of 781 bits. You subdivide further:
$781 \div 11 = 71$ bits of 87.4545 days

On this basis you can calculate a long cycle:
$71 \times 87.4545 = 6,209.2727$

This is also equal to:
$2.3636 \times 2,627 = 6,209.2727$
$3.3636 \times 1,846 = 6,209.2727$

On the basis of this number I succeeded in deciphering the Dresden Codex. From these calculations, it turns out that this is an essential number of the sunspot cycle. This is why the Maya inserted it into their codes.

The Duration of the Magnetic Fields of the Sun
Calculated from the Sunspot Cycles of the Maya
The Atlanteans, as well as their descendants the Maya, liked to play with numbers. Once again this will become clear from the following calculations. You know from the previous section that an important cycle is completed after 6,209.272727 days. It shows an endless series with the number 27. Knowing the Maya, there had to be something else to work out concerning this number. The Maya used two numbers for the period of the sunspot cycle.

When you divide them by 27, you will find the first clue:
$$68,328 \div 27 = \quad 2,530.66666666$$
$$68,302 \div 27 = \quad \underline{2,529.70370370}$$
$$0.96296296$$

The difference shows what you are looking for:
$$962 = 37 \times 26$$

The correlations do not stop here:
$$27 \times 37 = 999.$$

Dividing the cycles results in:
$$68,328 \div 999 = \quad 68.396396396$$
$$68,302 \div 999 = \quad \underline{68.370370370}$$
$$0.026026026$$

Here you see three important numbers: 26, 37 and 396. You can also calculate one cycle from the other. The endless series of 26 proves this more than clearly:
$$27 \times 26 = 702$$
$$68,328 \div 702 = \quad 97.333333333$$
$$68,302 \div 702 = \quad \underline{97.296296296}$$
$$0.037037037$$
If this is not a brilliant game with numbers, then I'm crazy!

Mathematical geniuses should experiment with making such mathematical correlations. After a couple of days of fierce calculating, they will have to admit that the Maya were truly brilliant! With the help of this finding I succeeded in recovering the main code of the Dresden Codex.

Mathematical Connections Between the Sunspot Cycle and the Precession of the Zodiac

We have already shown in this book that there is a direct connection between the precession and the sunspot cycle. I repeat here the found values:
$$68,302 \div 37 = 1,846$$
$$68,302 \div 26 = 2,627$$

You have found the following with the precession:
$$25,920 \div 13.84615385 = 1,872 \ (360 \div 26 = 13.84615385)$$
$$25,920 \div 9.729729730 = 2,664 \ (360 \div 37 = 9.297297)$$

There is a relation between the differences of the time periods. In the sunspot cycle it is:
$$2,627 - 1,846 = 781$$

With the precession it is: 2,664 − 1,872 = 792

When you subtract the first number from the second, the result is: 792 − 781 = 11. When you divide 781 by 11, the result is 71. Again you produce here a beautiful argument:
26 x 37 = 962 and 71 x 962 = 68,302

It could not be more perfect. But it will always remain a riddle to me why these darned Atlanteans have made everything so complicated. It is a fact that knowledge is power, and they knew very well how to camouflage it. Without my perseverance and passionate research this may have been lost forever.

It doesn't stop here, so you must continue with your search. Multiply 11 by 360: 11 x 360 = 3,960. Divide the precession number by this result: 25,920 ÷ 3,960 = 6.454545. Again we find a correlation with another number: 11 x 6.454545 = 71. Skeptics, even the most hard-nosed, will not be in a position to declare that this is all a coincidence. To silence them once and for all, I will show some other correlations that cannot be ignored.

When I divided the precession number by 792, I found the following strange series:
25.920 ÷ 792 = 32.727272

The endless repetition of 72 seemed an Atlantean starting point to me. Therefore I began to search. Follow along with my argument and you will find the same as I did. Multiply the number of degrees that the magnetic field passes in one day in reverse order by the number of circles completed after 87.4545 days.

Replace the circles by days, and it results in:
13.84615385 x 2.363636 = 32.727272
9.729729730 x 3.363636 = 32.727272

Explanation: after 2.363636 and 3.363636 days, the solar fields have passed 32.727272 degrees of a circle. So much coincidence cannot be sheer happenstance. Of course, real sleuths like you and me don't give up that easily.

Here is another clue: 360 ÷ 32.727272 = 11

More thinking results in the solution of the riddle as follows:
3.3636 x 2.3636 = 7.9504132 x 11 = 87.4545

Of course there had to be more behind all of this. Those brilliant mathematicians of millennia ago were too bright not to have hidden more codes:

7.9504132 x 13.8461538 =	110.0826439
7.9504132 x 9.72972930 =	77.35536587
	32.72727272

Explanation: after 7.9504132 days there is a difference of 32.727272 degrees.

I hope you are as fully determined as I am to unravel one of the biggest secrets of this lost civilization. The magnitude of the forthcoming world cataclysm is such that you have to strain all your senses to the maximum. You have read before that one field overtakes the other after 87.4545 days. You may prove this mathematically as follows:

$$87.4545 \times 13.8461538 = 1{,}210.9090909$$
$$87.4545 \times 9.72972930 = \underline{850.9090909}$$
$$360$$

Conclusion: after 87.4545 days the equatorial field has completed one circle more than the polar field. When you multiply the number of degrees by 11, it results in known numbers:

$$1{,}210.90909 \times 11 = 13{,}320$$
$$850.90909 \times 11 = \underline{9{,}360}$$
$$3{,}960$$

The difference of 3,960 degrees is the number you have recently calculated from the Zodiac cycle! You also see a multiple of the often-used number 936. You cannot close your eyes to this. The relation between the precession and the sunspot cycle has been adequately proved.

The following calculation leads to the solution of the Dresden Codex. Take the numbers you found above in the precession cycle. Divide them by 36:

$$2{,}664 \div 36 = 74$$
$$1{,}872 \div 36 = 52$$
$$792 \div 36 = 22$$

These numbers lead to the solution of the Dresden Codex:
$$74 \div 22 = 3.363636 \text{ (period of equator field of the sun)}$$
$$52 \div 22 = 2.363636 \text{ (period of polar field)}$$

More code numbers are hidden in the precession numbers. The sunspot cycle exists of twenty cycles of 68,302 days. Multiply these precession numbers by 20. The reason for this is that the solar magnetism reverses after 20 cycles:

$$2{,}664 \times 20 = 53{,}280$$
$$1{,}872 \times 20 = 37{,}440$$
$$792 \times 20 = 15{,}840$$

Subtract the precession cycle from the first two numbers:
53,280 – 25,920 = 27,360
37,440 – 25,920 = 11,520 = time between the two previous crashes

Both results numbers contain code numbers:
27 x 36 = 972
11 x 52 = 572

Two subtractions prove our proposition:
972 - 792 = 180
792 - 572 = 220
180 x 220 = 39,600 = code number

This contains another code number:
39 x 6 = 234 = code number

We uncover more code numbers through more divisions:
972 ÷ 18 = 54
792 ÷ 22 = 36
54 x 36 = 1,944 = code number

Through some more logical calculations we may find again another number that appeared recently:
27,360 – 25,920 = 1,440
25,920 – 11,520 = 14,400
14,400 + 1,440 = 15,840 = 792 x 20

24.
THE DRESDEN CODEX DECIPHERED

The Dresden Codex contains a huge number: 1,366,560. Hundreds of codes are hidden behind this number, part of which correlate with the solar magnetism and the sunspot cycle. With the help of Venus you will be able to quickly discover a first code:
$$1,366,560 = 2,340 \times 584$$

Replace 584 by 583.92, which is the correct value for the synodic period of Venus. The difference is 0.08. Multiply this by 2,340:
$$0.08 \times 2,340 = 187.2$$

This is the period of a sunspot cycle! Without any doubt this is correct because:
$$1,366,560 \div 187.2 = 7,300 \; (= 365 \times 20)$$

Furthermore:
$$187.2 \times 365 = 68,328 = \text{sunspot cycle of the Maya}$$
$$68,328 \times 20 = 1,366,560$$

When you multiply 187.2 by 20 the result is 3,744, a known Maya number. At the same time you retrieve a second code in the calculation with Venus:
$$583.92 - 576 = 7.92$$

Other calculations showed that this is a code number when multiplied a hundred times (792). Divide the previous number by it and you get:
$$187.2 \div 7.92 = 23.636363$$

Here you stumble upon an important fact. The number is a code message. And you will encounter this number many more times leading to the revelation of the biggest Maya secret.
Other codes with the number 187.2 are:
5 Venusian = 8 terrestrial years
$$187.2 \times 5 = 936$$
$187.2 \times 8 = 1,497.6 = 57.6 \times 26$ (26 is the period of a magnetic field of the sun)
$$1,872 - 1,497.6 = 374.4$$

Now return to the code number 3,744 that we recovered

earlier. It shows the number of years of 365 days in the Maya super number:
1,366,560 = 3,744 x 365

Of course the Maya knew the real value of the orbit of the earth around the sun: 365. 2422. They used the code value: 365.242. There is also the real value of the sidereal period (orbit with respect to the stars): 365.2564. To simplify these calculations, you have to multiply only the values after the decimal point by 3,744. In this way you will produce the values by which these numbers will exceed the Maya super-number:
0.242 x 3,744 = 906.048
0.2422 x 3,744 = 906.7968
0.2564 x 3,744 = 959.9616

Add the number of the sunspot cycles, because the multiplication with the value of Venus produced a smaller number: 583.92 x 2,340 = 1,366,372.8 <1,366,560.
906.048 + 187.2 = 1,093.248
906.7968 + 187.2 = 1,093.9968
959.9616 + 187.2 = 1,147.1616

Subtract the first two values:
1,093.9968 – 1,093.248 = 0.7488

To remove the decimal points of the higher values, multiply them by 10,000. Then divide them by 7,488:
10,932,480 ÷ 7,488 = 1,460
10,939,968 ÷ 7,488 = 1,461
11,471,616 ÷ 7,488 = 1,532

Here you can distill a code message:
1,532 – 1,460 = 72 (72 x 11 = 792 = code number)
1,532 – 1,461 = 71 (71 x 11 = 781 = code number)

Divide the bigger values by 3,744 and 3,796 (leave out the decimal points):
1,093,248 ÷ 3,744 = 292
1,093,248 ÷ 3,796 = 288
10,939,968 ÷ 3,744 = 2,922
10,939,968 ÷ 3,796 = not evenly divisible
11,471,616 ÷ 3,744 = 3,064
11,471,616 ÷ 3,796 = not evenly divisible

You had found the four numbers above earlier in the Venus cycles! These are mentioned in Chapter 21. Divisions with other numbers *irrefutably* prove that you are on the track of something super important:

1,093,248 ÷ 8 = 136,656 (x 10 = 1,366,560 !)

10,939,968 ÷ 8 = 1,367,496 (= code number from other series = 1,366,560 + 936)

11,471,616 ÷ 8 = 1,433,952 (= 1,366,560 + 67,392) (67,392 = code number of Egyptian Zodiac)

1,093,248 ÷ 187.2 = 584 (= 36.5 x 16)

1,093,248 ÷ 576 = 1,898 (= 36.5 x 52)

10,939,968 ÷ 187.2 = 5,844 (code number from other series: 365.25 x 16)

10,939,968 ÷ 576 = 18,993 (code number from other series: 365.25 x 52)

11,471,616 ÷ 187.2 = 6,128 (= 383 x 16)

11,471,616 ÷ 576 = 19,916 (= 18,980 + 936 = 383 x 52)

The numbers 383 and 19,916 are also present in the deciphering of 65 Venus years = 104 terrestrial years. When you study the numbers above carefully, you will notice that there is a code number hiding there:

1,093,248 ÷ 36.5 = 29,952

10,939,968 ÷ 365.25 = 29,952

11,471,616 ÷ 383 = 29,952

With the help of this number you can recover several other codes:

29,952	= 576 x 52!
29,952	= 416 x 72 (416 = 52 x 8) = 208 x 144 = 104 x 288
	= 64 x 468
	= 36 x 832
	= 3,744 x 8 = main code number
	= 512 x 58.5 (512 = 64 x 8)
	= 2,304 x 13
	= 1,664 x 18
	= 1,152 x 26
	= 936 x 32
	= 288 x 104

The code numbers 8, 52 and 64 are clear and need to be used. In an earlier division series we found the numbers 292, 288 and 2,922 (see above). They are surely hiding another code! Dividing

these numbers by eight results in:
 2,922 ÷ 8 = 365.25
 292 ÷ 8 = 36.5
 288 ÷ 8 = 36

The last number results in: 3,064 ÷ 8 = 383. This discovered series (except the last number) contains the hidden calculation with the number of days in different year values:
 36 = 360 days in a year
 36.5 = 365 days in a year
 365.25 = correct

There is still another code:
 1,366,560 ÷ 36 = 37,960
 1,366,560 ÷ 36.5 = 37,440
 520

With this you can calculate the sunspot cycle!
 1,366,560 - 520 = 1,366,040 = cycle in which the sunspot cycle reverses = solution of Codex!

The following calculations in combination with 187.2 (the code number of the sunspot cycle mentioned above) produce:
 360 x 187.2 = 67,392 (code number of Egyptian Zodiac + 936 = 68,328)
 365 x 187.2 = 68,328
 365.25 x 187.2 = 68,374.8 (= 68,328 + 46.8 and 46.8 x 1,460 = 68,328)

When you express the numbers 288, 292 and 2,922 with the the same number of digits and multiply them by 468, the results are:
 2,880 x 468 = 1,347,840 (= 360 x 3,744)
 2,920 x 468 = 1,366,560 (= 365 x 3,744)
 2,922 x 468 = 1,367,496 (=365.25 x 3,744)

I found another possible series:
2,304 (see above at 29,952) = 288 x 8

2,304 is also a very important code in the calculation of the exact orbit period of the earth around the sun, and relates to the period between the previous crashes (see Chapter 5):
 288 x 8 = 2,304 x 8 = 18,432 + 288 = 18,720
 292 x 8 = 2,336 x 8 = 18,688 + 292 = 18,980 (2,336 = 23,360 = number of Maya codex)

292.2 x 8 = 2,337.6 x 8 = 18,700.8 + 292.2 = 18,993
18,700.8 = 187 years = sunspot cycle

You can show as follows that these basic numbers are correct, and that they are related to the events in Atlantis and the Maya codex:

288 x 2 = 576 x 20 = 11,520 (period between previous two crashes!)

292 x 2 = 584 x 20 = 11,680 (first number of Maya codex)
Subtract these numbers: 11,680 – 11,520 = 160

288 and 292 correlate with 360 and 365. Multiply these by 11,520 and 11,680 and then divide them by 160:

11,520 x 360 = 4,147,200 ÷ 160 = 25,920 = precession number
11,520 x 365 = 4,204,800 ÷ 160 = 26,280 = code number
11,680 x 360 = 4,204,800 ÷ 160 = 26,280
11,680 x 365 = 4,263,200 ÷ 160 = 26,645

When you make the respective subtractions, you again find 360 and 365!

26,645 – 26,280 = 365
26,280 – 25,920 = 360
365 - 360 = 5
11,520 x 5 = 57,600 = Venus
11,680 x 5 = 58,400 = Venus
26,645 x 0.7027027 (see further) = 18,723.51351 (1,872 and 0.351351 embedded in this result are are codes)

You have already found a relation between a Venus cycle of five years and a terrestrial one of eight years. Please delve a bit further into this:

583.92 x 5 = 2,919.6
365.242 x 8 = 2,921.936 – 2,919.6 = 2.336
365.2422 x 8 = 2,921.9376 – 2,919.6 = 2.3376
365.2564 x 8 = 2,922.0512 – 2,919.6 = 2.4512

Subtract the sidereal value from the Maya value. This results in the period between the crashes:

2.4512 – 2.336 = 0.1152 (= 11,520 = period between two crashes)

Leave out the decimal points and divide by eight:
2,336 ÷ 8 = 292
23,376 ÷ 8 = 2,922
24,512 ÷ 8 = 3,064 (code found above)

In the last number 64 (= 8 x 8) stands apart. I therefore multiplied it by 64:

3,064 x 64 = 196,096

I also multiplied the numbers above by 64:

2,921.936 x 64 = 187,003.904
2,921.9376 x 64 = 187,004.0064
2,922.0512 x 64 = 187,011.2768

These three numbers come amazingly close to the sunspot cycle. Here we have to look further for codes. A first one is the following:

187,200 – 187,003.904 = 196.096 = code number found above!
187,200 – 187,004.0064 = 195.9936
187,200 – 187,011.2768 = 188.7232

The code is reversed. It is found now in the first series, while it belonged to the last series before. Therefore, multiply it reversed, and convert the numbers into 187 years:

187.003904 x 365.2564 = 68,304.37276
187.0040064 x 365.2422 = 68,301.75471
187.0112768 x 365.242 = 68,304.37276

This code shows that the sunspot cycle of 187 years leads to the solution. The number you are looking for is supposed to be between 68,304.37276 and 68,301.75471.

The Breaking of the Dresden Codex

It contains two numbers:

1,366,560
1,364,360
Difference: 1,366,560 – 1,364,360 = 2,200

Divide both numbers by their difference:

1,366,560 ÷ 2,200 = 621.163636363
1,364,360 ÷ 2,200 = 620.163636363

The number series 0.1636363 corresponds to a full circle of 360 degrees:

360 ÷ 2,200 = 0.163636363

The difference between the series amounts to:

621.163636363 – 620.1636363 = 1

1 = 1 circle! Therefore the solution is related to a difference of 360 degrees!

You already know this: 3.363636 circles – 2.363636 circles = 1 circle of difference. The main code is the sunspot cycle of 187.2 years = 68,328 days. Cotterell found a value of 68,302 days.

1,366,560 = 20 x 68,328 = Maya code for the sunspot cycle.

The actual long sunspot cycle changes in the twentieth cycle: 68,302 x 20 = 1,366,040

Divide this number by 2,200:
1,366,040 ÷ 2,200 = 620.9272727

You know this number! You found it earlier as a code number of the sunspot cycle, but then it was indeed ten times bigger! Subtract this number from the correlating value of the Maya:
621.16363 – 620.92727 = 0.236363636.

The real value amounts to 2.363636. You can prove this as follows: 621.16363 x 11 = 6,832.8

Multiply by 10:
6,832.8 x 10 = 68,328 = Maya code for the sunspot cycle
621.16363 x 10 = 6,211.6363

Multiply the other number by 10:
620.92727 x 10 = 6,209.2727

The subtraction will now produce the correct value:
6,211.6363 – 6,209.2727 = 2.363636

This is the first main code! After 2.363636 orbits, one magnetic field of the sun surpasses the other magnetic field! In addition, you need to retrieve the code of the other field: 3.363636. This is relatively simple. As you know, you can find the codes multiplying by three numbers:

999 = 27 x 37
962 = 26 x 37
702 = 26 x 27

Divide 520 by these numbers:
520 ÷ 999 = 0.520520520 (an endless series with 520!)
520 ÷ 962 = 0.540540540
520 ÷ 702 = 0.740740740

Divide the last series as well by 2,200:
540 ÷ 2,200 = 0.245454545
740 ÷ 2,200 = 0.3363636363

The difference between the number of the Maya codes and the twentieth cycle in which the field reverses amounts to:
1,366,560 − 1,366,040 = 520.

Divide by 2,200:
520 ÷ 2200 = 0.236363636

This code is ten times too small. You can prove this as follows:
740 - 520 = 220
2,200 = 220 x 10

You immediately know the correct solution:
3.363636 − 2.36363636 = 1 circle of difference

The Codes of Venus

The known numbers of Venus also lead to a further revelation:
584 ÷ 2,200 = 0.26545454 (26 + endless series 54)
576 ÷ 2,200 = 0.26181818 (26 + endless series 18)

The following codes are hiding behind it:
26 x 54 = 1,404
26 x 18 = 468

Adding up and subtracting confirms the correctness of the numbers:
1,404 + 468 = 1,872 = code number
1,404 - 468 = 936 = code number

So we need to look further. The next connection sheds some light on the old code message:
54 ÷ 3.3636363 = 16.054054
1,404 ÷ 16.054054 = 87.45454545

After 87.454545 days one solar field catches up with the other! You find the same outcome in this calculation:
18 ÷ 3.363636 = 5.351351
468 ÷ 5.351351 = 87.454545

There is more behind the number 5.351351:
5.351351 x 2.363636 = 12.648648
5.351351 x 3.363636 = 18

Use 5.351351 together with 468. This is equal to:
468 = 13 x 36
468 = 18 x 26

A simple subtraction and a division produce two codes:
13 − 12.648648 = 0.351351 = earlier found code number (see Chapter 22)
26 ÷ 0.351351 = 74 = used in code breaking with the number 0.351351

Code with 936:
936 = 26 x 36
936 ÷ 87.4545 = 10.7027027

Multiply by the orbit periods of the fields:
10.7027027 x 2.363636 = 25.297297
10.7027027 x 3.363636 = 36

Subtract 25.297297 from 26:
26 − 25.297297 = 0.7027027

When you multiply this by the orbit period of the equatorial field, this results in the orbit period of the polar fields:
3.363636 x 0.7027027 = 2.363636
26 ÷ 0.7027027 = 37 = period of magnetic field of the sun at the poles

The Code Number 36 Hidden in the Venus Codes
You can find this number by subtracting the above found values for Venus:
0.26545454 − 0.26181818 = 0.0036363636

This code clearly means something. When you divide the periods of the magnetic fields by ten, you obtain the following outcome:
0.3363636 ÷ 10 = 0.033636363
0.2363636 ÷ 10 = 0.023636363

The endless series 36 is now positioned identically as in the Venus codes. In order to get this, you need to adjust the other numbers:
740 ÷ 10 = 74
520 ÷10 = 52

The subtraction of the resulting numbers produces 22. When you multiply 22 by 36 it results in a known code:

22 x 36 = 792 = code number!

The Solution of the Dresden Codex

The found numbers lead to the following solution:

74 ÷ 22 = 3.363636

52 ÷ 22 = 2.363636

The numbers 3 and 2 point to a code as well:

32 x 36 = 1,152 x 10 = 11,520 = period between previous crashes

You see an endless series with 36. Therefore multiply 74 and 52 by 36:

74 x 36 = 2,664 (main code number)

52 x 36 = 1,872 (main code number)

When you divide them by the orbit period of the fields, this results in a code number:

2,664 ÷ 3.363636 = 792

1,872 ÷ 2.363636 = 792

This number is also equal to the subtraction of the found products:

2,664 – 1,872 = 792 = 72 x 11

The following division of the found products gives anadditional code:

1,872 ÷ 2,664 = 0.7027027

The Maya number of the long sunspot cycle also produces a code series:

1,366,040 ÷ 740 = 1,846

1,366,040 ÷ 520 = 2,627

These numbers show the relation with the precession (see the corresponding chapter). It creates very important evidence in the whole. The subtraction of these numbers shows a code:

2,627 – 1,846 = 781 = 71 x 11

This division produces the same value shown above:

1,846 ÷ 2,627 = 0.7027027

Further proofs:
620.92727 ÷ 0.2363636 = 2,627
2,627 x 26 = 68,302 = sunspot cycle of 187 years
620.92727 ÷ 0.336363 = 1,846
1,846 x 37 = 68,302 = sunspot cycle of 187 years

The Maya Calendar Round

The number 1,366,560 of the Dresden Codex is equal to:

1,366,560	= 18,720 x 73
	= 18,980 x 72

18,980 = calendar round of the Maya of 52 years with 365 days
73 x 72 = 5,256
1,366,560 ÷ 5,256 = 260 = magical year

You can also find this number as follows:
18,980 – 18,720 = 260

You can also obtain 260 as the hidden Venus code in the cycle of 1,898,000 days (see proofs at the beginning of the Maya decodings). So 260 is a special number. It has is a connection with the several calendar rounds and the orbits of the magnetic fields of the sun:

Each day the polar field traverses:
360 ÷ 37 = 9.729729 degrees.

Each day the equatorial field traverses:
360 ÷ 26 = 13.84615 degrees.

You have already found the number 0.7027027 several times. This is also equal to:
26 ÷ 37 = 0.7027027027

The Cycle of 260 Days

After 260 days the polar field has traversed 7.027027 orbits. The number of degrees for this time period amounts to:
260 x 9.729729 = 2,529.729729

You can calculate the number of rotations from this as follows:
2,529.729729 ÷ 360 = 7.027027

The field is located at 0.027027027 rotation from its starting point. This is equal to the following number of degrees:
0.027027 x 360 = 9.729729

This means in fact that the field is located one day past its

starting point or at 9.729729 degrees. The equatorial field has made ten rotations after 260 days (!) and is positioned at its starting point. The following code breaking proves the correctness of this reasoning:

$10 - 9.729729 = 0.27027027027$

$7.027027 \div 0.27027027 = 26$

$7.027027 \div 0.027027027 = 260$

All this points to a code for the calendar round of the Maya!

$260 \times 72 = 18{,}720$

$260 \times 73 = 18{,}980$

Multiply this by the number of degrees that the fields traverse in one day and you will get the following results:

$18{,}720 \times 9.729729 = 182{,}140.54054$

$18{,}720 \times 13.84615 = 259{,}200 = \text{precession number!}$

$18{,}980 \times 9.729729 = 184{,}670.27027$

$18{,}980 \times 13.84615 = 262{,}800 = \text{code number!}$

Multiply 72 by the number of rotations of a cycle in 260 days (reason: $18{,}720 = 72 \times 260$):

$72 \times 7.027027 = 505.945945$

Make this number a thousand times bigger so it correlates with the above found numbers, which are in hundred thousands. This shows a relation with a Maya number: 505,440 (= 1,440 x 351; see Chapter 22).

When you subtract this last value from the one found above, you see:

$505{,}945.945 - 505{,}440 = 505.945945$

The outcome is identical to the first number; only the units differ! It doesn't stop with this. The number of degrees that the field traverses in 72 days also produces a code:

$72 \times 9.729729 = 700.54054054$

Divide this number by the previous one and you can calculate the number of degrees that the other field traverses in one day:

$700.54054054 \div 505.945945 = 1.3846153$ (x 10 = degrees per day of the other field)

Further exploration of the found code number will lead you to find the following:

$700.54054 \div 360 = 1.945945$ (x 10 = 19.459459 = 2 x 9.729729)

After 18,720 days the polar field has traversed 182,140.54054 degrees. This is 19.459459 degrees more than a whole circle. The equatorial field is located at its starting point. Conclusion: the field runs 2 x 9.729729 degrees quicker than the other. According to the Maya way of thinking, you can also describe this as follows:
720 – 700.54054 = 19.459459

For the calendar round of 18,980 days this results in:
73 x 7.027027 = 512.972972

Here is a connection with a Maya number:
512,460 (= 1,460 x 351)
512,972.972 – 512,460 = 512.972972 = identical to the earlier found number, except the units.
When you decipher the same way as before, the result is:
73 x 9.729729 = 710.27027
720 – 710.27027 = 9.729729

Conclusion: the cycle of 260 days shows a difference of 9.729729 degrees between the fields. After 18,980 days this phenomenon shows up again. The calendar round therefore shows a cycle of the solar pole and the solar equator.

Further Deciphering of the Dresden Codex
1,366,560 = 5,256 x 260
1,366,040 = 5,254 x 260

In 260 days the polar field traverses 7.027027 rotations. After 5,256 and 5,254 times of this cycle, you get the following number of rotations:
5,256 x 7.027027 = 36.934.054054
5,254 x 7,027027 = 36,920

There is a connection with the Maya number 37,440:
37,440 – 36,920 = 520 = difference between the two big numbers (1,366,560 – 1,366,040)

Another striking decoding is:
36,934.054054 – 36,920 = 14.054054 = 20 x 0.7027027

A little game with numbers:
1,366,560 ÷ 36.363636 = 37,580.4
37,960 – 37,580.4 = 379.6 (x 100 = 37,960)

Other clues:

5 Venusian years = 8 terrestrial years

18,720 ÷ 5 = 3,744 = code number

18,980 ÷ 5 = 3,796 = code number

18,720 ÷ 8 = 2,340

2,340 x 584 = 1,366,560

18,980 ÷ 8 = 2,372.5

2,372.5 x 584 = 1,385,540

Subtract the Maya calendar round of 52 years and you will see the main code numbers of the Dresden Codex:

1,385,540 − 18,980 = 1,366,560

If you had multiplied the number by the other value of Venus, you would have immediately obtained the super number:

2,372.5 x 576 = 1,366,560

Divide the Maya calendar rounds by the values of Venus and multiply them by eight. The result is the Maya cycle of 260 days:

18,980 ÷ 584 = 32.5 x 8 = 260

18,720 ÷ 576 = 32.5 x 8 = 260

The following deciphering provides another glimpse into their pattern of thinking:

1,366,560 ÷ 740 = 1,846.7027027

1,366,040 ÷ 740 = 1,846

Difference: 0.7027027

Divide the Maya super number by the number of rotations that the polar field completes in 260 days, and you will see two code numbers:

1,366,560 ÷ 7.027027 = 194,472

Two code numbers are hiding here: 1,944 and 72.

1,944 = 54 x 36!

1,944 x 72 = 139,968

139,968 = 54 x 2,592 (x 10 = precession cycle)

576 x 243 = code number to find codes in the precession cycle (see previous discussion).

When you multiply the code number 1,944 by the number of rotations in 260 days, another code shows up:

1,944 x 7.027027 = 13,660.54054

Multiply by 100 and subtract the value of the twentieth cycle in which the reversal of the magnetic field of the sun takes place:

1,366,054.054 − 1,366,040 = 14.054054 (= 20 x 0.7027027)

A cycle of 1,366,040 days exists of 20 cycles of 68,302 days!

Divide 1,944 by 20:
1,944 ÷ 20 = 97.2

Multiply this by the number of rotations in 260 days:
97.2 x 7.027027 = 683.027027 (x 100 = 68,302.7027)

Subtract the correct value of a sunspot cycle:
68,302.7027 – 68,302 = 0.7027027

The Maya knew cycles of 52 years. Again the result is a code:
52 x 0.7027027 = 36.54054054 (36 + endless series 54)

Multiply 36 by 54:
36 x 54 = 1,944
54 x 7.027027 = 379.45945
37,960 – 37,945.945 = 14.054054

Those who understand the way of decoding can now try to break the Codex further by themselves.

25.
666—THE NUMBER
OF THE BEAST

An essential number to break the Maya codex is 22. Three other numbers are important: 2,664, 1,872 and 1,944. Once I learned this, and the importance of the number 666 permeated through my mind, I started to calculate without hesitation. Several minutes later I quickly approached the solution of this riddle thousands of years old. Subtract the three numbers above from the total precession cycle and divide by 36:

$$25,920 - 2,664 = 23,256 \div 36 = 646$$
$$25,920 - 1,872 = 24,048 \div 36 = 668$$
$$25,920 - 1,944 = 23,976 \div 36 = 666 = \text{number of the beast!}$$

$1,944 = 54 \times 36$ (= code of the Egyptian Zodiac = code you find while breaking the Maya codex).

1,944 is also equal to 2,664 - 720

Besides the number of the beast, you have found above two other numbers: 668 and 646. When you subtract them it results in a code number!

$668 - 646 = 22$ = code to solve the Dresden Codex.

Dividing the number of the beast by 22, with which you can break the Maya codex, results in:

$$666 \div 22 = 30.272727$$

Here you are close to a vital solution, but first you need to make some other calculations: $2,664 - 1,872 = 792 = $ code number. When you subtract 72 from this code number, you obtain the difference between the longest and the shortest period of the Egyptian Zodiac:

792 - 72 = 720 (difference between shortest and longest period of Egyptian Zodiac)

Divide these numbers by 22:

$$792 \div 22 = 36$$
$$72 \div 22 = 3.2727$$
$$720 \div 22 = 32.7272$$

In the following subtraction, replace the numbers 792, 72 and 720 with their correlating values after the division by 22:

$$36 - 3.2727 = 32.7272$$

32.727272 = code found in precession (see the section of Chapter 23 titled "Mathematical Connections between the Sunspot Cycle and the Precession of the Zodiac"). Our proof is completed in a flash. With 720 and 666 you also get the result:

720 - 666 = 54 = code number of Maya codex
54 ÷ 22 = 2.454545 = code number of Maya codex!
666 ÷ 22 = 30.272727

Replace the numbers 720, 666 and 54 with their respective divisions by 22:

32.727272 – 30.2727272 = 2.454545

You can also describe it in the following manner:
720 - 54 = 666!

In other words, the number 30.272727 is considered equal to the number of the beast! Before decoding further, you need to know that there are deviations in the sunspot cycle.

Deviating Cycles in the Sunspot Cycle

The complete sunspot cycle includes five cycles that contain nine bits of 87.4545 days. This involves a total of 45 bits. There is a clear connection with the Egyptians and the numerous calculations I have made. I will get back to this later. A complete sunspot cycle is as follows:

Bits in normal cycles: 92 x 8 = 736
Bits in deviating cycles: 5 x 9 = 45
The total numbers of bits amounts to: 736 + 45 = 781
The total period of a sunspot cycle amounts to:
781 x 87.454545 = 68,302 days
The total period of the deviating cycles amounts to:
45 x 87.454545 = 3,935.454545 days.
The total period of the normal cycles amounts to:
736 x 87.454545 = 64,366.545454 days.

Some important remarks will clarify this finding:

1) I found the number 45 in calculations with the astronomical Zodiac of Egypt. They indeed knew this deviating behavior.

2) In total, there are five cycles with one extra bit. Five is an incredibly important number in Egypt. It is converted in their calendar calculations and in other things. The Golden Section, for instance, determines the number series up to five. Five terms are needed to explain the principle of a "deed of creation." Therefore five is the number of the Everlasting Creation. It is for this reason the Egyptians gave the number five so many honors.

3) The Maya ranked the number nine highest on their list. Also, it shows up abundantly in my calculations. Let me give you an example from the seemingly endless possibilities:

13 x 9 = 117	1,777 x 9 = 160	7,111 x 9 = 64
18 x 9 = 162	160 x 9 = 1,440	64 x 9 = 576
27 x 9 = 243	2,880 x 9 = 25,920	576 x 9 = 5,184
25.22 x 9 = 227		

The list contains several numbers that I found that enabled me to discover the mathematical established end date. This shows the importance of the number nine, which brings us full circle.

Conclusion: The Atlanteans knew the deviating cycles and inserted them in a masterful way in their culture. The number 666 provides decisive evidence for this proposition. I will continue in a minute with the deciphering that will prove this. Multiply nine by the period of the magnetic fields of the sun:

9 x 3.363636 = 30.272727 = number correlating with that of the beast!

9 x 2.363636 = 21.272727

In their way of thinking, the codes had to show up as much as possible. The next connection fits perfectly into their pattern of reasoning:

21.272727 + 2.454545 = 23.727272 = anagram for 32.727272
32.727272 – 23.727272 = 9 = deviation in sunspot cycle

Multiply the found numbers by 22 and again this results in mathematical correlations:

21.272727 x 22 = 468 (666 - 180 = 468)
23.727272 x 22 = 522 (666 - 144 = 522)
180 + 144 = 324 = anagram for 243
522 - 468 = 54 = anagram for 45
324 - 54 = 270 = code number = anagram for 72

You have already seen that there is a relation with the nine deviating cycles in a sunspot cycle. When I started to think about this I had already found a hidden code:

32.727272 – 2.454545 = 30.272727.

Multiply the numbers after the decimal point by nine:

72 x 9 = 648 = anagram for 468
45 x 9 = 405 (45 = number of deviating bits in sunspot cycle)
27 x 9 = 243 = code to get back their code numbers = correlates with the number of the beast!

By simply subtracting the correlating numbers you can prove that this calculation is super important: 648 - 405 = 243. The outcome is correct!

Conclusion: The breaking of the number of the beast leads to the number 243, which is essential to break further codes. The number 243 is equal to the rotation period of Venus. First of all you can recreate the following codes:

666 ÷ 243 = 2.74074074 (see Chapter 22)
666 - 243 = 423 = anagram for 243
423 - 243 = 180
666 - 180 = 468 = number found above (relates to Venus:
468 - 243 = 225 = orbit period of Venus around the sun)

The Maya codex is partly broken with the figures 36.5 and 36. When you first multiply 36.5 by the number of the beast, you will find a new code message:
36.5 x 666 = 24,309

Here you see 243 and 9 standing apart. This signifies a code, because 243 and 9 correlate with the number 666:
243 ÷ 9 = 27

Multiply 36 by the number of the beast and divide by nine as the above found code indicates:
36 x 666 = 23,976
23,976 ÷ 9 = 2,664 = code number

Divide 243 by 22, the number to break the Maya codex:
243 ÷ 22 = 11.0454545

Divide this by 2.4545, a code number of the Maya codex:
11.0454545 ÷ 2.454545 = 4.5 = 45

The total number of deviating cycles consists of five, made up of nine bits = 45. Now we are going to try to prove that this proposition is correct. 45 = 5 x 9, and 243 correlates with 9. Multiply by five:
243 x 5 = 1,215 = 45 x 27

Divide the precession number by this:
25,920 ÷ 1,215 = 21.3333333 = code number.

There are five deviating cycles of nine bits. Multiply the earlier found values for the nine bits by five:

5 x 30.272727 = 151.363636
5 x 21.272727 = 106.363636
151.363636 − 106.363636 = 45
Difference: 45 circles
45 x 360 (a circle is 360 degrees) = 16,200 = code number

Extra proof: Multiply the values preceding the endless series 36:
151 x 36 = 5,436
106 x 36 = 3,816

Subtract these two values:
5,436 − 3,816 = 1,620

Divide the precession number by the result:
25,920 ÷ 1,620 = 16

Divide the code number mentioned above by 16:
21.33333 ÷ 16 = 1.3333 = code number

Divide the precession number by the 45 bits in total:
25,920 ÷ 45 = 576

Dividing this number of Venus by the above found code number produces the following remarkable outcomes:

576 ÷ 1.333 = 432
432 ÷ 1.333 = 324
324 ÷ 1.333 = 243

Note that the last three outcomes, 432, 324 and 243 comprise the same integers, arranged in various orders!

A normal sunspot cycle consists of eight bits:
8 x 3.363636 = 26.90909 (26 x 9 = 234)
8 x 2.363636 = 18.90909 (18 x 9 = 162)

Through some simple calculations you will find new code numbers, which show the correctness of this:

234 + 162 = 396 = code number
234 x 162 = 37,908

This last number shows the 52-year Maya cycle:
37,960 − 37,908 = 52

Six cycles of eight bits (6 x 8 = 48) form an important cycle:
6 x 26.90909 = 161.4545
6 x 18.90909 = 113.4545
Extra codes:
6 x 26 = 156
6 x 18 = 108
156 - 108 = 48

The total numbers of bits amounts to 48. Again codes are hiding behind this:
48 x 36 = 1,728 = code number
48 x 45 = 2,160 = code number

Conclusions:
•The number 666 refers to an essential deviation in the sunspot cycle.
•The deciphering makes us come across several other code numbers that are important in other series.

APPENDIX

APPENDIX

Calculations from Chapter 4

Dividing the first codes will make you come across the code number 1,728. You will also find this in the deciphering of the Egyptian Zodiac (see my previous book). Remember that the unit is of no importance. Again and again, they used the same code numbers for all their calculations:

$$4,207,680 \div 243.4999 = 17,280$$
$$4,204,800 \div 243.3333 = 17,280$$
$$4,147,200 \div 240 = 17,280$$

You can find the number 0.6666 as follows:
$$17,280 \div 25,920 = 0.6666$$

When you multiply 17,280 by 0.6666 you get 11,520 (period between the crashes!). Later it will become clear that the number 17.28 is an important code to calculate the exact period of the earth's orbit around the sun up to at least twelve figures after the decimal point! Furthermore:

$$17,280 \times 3 = 51,480 = \text{an important code number which you}$$
will find innumerable times

Further Calculations with the Number 0.66666

When you continue to calculate on the basis of previously found numbers, you will encounter several other "Holy Numbers." You have to use for this purpose the series 0.6666:

$$162.3333 \times 0.6666 = 108.2222$$
$$162.2222 \times 0.6666 = 108.148148$$
$$160 \times 0.6666 = 106.666666 = \text{important code number (see}$$
Chapter 17, "Venus, the Key to All Mysteries").

Here you have the number 108, which is of primary importance in the deciphering of the Egyptian Zodiac. It is directly connected to the code number 106.6666:

$$11,520 \div 108 = 106.6666$$

By means of the precession number and 106.666, you will find again the number 243, the axis orbit of Venus:

$$25,920 \div 106.6666 = 243$$

If you multiply the above found series by 0.6666 you will come across the number 72:

108.2222 x 0.6666 = 72.148148

108.148148 x 0.666 = 72.0987654320987654320 (after the point = denary scale, except number 1!)

106.6666 x 0.6666 = 71.111111 = code number (again, see Chapter 17)

In the middle number, all the figures of the denary scale appear after the point except number one! This means that number 72 is extremely important. Besides, you have already proved that you are able to find the important code numbers of Venus on the basis of number 72. Of course this is no coincidence. It proves how unbelievably meticulous they were about their calculations. The following operation proves this:

72 - 71.11111111 = 0.8888888 = important code number of the Egyptians.

Additionally, 1.11111 x 1.1111111 = 1.234567912345679, in which the number eight is absent! As a matter of fact, here we have a case of interrelation of a complete series of code numbers!

Calculations from Chapter 5

Multiply the period between the previous crashes by the orbit of the earth around the sun, according to the Maya and the currently known value:

11,520 x 365.242 = 4,207,587.84

11,520 x 365.2422 = 4,207,590.144

If you want to understand the breaking of the code, just have a quick look at the numbers. From there on you continue with the deciphering. You have to subtract the above found code value of Venus from these numbers:

4,207,590.144 – 4,204,224 = 3366.144

4,207,587.84 – 4,204,224 = 3363.84 = Maya value

The difference between the results is:

3366.144 – 3363.84 = 2.304

If you divide both results by this difference you will get the Sothic cycle! You will immediately know why this cycle was so greatly respected by the Egyptians. It is an essential part of the calculation of the previous catastrophe date:

3366.144 ÷ 2.304 = 1,461

3363.84 ÷ 2.304 = 1,460

With the above found Maya value, you will prove that this is correct: 3363.84 ÷ 576 = 584!

This evidence is mathematically indisputable because this level of coincidence is impossible. The reason for this is that the "Holy" Maya number of the earth's orbit around the sun is used in this calculation. 3363.84 = Maya value of the interval between the previous crashes = coded orbit according to Venus!
Note: Study this deciphering most carefully. You can decipher the Mayan calendars and the Dresden Codex in exactly the same manner!

Calculations from Chapter 10
Sirius, the Great Pyramid and the Number 27
Divide the respective periods of time between the previous crashes by 27:
4,249,440 ÷ 27 = 153,600
4,308,460 ÷ 27 = 155,733.3333
4,311,411 ÷ 27 = 155,840

Attentive readers will immediately see a first connection. Code numbers are hiding in the first and the last numbers: 360 and 584. These stand for a circle of 360 degrees and the orbit of Venus. In the middle you find the precession code: 0.333333. Again this cannot be a coincidence. There must be more. And look, when you subtract the second number from the third, you come to an important result to further break the codes. I had already encountered this in earlier calculations:
155,840 – 155,733.3333 = 106.666666 = code number

Another number that shows up again and again is the following:
155,733.3333 – 153,600 = 213.33333 = code number

On the basis of this number we can solve the riddle of their way of calculation. Furthermore, you encounter several numbers that are hidden in the pyramids, including the angles of 72 and 144 degrees:
153,600 ÷ 213.3333 = 720
153,600 ÷ 106.6666 = 1,440

Finally you can calculate the Sothic cycle from the period between the crashes:
11,520 x 365.25 = 4,207,680 ÷ 106.666 = 39,447

Divide this last number by 27 and you come to:
$39,447 \div 27 = 1,461!$

Calculations from Chapter 12
*Proof of 315 Declinations in the Sunspot Cycle Between
the Previous and the Forthcoming Catastrophe*
This argument can be proved by means of the period between
the crashes. Multiplying 315 by 37.44 results in the period
according to the calculation of the Maya:
$315 \times 37.44 = 11,793.6$ years

Here you have two numbers that were often used by the
Maya: 117 and 936. I found the number 117 as a code value in my
previous book *The Orion Prophecy*. The Maya divided this number
by the period between the previous and the forthcoming crash,
which amounts to 11,804 years:
$11,804 \div 117 = 100.88888 =$ code number

When you subtract the period between the crashes from the
value above, then you find another important Maya number:
$11,804 - 11,793.6 = 10.4$

You already know this number. Multiplied by 10 it results in 104,
the number of terrestrial years equivalent to 65 Venusian years.

Calculations from Chapter 13
The sunspot cycle can be mathematically depicted in Excel by
entering the following information in the given cells:
A1 = 365,25 : 87,454545454545
B1 = 360 : A1
B2 = IF(B1 +B1>359.999;(B1+B1)-360;B1+B1)
C1 = 360 X 0,363636363636
D1 = C1
D2 = IF(D1+D1>=359.999;(D1+D1)-360;D1+D1)
E1 = ABS(D1-B1)

11,567 Years for a Theoretical Sunspot Cycle
Six charts form a cycle of 11.5 years. Every sunspot cycle of 187
years contains 97 charts. Therefore there are sixteen cycles that last
approximately 11.5 years, which in total are 96 charts long. So I
determined the mean of 11,567 years for a theoretical cycle.

Calculations from Chapter 14
You already know that a complete shifting of the Zodiac
involves 25,920 years. Multiply this by the exact orbit of the earth

around the sun. Precise calculations have showed that it lasts 365.2422 days:

25,920 x 365.2422 = 9,467,077.824

The number is huge: more than nine million days. However this doesn't make any difference, because the Maya had even bigger numbers. The Maya counted with a slightly different period: 365.2420 days. This gives the following outcome, after multiplying it by the precession number:

25,920 x 365.242 = 9,467,072.640

Subtract the second number from the first. You will get 5.184 days. This number should flip a switch in the minds of attentive readers because we have already seen it several times as an important code number!"

But besides this, there is another important number: 20,736. If you forget the decimals for a minute and add this number to the previous one, then you will get 25,920 again:

5,184 + 20,736 = 25,920!

You also find this in an identical and simple calculation. From breaking previous codes I had discovered that they also operated with 365.25 days. The difference between this number and that of the Maya is exact:

365.25 – 365.242 = 0.008 days

Eight is an important finding. For eight days Venus disappears behind the sun and is invisible. Therefore, there is a connection here between the orbit of the earth and the oribt of Venus. Multiplying 0.008 by 25,920, you will find:

25,920 x 0.008 = 207.36 days

The Sidereal Orbit of the Earth

On the basis of the endless series 74 you can define the orbit of the earth in relation to the stars:

0.000000074074074 x 86,400 = 0.0064

Now add the numbers of days of the longest calendar round, and you will get the sidereal orbit:

365.25 + 0.0064 = 365.2564!

You can also prove as follows that this is correct:

64 ÷ 74 = 0.864864864 (an endless series with 864).

Later decodings confirm the exactitude of this sensational finding (every astronomer can verify this)!

THE LABYRINTH:
THE BIGGEST ARCHEOLOGICAL
DISCOVERY OF ALL TIME

An Interview Published in *Frontier Magazine*, **Frontier Sciences Foundation, The Netherlands**

With the help a GPS, Patrick Geryl and Gino Ratinckx have measured the position of the most important temples and pyramids in Egypt, on which basis they decoded the "Master Plan." They found out that the ancient Egyptians positioned their buildings according to this plan, and through various calculations they discovered the location of the Labyrinth. This huge temple, which consists of more than three thousand rooms, was the astronomical heart of Egypt. It is in this Labyrinth that they hope to find the proof of the great tidal wave that will hit the earth in 2012, in much the same way that the Great Flood was described in the Bible.

Geryl: "There have been rumors for thousands of years of an age-old time capsule hidden in the earth of Egypt. This capsule is supposed to be infinitely more important than the treasure of Tutankhamun. The reports are that the Labyrinth has secret chambers filled with technological *tours de force* of a forgotten civilization that was much older than the Egyptian one.

"On the basis of star signs we were able to determine the location of the Labyrinth. Whether coincidental or not, the Egyptologists point to the same spot as the most probable location of the Labyrinth! To our great surprise, no digging has taken place on that particular spot in the last hundred years. Just a few superficial explorations have been done. For this reason we urgently need to start working on a new project!"

FM: "What do you know about the story of Atlantis?"

Geryl: "The Egyptologist Albert Slosman has written several works on the subject. He based his writings on hieroglyphs that were carved on the temples of Esna, Dendera and Edfu. His deciphering of the hieroglyphs is unique, and you can therefore consider the following text as quite correct:

"You are now going back to the year 21,312 BC, the year of a shocking occurrence. In less than an hour a catastrophe took place. Not only the continent, but also the whole earth was subjected to huge earthquakes. Then the earth's axis started to glide. Buildings collapsed, mountain chains shook and crumbled, while it seemed that the world had

started to slip away. The movement of the planet filled the seas with an enormous quantity of kinetic energy. Uncontrollable floods of water washed over large parts of the land. Atlantis sank below water level, and because of the shift of the earth, it came to lie partially under, at that time, the North Pole, and was covered with a thick layer of ice."

FM: "What was the effect on the population?"

Geryl: "They were deeply shocked, and therefore decided to study the sky even more accurately. All the movements and combinations of the sun, the moon and the planets were carefully registered and written down in scriptures. The slightest detail was intensively studied and described meticulously. They paid special attention to the movement of the Zodiac.

"As they advanced, gaining knowledge and learning the practical use of raw materials, the inhabitants decided to build religious buildings, which resulted in a super-building: 'The Circle of Gold.' The construction took them hundreds of years. In this indescribably huge building, which had a cross-section of several kilometers, all astronomical and other observations were registered and preserved. The "Experts of the Number" studied in it the "Mathematical Celestial Combinations." They studied the sun, the planets, the stars, etc. They discovered the laws of movement, gravity, cartography and countless other sciences. Finally they could predict the catastrophe of 9792 BC. They built tens of thousands of Mandjits and escaped."

FM: "It sounds incredibly exciting…"

Geryl: "If you knew that at present an identical copy of "The Circle of Gold" lies underground in Egypt, you would have reason enough to alert the most fanatical treasure hunters in the world. However, they do not need to search anymore, because Gino and I have found the location.

"For now we are only waiting for sponsors to help us dig up this unearthly monument, in which untold secrets are hiding."

FM: "Why do you want to do this? What is your exact drive?"

Geryl: "The labyrinth contains information through which the pre-tidal wave civilization was able to calculate the exact day of the previous polar reversal. That is to say, the moment when the North Pole changed places with the South Pole, accompanied by a huge catastrophe. The population was destroyed worldwide. For that reason, they wanted to preserve their discoveries for later generations.

"When we dig up this information it will have world-shattering consequences. It will turn the entire archeological world upside-

down. The present astronomers will be scared out of their wits. Fifteen thousand years ago a civilization ruling on earth was able to theoretically calculate the sunspot cycle, something our present sun specialists are still not able to do! With the help of this cycle, they knew how to calculate exactly the date of the previous catastrophe. They escaped to Egypt and South America, where they built a new culture. We therefore have to take Noah's story literally."

FM: "Patrick, have you deciphered the Dresden Codex of the Maya?"

Geryl: "Part of it. I have been busy with it day and night for the last two years. I couldn't sleep until I found it. The content is world-shocking. It concerns a formula about the sunspot cycle that is based on the magnetic fields of the sun. Once they reach a crucial point it will result in fatal consequences for the magnetic field of the earth."

FM: "What are the consequences of a polar reversal?"

Geryl: "In one word: catastrophic. Everybody knows that the earth rotates around the sun. The sun doesn't move at all. The turning of the earth causes its apparent movement. When the North Pole changes to become the South Pole, it will mean that it would be the result of the internal spinning of the earth moving in the opposite direction."

FM: "So this involves an enormous disaster?"

Geryl: "A reversal is not a mild event. Let's make it clear. All cultures in the world have sagas and legends that describe it. The Chinese, the Hindus, the Maya and countless other civilizations tell stories about terrifying events on earth. According to the Lapp cosmogonist story, almost all human beings died when the world was overwhelmed by hurricanes and a huge tidal wave."

FM: "Is there any evidence for this?"

Geryl: "One can prove these reversals scientifically with the help of pyrogenous rock. Geological data show that polar reversals have taken place countless times, but scientists still haven't the slightest idea what mechanism causes these reversals. Besides, it is also a puzzle for them why the previous poles are found at different places. For example, quite a long time ago, the central point of the North Pole was, at different times, located in places as far apart as China and Madagascar.

"Coagulated lava, with a reversed magnetism with a strength one hundred to one thousand times stronger than the magnetic field of the earth, proves this. It also reveals the nature of the powers present at that time. Because in all the places where reversed polarities were detected, abundant flows of lava were also found."

FM: "Can you give us a more detailed description of what you hope to find in the Labyrinth?"

Geryl: "The archives we can find there concern a civilization that had the same background and culture as the Old Egyptians, as well as the same laws, arts and diplomacy. And let's not forget the secret knowledge hidden in their Holy Scriptures."

FM: "What else can be found in this 'Circle of Gold'?"

Geryl: "Incredibly much more than is readily imaginable. In the middle, there is a circle that depicts the Zodiac of Dendera. The twelve star signs that are depicted are extremely large in size. The second circle contains more complex things. Thirty-six elements are depicted in it, through which they were able to predict the previous catastrophe. This was of vital importance. Without these calculations nobody could have survived that catastrophe.

"Furthermore, we see depicted there Geb, the last ruler of Aha-Men-Ptah (Atlantis), who died in the catastrophe. He is carrying on his head the weight of the earth, which will be reborn through his wife Nut. She managed to escape and, together with other survivors, laid the foundations of the new fatherland.

"Without proper knowledge of this mingling of historical and spiritual events you cannot properly reconstruct the history of Egypt. The Great Sphinx, for example, is depicted as a lion, because the previous catastrophe took place in the Age of the Lion. On the Zodiac of Dendera you can see the broken lines under the lion. These lines form the symbol of a huge tidal wave.

"Furthermore, the Labyrinth contains masses of hieroglyphs about the Exodus, in which Horus and Isis play a main role. There are also pictures that point to a new age, like those of Taurus and Aries. Also an indescribable planetary sphere is present, containing an immeasurable number of stars.

"In short, the knowledge we can find there makes any other archeological discovery fade away. Hopefully, we don't have to wait much longer for the discovery."

FM: "Are there any treasures in the Labyrinth?"

Geryl:: "Very beautiful ones. The 'Circle of Gold' lies hidden somewhere in the complex. As the name implies, it is completely made of gold. Hundreds of tons are melted into it.

"Furthermore, you can recover the mausoleums of the first pharaohs of Egypt. They completely overshadow the one of Tutankhamun. In other words, all treasure hunters in the world should be in the highest state of readiness to uncover this monument!"

FM: "Will you get part of the treasures?"

Geryl: "No, which is logical, by the way. They comprise a unique inheritance that belongs to a museum. And the discovery

alone will invoke so much attention, that we will be able to cover the costs."

FM: "How do you plan to actually start digging for the Labyrinth?"

Geryl: "First we need to be certain that the Labyrinth is at the location we determined. Excavation costs an incredibly large amount of money, so for that reason we plan to go to Egypt with radar equipment."

FM: "What sort of equipment is that?"

Geryl: "The same that is used to search for hollow spaces. With the aid of it we should be able to look through the sand to a depth of at least twenty meters, in order to be one hundred percent sure that the Labyrinth is located there."

FM: "How much does it cost?"

Geryl: "About 30,000 Euros. The only firm in Belgium that owns this equipment is Forintec International in Merksem. We almost have the money thanks to some sponsors. "

FM: "Thank you."

BIBLIOGRAPHY

In order to prevent researchers, as well as readers, from wasting unnecessary time, I have mentioned in my previous work *The Orion Prophecy* the leading books that in my opinion are most significant. I would like to recommend the following books as well, which are also of crucial importance:

Patrick Geryl, *The Orion Prophecy*
Maurice Cotterell, *The Supergods*
Albert Slosman, *Les Survivants de l'Atlantide*, Laffont, 1978.
Velikovsky, *Worlds in Collision*, Part *I and II*, Ankh-Hermes, 1971.

INTERNET

My website is www.howtosurvive2012.com.
You can find further information at the site of Robert Bast. This is the best site about 2012. Go to Google. Fill in: Robert Bast 2012

E-MAIL

Anybody who thinks he can help me with something important can e-mail me at the following address:
patrick.geryl@belgacom.net

Please mail me only with really important matters!

GUARDIANS OF THE HOLY GRAIL
by Mark Amaru Pinkham

This book presents this extremely ancient Holy Grail lineage from Asia and how the Knights Templar were initiated into it. It also reveals how the ancient Asian wisdom regarding the Holy Grail became the foundation for the Holy Grail legends of the west while also serving as the bedrock of the European Secret Societies, which included the Freemasons, Rosicrucians, and the Illuminati. Also: The Fisher Kings; The Middle Eastern mystery schools, such as the Assassins and Yezidhi; The ancient Holy Grail lineage from Sri Lanka and the Templar Knights' initiation into it; The head of John the Baptist and its importance to the Templars; The secret Templar initiation with grotesque Baphomet, the infamous Head of Wisdom; more.
248 PAGES. 6x9 PAPERBACK. ILLUSTRATED. BIBLIOGRAPHY. $16.95. CODE: GOHG

SECRETS OF THE HOLY LANCE
The Spear of Destiny in History & Legend
by Jerry E. Smith

As Jesus Christ hung on the cross a Roman centurion pierced the Savior's side with his spear. A legend has arisen that "whosoever possesses this Holy Lance and understands the powers it serves, holds in his hand the destiny of the world for good or evil." *Secrets of the Holy Lance* traces the Spear from its possession by Constantine, Rome's first Christian Caesar, to Charlemagne's claim that with it he ruled the Holy Roman Empire by Divine Right, and on through two thousand years of kings and emperors, until it came within Hitler's grasp—and beyond! Did it rest for a while in Antarctic ice? Is it now hidden in Europe, awaiting the next person to claim its awesome power? Neither debunking nor worshiping, *Secrets of the Holy Lance* seeks to pierce the veil of myth and mystery around the Spear. Mere belief that it was infused with magic by virtue of its shedding the Savior's blood has made men kings. But what if it's more? What are "the powers it serves"?
312 PAGES. 6x9 PAPERBACK. ILLUSTRATED. BIBLIOGRAPHY. $16.95. CODE: SOHL

SUNS OF GOD
Krishna, Buddha and Christ Unveiled
by Acharya S

From the author of the controversial and best-selling book *The Christ Conspiracy: The Greatest Story Ever Sold* comes this electrifying journey into the origins and meaning of the world's religions and popular gods. Over the past several centuries, the Big Three spiritual leaders have been the Lords Christ, Krishna and Buddha, whose stories and teachings are so remarkably similar as to confound and amaze those who encounter them. As classically educated archaeologist, historian, mythologist and linguist Acharya S thoroughly reveals, these striking parallels exist not because these godmen were "historical" personages who "walked the earth" but because they are personifications of the central focus of the famous and scandalous "mysteries." These mysteries date back thousands of years and are found globally, reflecting an ancient tradition steeped in awe and intrigue. In unveiling the reasons for this highly significant development, the author presents an in-depth analysis that includes fascinating and original research based on evidence both modern and ancient—captivating information kept secret and hidden for ages.
428 PAGES. 6x9 PAPERBACK. ILLUSTRATED. BIBLIOGRAPHY. INDEX. $18.95. CODE: SUNG

THE ORION PROPHECY
Egyptian and Mayan Prophecies on the Cataclysm of 2012
by Patrick Geryl and Gino Ratinckx

In the year 2012 the Earth awaits a super catastrophe: its magnetic field will reverse in one go. Phenomenal earthquakes and tidal waves will completely destroy our civilization. These dire predictions stem from the Mayans and Egyptians—descendants of the legendary Atlantis. The Atlanteans had highly evolved astronomical knowledge and were able to exactly predict the previous world-wide flood in 9792 BC. They built tens of thousands of boats and escaped to South America and Egypt. In the year 2012 Venus, Orion and several others stars will take the same 'code-positions' as in 9792 BC! For thousands of years historical sources have told of a forgotten time capsule of ancient wisdom located in a labyrinth of secret chambers filled with artifacts and documents from the previous flood.
324 PAGES. 6x9 PAPERBACK. ILLUSTRATED. BIBLIOGRAPHY. $16.95. CODE: ORP

HOW TO SURVIVE 2012
by Patrick Geryl

In his previous books, *The Orion Prophecy* and *The World Cataclysm in 2012*, Patrick Geryl presented in great detail the scenario set to take place in the year 2012, a scenario of complete and utter destruction which has occurred in Earth's past and will occur again. Due to a recurring pattern of activity in the sun's magnetic fields, the magnetic poles of the sun reverse from time to time. This, in turn, causes the release of massive solar flares that lash out into the solar system. These cause havoc with the Earth's magnetic field, resulting in the reversal of the Earth's magnetic poles, hence a reversal of its very rotation! The Earth's outer crust is thrown into chaos, with planet-wide earthquakes, volcanoes and tidal waves reshaping landmasses and seas in a matter of hours. Civilization as we know it will end. Billions of casualties will occur worldwide; very few humans will survive. In the face of this immense cataclysm, Geryl urges mankind to prepare and endure. The outlook is bleak, but the obstacles are not insurmountable. In this book, Geryl provides the blueprint for those wishing to survive the disaster to prepare themselves and prevail. He explains in detail the myriad problems survivors will encounter, and the precautions that need to be taken to overcome them. It is his hope that with this information in hand, enough people will live on to reestablish civilization and continue human life on Earth.
294 Pages. 6x9 Paperback. Illustrated. Bibliography. Index. $16.95. Code: HS20

THE A.T. FACTOR
A Scientists Encounter with UFOs: Piece For A Jigsaw Part 3
by Leonard Cramp
British aerospace engineer Cramp began much of the scientific anti-gravity and UFO propulsion analysis back in 1955 with his landmark book *Space, Gravity & the Flying Saucer* (out-of-print and rare). His next books (available from Adventures Unlimited) *UFOs & Anti-Gravity: Piece for a Jig-Saw* and *The Cosmic Matrix: Piece for a Jig-Saw Part 2* began Cramp's in depth look into gravity control, free-energy, and the interlocking web of energy that pervades the universe. In this final book, Cramp brings to a close his detailed and controversial study of UFOs and Anti-Gravity.
324 PAGES. 6x9 PAPERBACK. ILLUSTRATED. BIBLIOGRAPHY. INDEX. $16.95. CODE: ATF

COSMIC MATRIX
Piece for a Jig-Saw, Part Two
by Leonard G. Cramp
Leonard G. Cramp, a British aerospace engineer, wrote his first book *Space Gravity and the Flying Saucer* in 1954. Cosmic Matrix is the long-awaited sequel to his 1966 book *UFOs & Anti-Gravity: Piece for a Jig-Saw*. Cramp has had a long history of examining UFO phenomena and has concluded that UFOs use the highest possible aeronautic science to move in the way they do. Cramp examines anti-gravity effects and theorizes that this super-science used by the craft—described in detail in the book—can lift mankind into a new level of technology, transportation and understanding of the universe. The book takes a close look at gravity control, time travel, and the interlocking web of energy between all planets in our solar system with Leonard's unique technical diagrams. A fantastic voyage into the present and future!
364 PAGES. 6x9 PAPERBACK. ILLUSTRATED. BIBLIOGRAPHY. $16.00. CODE: CMX

UFOS AND ANTI-GRAVITY
Piece For A Jig-Saw
by Leonard G. Cramp
Leonard G. Cramp's 1966 classic book on flying saucer propulsion and suppressed technology is a highly technical look at the UFO phenomena by a trained scientist. Cramp first introduces the idea of 'anti-grav- ity' and introduces us to the various theories of gravitation. He then examines the technology necessary to build a flying saucer and examines in great detail the technical aspects of such a craft. Cramp's book is a wealth of material and diagrams on flying saucers, anti-gravity, suppressed technology, G-fields and UFOs. Chapters include Crossroads of Aerodymanics, Aerodynamic Saucers, Limitations of Rocketry, Gravitation and the Ether, Gravitational Spaceships, G-Field Lift Effects, The Bi-Field Theory, VTOL and Hovercraft, Analysis of UFO photos, more.
388 PAGES. 6x9 PAPERBACK. ILLUSTRATED. $16.95. CODE: UAG

THE TESLA PAPERS
Nikola Tesla on Free Energy & Wireless Transmission of Power
by Nikola Tesla, edited by David Hatcher Childress
David Hatcher Childress takes us into the incredible world of Nikola Tesla and his amazing inventions. Tesla's rare article "The Problem of Increasing Human Energy with Special Reference to the Harnessing of the Sun's Energy" is included. This lengthy article was originally published in the June 1900 issue of *The Century Illustrated Monthly Magazine* and it was the outline for Tesla's master blueprint for the world. Tesla's fantastic vision of the future, including wireless power, anti-gravity, free energy and highly advanced solar power. Also included are some of the papers, patents and material collected on Tesla at the Colorado Springs Tesla Symposiums, including papers on: •The Secret History of Wireless Transmission •Tesla and the Magnifying Transmitter •Design and Construction of a Half-Wave Tesla Coil •Electrostatics: A Key to Free Energy •Progress in Zero-Point Energy Research •Electromagnetic Energy from Antennas to Atoms •Tesla's Particle Beam Technology •Fundamental Excitatory Modes of the Earth-Ionosphere Cavity
325 PAGES. 8x10 PAPERBACK. ILLUSTRATED. $16.95. CODE: TTP

THE FANTASTIC INVENTIONS OF NIKOLA TESLA
by Nikola Tesla with additional material by David Hatcher Childress
This book is a readable compendium of patents, diagrams, photos and explanations of the many incredible inventions of the originator of the modern era of electrification. In Tesla's own words are such topics as wireless transmission of power, death rays, and radio-controlled airships. In addition, rare material on German bases in Antarctica and South America, and a secret city built at a remote jungle site in South America by one of Tesla's students, Guglielmo Marconi. Marconi's secret group claims to have built flying saucers in the 1940s and to have gone to Mars in the early 1950s! Incredible photos of these Tesla craft are included. The Ancient Atlantean system of broadcasting energy through a grid system of obelisks and pyramids is discussed, and a fascinating concept comes out of one chapter: that Egyptian engineers had to wear protective metal head-shields while in these power plants, hence the Egyptian Pharoah's head covering as well as the Face on Mars! •His plan to transmit free electricity into the atmosphere. •How electrical devices would work using only small antennas. •Why unlimited power could be utilized anywhere on earth. •How radio and radar technology can be used as death-ray weapons in Star Wars.
342 PAGES. 6x9 PAPERBACK. ILLUSTRATED. $16.95. CODE: FINT

THE ANTI-GRAVITY HANDBOOK
edited by David Hatcher Childress, with Nikola Tesla, T.B. Paulicki, Bruce Cathie, Albert Einstein and others

The new expanded compilation of material on Anti-Gravity, Free Energy, Flying Saucer Propulsion, UFOs, Suppressed Technology, NASA Cover-ups and more. Highly illustrated with patents, technical illustrations and photos. This revised and expanded edition has more material, including photos of Area 51, Nevada, the government's secret testing facility. This classic on weird science is back in a 90s format!
- **How to build a flying saucer.**
- **Arthur C. Clarke on Anti-Gravity.**
- **Crystals and their role in levitation.**
- **Secret government research and development.**

230 PAGES. 7x10 PAPERBACK. ILLUSTRATED. $16.95. CODE: AGH

ANTI–GRAVITY & THE WORLD GRID

Is the earth surrounded by an intricate electromagnetic grid network offering free energy? This compilation of material on ley lines and world power points contains chapters on the geography, mathematics, and light harmonics of the earth grid. Learn the purpose of ley lines and ancient megalithic structures located on the grid. Discover how the grid made the Philadelphia Experiment possible. Explore the Coral Castle and many other mysteries, including acoustic levitation, Tesla Shields and scalar wave weaponry. Browse through the section on anti-gravity patents, and research resources.

274 PAGES. 7x10 PAPERBACK. ILLUSTRATED. $14.95. CODE: AGW

ANTI–GRAVITY & THE UNIFIED FIELD
edited by David Hatcher Childress

Is Einstein's Unified Field Theory the answer to all of our energy problems? Explored in this compilation of material is how gravity, electricity and magnetism manifest from a unified field around us. Why artificial gravity is possible; secrets of UFO propulsion; free energy; Nikola Tesla and anti-gravity airships of the 20s and 30s; flying saucers as superconducting whirls of plasma; anti-mass generators; vortex propulsion; suppressed technology; government cover-ups; gravitational pulse drive; spacecraft & more.

240 PAGES. 7x10 PAPERBACK. ILLUSTRATED. $14.95. CODE: AGU

THE MYSTERY OF THE OLMECS
by David Hatcher Childress

Lost Cities author Childress takes us deep into Mexico and Central America in search of the mysterious Olmecs, North America's early, advanced civilization. The Olmecs, now sometimes called Proto-Mayans, were not acknowledged to have existed as a civilization until an international archeological meeting in Mexico City in 1942. At this time, the megalithic statues, large structures, ceramics and other artifacts were acknowledged to come from this hitherto unknown culture that pre-dated all other cultures of Central America. But who were the Olmecs? Where did they come from? What happened to them? How sophisticated was their culture? How far back in time did it go? Why are many Olmec statues and figurines seemingly of foreign peoples such as Africans, Europeans and Chinese? Is there a link with Atlantis? In this heavily illustrated book, join Childress in search of the lost cites of the Olmecs!

432 Pages. 6x9 Paperback. Illustrated. Bibliography. $20.00. Code: MOLM

PATH OF THE POLE
Cataclysmic Pole Shift Geology
by Charles H. Hapgood

Maps of the Ancient Sea Kings author Hapgood's classic book *Path of the Pole* is back in print! Hapgood researched Antarctica, ancient maps and the geological record to conclude that the Earth's crust has slipped on the inner core many times in the past, changing the position of the pole. *Path of the Pole* discusses the various "pole shifts" in Earth's past, giving evidence for each one, and moves on to possible future pole shifts. Packed with illustrations, this is the sourcebook for many other books on cataclysms and pole shifts.

356 PAGES. 6x9 PAPERBACK. ILLUSTRATED. $16.95. CODE: POP

MAPS OF THE ANCIENT SEA KINGS
Evidence of Advanced Civilization in the Ice Age
by Charles H. Hapgood

Charles Hapgood's classic 1966 book on ancient maps produces concrete evidence of an advanced world-wide civilization existing many thousands of years before ancient Egypt. He has found the evidence in the Piri Reis Map that shows Antarctica, the Hadji Ahmed map, the Oronteus Finaeus and other amazing maps. Hapgood concluded that these maps were made from more ancient maps from the various ancient archives around the world, now lost. Not only were these unknown people more advanced in mapmaking than any people prior to the 18th century, it appears they mapped all the continents. The Americas were mapped thousands of years before Columbus. Antarctica was mapped when its coasts were free of ice!

316 PAGES. 7x10 PAPERBACK. ILLUSTRATED. BIBLIOGRAPHY & INDEX. $19.95. CODE: MASK

REICH OF THE BLACK SUN
Nazi Secret Weapons and the Cold War Allied Legend
by Joseph P. Farrell

Why were the Allies worried about an atom bomb attack by the Germans in 1944? Why did the Soviets threaten to use poison gas against the Germans? Why did Hitler in 1945 insist that holding Prague could win the war for the Third Reich? Why did US General George Patton's Third Army race for the Skoda works at Pilsen in Czechoslovakia instead of Berlin? Why did the US Army not test the uranium atom bomb it dropped on Hiroshima? Why did the Luftwaffe fly a non-stop round trip mission to within twenty miles of New York City in 1944? *Reich of the Black Sun* takes the reader on a scientific-historical journey in order to answer these questions. Arguing that Nazi Germany actually won the race for the atom bomb in late 1944, *Reich of the Black Sun* then goes on to explore the even more secretive research the Nazis were conducting into the occult, alternative physics and new energy sources. The book concludes with a fresh look at the "Nazi Legend" of the UFO mystery by examining the Roswell Majestic-12 documents and the Kecksburg crash in the light of parallels with some of the super-secret black projects being run by the SS. *Reich of the Black Sun* is must-reading for the researcher interested in alternative history, science, or UFOs!

352 PAGES. 6x9 PAPERBACK. ILLUSTRATED. BIBLIOGRAPHY. $16.95. CODE: ROBS

THE GIZA DEATH STAR DEPLOYED
The Physics & Engineering of the Great Pyramid
by Joseph P. Farrell

Farrell expands on his thesis that the Great Pyramid was a chemical maser, designed as a weapon and eventually deployed—with disastrous results to the solar system. Includes: Exploding Planets: The Movie, the Mirror, and the Model; Dating the Catastrophe and the Compound; A Brief History of the Exoteric and Esoteric Investigations of the Great Pyramid; No Machines, Please!; The Stargate Conspiracy; The Scalar Weapons; Message or Machine?; A Tesla Analysis of the Putative Physics and Engineering of the Giza Death Star; Cohering the Zero Point, Vacuum Energy, Flux: Synopsis of Scalar Physics and Paleophysics; Configuring the Scalar Pulse Wave; Inferred Applications in the Great Pyramid; Quantum Numerology, Feedback Loops and Tetrahedral Physics; and more.

290 PAGES. 6x9 PAPERBACK. ILLUSTRATED. BIBLIOGRAPHY. $16.95. CODE: GDSD

THE GIZA DEATH STAR
The Paleophysics of the Great Pyramid & the Military Complex at Giza
by Joseph P. Farrell

Physicist Joseph Farrell's amazing book on the secrets of Great Pyramid of Giza. *The Giza Death Star* starts where British engineer Christopher Dunn leaves off in his 1998 book, *The Giza Power Plant*. Was the Giza complex part of a military installation over 10,000 years ago? Chapters include: An Archaeology of Mass Destruction, Thoth and Theories; The Machine Hypothesis; Pythagoras, Plato, Planck, and the Pyramid; The Weapon Hypothesis; Encoded Harmonics of the Planck Units in the Great Pyramid; High Freqguency Direct Current "Impulse" Technology; The Grand Gallery and its Crystals: Gravito-acoustic Resonators; The Other Two Large Pyramids; the "Causeways," and the "Temples"; A Phase Conjugate Howitzer; Evidence of the Use of Weapons of Mass Destruction in Ancient Times; more.

290 PAGES. 6x9 PAPERBACK. ILLUSTRATED. $16.95. CODE: GDS

THE LAND OF OSIRIS
An Introduction to Khemitology
by Stephen S. Mehler

Was there an advanced prehistoric civilization in ancient Egypt who built the great pyramids and carved the Great Sphinx? Did the pyramids serve as energy devices and not as tombs for kings? Mehler has uncovered an indigenous oral tradition that still exists in Egypt, and has been fortunate to have studied with a living master of this tradition, Abd'El Hakim Awyan. Mehler has also been given permission to present these teachings to the Western world, teachings that unfold a whole new understanding of ancient Egypt . Chapters include: Egyptology and Its Paradigms; Asgat Nefer—The Harmony of Water; Khemit and the Myth of Atlantis; The Extraterrestrial Question; more.

272 PAGES. 6x9 PAPERBACK. ILLUSTRATED. COLOR SECTION. BIBLIOGRAPHY. $18.00 CODE: LOOS

EDEN IN EGYPT
by Ralph Ellis

The story of Adam and Eve from the Book of Genesis is perhaps one of the best-known stories in circulation, even today, and yet nobody really knows where this tale came from or what it means. But even a cursory glance at the text will demonstrate the origins of this tale, for the river of Eden is described as having four branches. There is only one river in this part of the world that fits this description, and that is the Nile, with the four branches forming the Nile Delta. According to Ellis, Judaism was based upon the reign of the pharaoh Akhenaton, because the solitary Judaic god was known as Adhon while this pharaoh's solitary god was called Aton or Adjon. But what of the identities of Adam and Eve? The Israelites were once the leaders of Egypt and would originally have spoken Egyptian (Joseph, according to the Bible, was prime minister of all Egypt). This discovery allows us to translate the Genesis story with more confidence, and the result is that it seems that Adam and Eve were actually Pharaoh Akhenaton and his famous wife Queen Nefertiti. Includes 16 page color section.

320 PAGES. 6x9 PAPERBACK. ILLUSTRATED. BIBLIOGRAPHY. INDEX. $20.00. CODE: EIE

TECHNOLOGY OF THE GODS

The Incredible Sciences of the Ancients
by David Hatcher Childress

Popular *Lost Cities* author David Hatcher Childress takes us into the amazing world of ancient technology, from computers in antiquity to the "flying machines of the gods." Childress looks at the technology that was allegedly used in Atlantis and the theory that the Great Pyramid of Egypt was originally a gigantic power station. He examines tales of ancient flight and the technology that it involved; how the ancients used electricity; megalithic building techniques; the use of crystal lenses and the fire from the gods; evidence of various high tech weapons in the past, including atomic weapons; ancient metallurgy and heavy machinery; the role of modern inventors such as Nikola Tesla in bringing ancient technology back into modern use; impossible artifacts; and more.

356 PAGES. 6x9 PAPERBACK. ILLUSTRATED. BIBLIOGRAPHY. $16.95. CODE: TGOD

VIMANA AIRCRAFT OF ANCIENT INDIA & ATLANTIS

by David Hatcher Childress, introduction by Ivan T. Sanderson

Did the ancients have the technology of flight? In this incredible volume on ancient India, authentic Indian texts such as the *Ramayana* and the *Mahabharata* are used to prove that ancient aircraft were in use more than four thousand years ago. Included in this book is the entire Fourth Century BC manuscript *Vimaanika Shastra* by the ancient author Maharishi Bharadwaaja, translated into English by the Mysore Sanskrit professor G.R. Josyer. Also included are chapters on Atlantean technology, the incredible Rama Empire of India and the devastating wars that destroyed it. Also an entire chapter on mercury vortex propulsion and mercury gyros, the power source described in the ancient Indian texts. Not to be missed by those interested in ancient civilizations or the UFO enigma.

334 PAGES. 6x9 PAPERBACK. ILLUSTRATED. $15.95. CODE: VAA

LOST CONTINENTS & THE HOLLOW EARTH

I Remember Lemuria and the Shaver Mystery
by David Hatcher Childress & Richard Shaver

Lost Continents & the Hollow Earth is Childress' thorough examination of the early hollow earth stories of Richard Shaver and the fascination that fringe fantasy subjects such as lost continents and the hollow earth have had for the American public. Shaver's rare 1948 book *I Remember Lemuria* is reprinted in its entirety, and the book is packed with illustrations from Ray Palmer's *Amazing Stories* magazine of the 1940s. Palmer and Shaver told of tunnels running through the earth—tunnels inhabited by the Deros and Teros, humanoids from an ancient spacefaring race that had inhabited the earth, eventually going underground, hundreds of thousands of years ago. Childress discusses the famous hollow earth books and delves deep into whatever reality may be behind the stories of tunnels in the earth. Operation High Jump to Antarctica in 1947 and Admiral Byrd's bizarre statements, tunnel systems in South America and Tibet, the underground world of Agartha, the belief of UFOs coming from the South Pole, more.

344 PAGES. 6x9 PAPERBACK. ILLUSTRATED. $16.95. CODE: LCHE

ATLANTIS & THE POWER SYSTEM OF THE GODS

Mercury Vortex Generators & the Power System of Atlantis
by David Hatcher Childress and Bill Clendenon

Atlantis and the Power System of the Gods starts with a reprinting of the rare 1990 book *Mercury: UFO Messenger of the Gods* by Bill Clendenon. Clendenon takes on an unusual voyage into the world of ancient flying vehicles, strange personal UFO sightings, a meeting with a "Man In Black" and then to a centuries-old library in India where he got his ideas for the diagrams of mercury vortex engines. The second part of the book is Childress' fascinating analysis of Nikola Tesla's broadcast system in light of Edgar Cayce's "Terrible Crystal" and the obelisks of ancient Egypt and Ethiopia. Includes: Atlantis and its crystal power towers that broadcast energy; how these incredible power stations may still exist today; inventor Nikola Tesla's nearly identical system of power transmission; Mercury Proton Gyros and mercury vortex propulsion; more. Richly illustrated, and packed with evidence that Atlantis not only existed—it had a world-wide energy system more sophisticated than ours today.

246 PAGES. 6x9 PAPERBACK. ILLUSTRATED. $15.95. CODE: APSG

A HITCHHIKER'S GUIDE TO ARMAGEDDON

by David Hatcher Childress

With wit and humor, popular Lost Cities author David Hatcher Childress takes us around the world and back in his trippy finalé to the Lost Cities series. He's off on an adventure in search of the apocalypse and end times. Childress hits the road from the fortress of Megiddo, the legendary citadel in northern Israel where Armageddon is prophesied to start. Hitchhiking around the world, Childress takes us from one adventure to another, to ancient cities in the deserts and the legends of worlds before our own. Childress muses on the rise and fall of civilizations, and the forces that have shaped mankind over the millennia, including wars, invasions and cataclysms. He discusses the ancient Armageddons of the past, and chronicles recent Middle East developments and their ominous undertones. In the meantime, he becomes a cargo cult god on a remote island off New Guinea, gets dragged into the Kennedy Assassination by one of the "conspirators," investigates a strange power operating out of the Altai Mountains of Mongolia, and discovers how the Knights Templar and their off-shoots have driven the world toward an epic battle centered around Jerusalem and the Middle East.

320 PAGES. 6x9 PAPERBACK. ILLUSTRATED. BIBLIOGRAPHY. INDEX. $16.95. CODE: HGA

ORDER FORM

**10% Discount
When You Order
3 or More Items!**

One Adventure Place
P.O. Box 74
Kempton, Illinois 60946
United States of America
Tel.: 815-253-6390 • Fax: 815-253-6300
Email: auphq@frontiernet.net
http://www.adventuresunlimitedpress.com

ORDERING INSTRUCTIONS

✓ Remit by USD$ Check, Money Order or Credit Card

✓ Visa, Master Card, Discover & AmEx Accepted

✓ Paypal Payments Can Be Made To:

 info@wexclub.com

✓ Prices May Change Without Notice

✓ 10% Discount for 3 or more Items

SHIPPING CHARGES

United States

✓ Postal Book Rate { $4.00 First Item
 50¢ Each Additional Item

✓ POSTAL BOOK RATE Cannot Be Tracked!

✓ Priority Mail { $5.00 First Item
 $2.00 Each Additional Item

✓ UPS { $6.00 First Item
 $1.50 Each Additional Item

 NOTE: UPS Delivery Available to Mainland USA Only

Canada

✓ Postal Air Mail { $10.00 First Item
 $2.50 Each Additional Item

✓ Personal Checks or Bank Drafts MUST BE

 US$ and Drawn on a US Bank

✓ Canadian Postal Money Orders OK

✓ Payment MUST BE US$

All Other Countries

✓ Sorry, No Surface Delivery!

✓ Postal Air Mail { $16.00 First Item
 $6.00 Each Additional Item

✓ Checks and Money Orders MUST BE US$
 and Drawn on a US Bank or branch.

✓ Paypal Payments Can Be Made in US$ To:
 info@wexclub.com

SPECIAL NOTES

✓ RETAILERS: Standard Discounts Available

✓ BACKORDERS: We Backorder all Out-of-
 Stock Items Unless Otherwise Requested

✓ PRO FORMA INVOICES: Available on Request

ORDER ONLINE AT: www.adventuresunlimitedpress.com

Please check: ✓

| This is my first order ☐ | I have ordered before ☐ |

Name

Address

City

State/Province Postal Code

Country

Phone day Evening

Fax Email

Item Code	Item Description	Qty	Total

Please check: ✓

☐ Postal-Surface	Subtotal ▶
	Less Discount-10% for 3 or more items ▶
☐ Postal-Air Mail (Priority in USA)	Balance ▶
	Illinois Residents 6.25% Sales Tax ▶
	Previous Credit ▶
☐ UPS	Shipping ▶
(Mainland USA only)	Total (check/MO in USD$ only) ▶

☐ Visa/MasterCard/Discover/American Express

Card Number

Expiration Date

10% Discount When You Order 3 or More Items!